Painting Nature's Peaceful Places

Robert Reynolds with Patrick Seslar

Paintings by Robert Reynolds

NORTH LIGHT BOOKS
CINCINNATI, OHIO

Painting Nature's Peaceful Places. Copyright © 1993 by Robert
Reynolds and Patrick Seslar. Printed and bound in Hong Kong. All
rights reserved. No part of this book may be reproduced in any form
or by any electronic or mechanical means including information
storage and retrieval systems without permission in writing from the
publisher, except by a reviewer, who may quote brief passages in a
review. Published by North Light Books, an imprint of F&W
Publications, Inc., 1507 Dana Avenue, Cincinnati, Ohio 45207.
1-800-289-0963. First edition.

97 96 95 94 93 5 4 3 2 1

Library of Congress Cataloging-in-Publication Data

Reynolds, Robert
 Painting nature's peaceful places / by Robert Reynolds with
Patrick Seslar; paintings by Robert Reynolds.
 p. cm.
 Includes index.
 ISBN 0-89134-511-6
 1. Landscape in art. 2. Watercolor painting—Technique.
I. Seslar, Patrick. II. Title.
ND2240.R48 1993
751.42'2436—dc20 93-8043
 CIP
 Rev.

Painting on title page: OCTOBER SKY, 25″×39″
Painting in table of contents: ATASCADERO AUTUMN, 22″×30″
Edited by Rachel Wolf
Designed by Sandy Conopeotis

4″×5″ transparencies of Robert Reynolds's paintings were provided
by Dennis Johansen.

ABOUT THE AUTHORS

Robert Reynolds

From early childhood, Robert Reynolds knew he wanted to be an artist, and so, with the support and encouragement of family, friends and many of his teachers, Reynolds worked at a variety of other jobs as he pursued his dream through high school and college. In due course, Reynolds earned a bachelor of professional art degree with honors from the Art Center College of Design in Los Angeles and later, a master of art degree from California Polytechnic State University (CPSU) in San Luis Obispo. After completing his master's degree, Reynolds accepted a faculty position at CPSU, where today he serves as a professor of art. Among his many accomplishments during the past seventeen years at CPSU's Art and Design Department, Reynolds developed and now teaches the department's watercolor courses. He also served as the department chairman from 1980-1981 and from 1984-1986. In 1988 Reynolds received a Distinguished Teaching Award from CPSU.

In addition to his responsibilities at CPSU, Reynolds has, for the past twenty years, devoted a portion of each summer to teaching private outdoor painting workshops in the Kirkwood/Kit Carson area of California's High Sierra mountains. Reynolds considers teaching an integral part of the creative process and a natural extension of his art.

Reynolds's paintings are in numerous private and public collections throughout the United States and have been shown in over thirty-five one-person exhibitions as well as in many other group exhibitions on the West Coast. His work has also been featured in *Watercolor Magic*, *American Artist* magazine and in *The Artist's Magazine* (where it appeared on the cover). Reynolds is listed in many national journals, including *Who's Who in American Art* and *The California Art Review*; in 1988, he was commissioned by the U.S. Postal Service to design a postal card stamp commemorating California's famed Hearst Castle as an architectural landmark.

Although he continues to be inspired by the rich variety of outdoor subjects found in other parts of California, most of his subjects for the past ten years have originated in the High Sierra or along the central coast of California near the town of San Luis Obispo, where he lives with his wife, Pat.

Reynolds's work is represented by Visions Fine Art Gallery in Morro Bay, California and by Gallerie Iona in Stockton, California.

Patrick Seslar

A graduate of Purdue University, Patrick Seslar has served as a Contributing Editor for *The Artist's Magazine* for the past seven years during which time he has written over forty articles on art technique and art marketing. Mr. Seslar's humorous monthly column on travel was a regular feature in *Trailer Life* magazine for several years, and his writings have been published in numerous other national magazines, including *American West*, *Backpacker*, *Personal Computing* and *Motorhome*. Mr. Seslar is listed in *Who's Who in U.S. Poets, Editors, and Authors*.

Mr. Seslar is also an accomplished artist. Along with twenty other artists, his life and work are profiled in *Being an Artist* (North Light Books, 1992). His paintings have been exhibited in galleries across the country and have appeared in numerous national magazines and newspapers including *The Artist's Magazine*, *Trailer Life*, *The Los Angeles Times* and the *Miami Herald*.

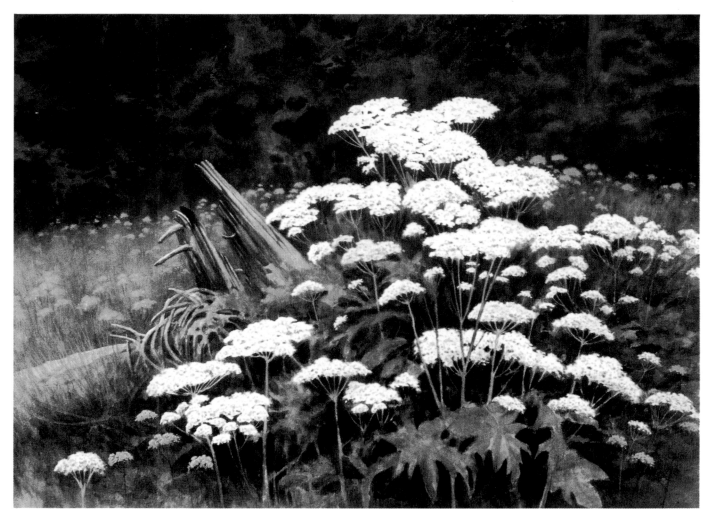

Cow Parsnip, 25″ × 39″

ACKNOWLEDGMENTS

*My sincere thanks to those who have helped
to make this book a reality:*

. . . to my wife Pat, who for countless hours allowed me to read first drafts to her and had the courage to say what I didn't always want to hear. Her support has been unwavering.

. . . to Viola E. Reynolds, my mother, who from the beginning, kindled and sustained the spark.

. . . to Patrick Seslar, a talented writer and colleague, whose tremendous work and help have been deeply appreciated and whose idea it was to begin this project. Also, he is directly responsible for *patiently* bringing me into the computer age.

. . . to North Light Books editors, Greg Albert and Rachel Wolf, whose professional help and expertise have shaped and refined this book.

. . . and finally, to all my past art students who constantly asked those unrelenting, piercing questions that helped me formulate and shape my answers.

Many thanks!
Robert Reynolds

TABLE OF CONTENTS

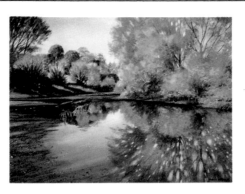

PART THREE

MOOD AND SPIRIT OF PLACE

*How to successfully capture the mood and impression
that inspired you to paint a particular scene.*

100

A Personal Philosophy • Lessons From the Past
Exploring Variations in Similar Subject Matter

FOREWORD

by Patrick Seslar

How do you capture a sense of mood and place in watercolor? Actually, the nature of the answer varies considerably, depending on where you are in your artistic growth. For example, remember the first time you picked up a brush? Those first tentative brushstrokes were probably an uneasy mixture of eagerness and apprehension, and in all likelihood, you probably weren't especially concerned with any overriding philosophy of art. More likely you were simply wondering: What kind of green will I get when I mix cobalt blue and cadmium yellow light? Which brushes should I use? Or perhaps, why does the rock I've just painted look more like a baked potato?

If you've painted for awhile, those early concerns have no doubt become less pressing and you've probably begun looking at your paintings at another level. Now you may be wondering how to create more pleasing colors, and you may have begun poking around the edges of that most mysterious world—composition and design. Perhaps you've gone a step further and have begun to consider your work on a more emotional, spiritual or philosophical level, asking yourself the "cosmic" questions: What is a painting supposed to be or do? How can I create paintings that are not only a representation of an actual scene but, more important, an expression of my own uniqueness?

Three Stages of Artistic Development

Taken as a whole, these questions reflect three principal stages of artistic development: Initially, most artists are understandably preoccupied with their first tentative attempts to manipulate the tools, techniques and materials of art making. Later, they progress through a period of thoughtful contemplation on how to create more pleasing imagery. Finally, they attempt to couple all their previous knowledge and experience into artworks that are not only well crafted and well conceived but which are, at the same time, unique expressions of their subjects and of themselves.

Hence the answer to the question, "How do I capture a sense of mood and place in watercolor?" depends on where you are artistically at the time. No one stage of development is more important than the others, and none of the questions is less valid than the others. Each stage and its associated set of questions is simply another milestone on a journey of learning and self-discovery that we must all take.

This Book's Approach

With that concept in mind, the information in this book was organized to coincide with the natural pattern of artistic growth and development.

In Part I you'll learn about the materials, techniques and working arrangements you'll need in order to capture landscape moods in watercolor. You'll learn which colors to use and how to mix them, along with various ways to put paint on paper to create realistic skies, landscape and water.

In Part II you'll see how to decipher the mysterious world of composition and design. Using specific examples and thorough step-by-step illustrations, you'll learn down-to-earth solutions you can apply in your own paintings. You'll learn how to look beyond the obvious subject matter to create pleasing relationships between the shapes and colors in your paintings. You'll learn how to select and analyze a subject, then plan, edit and execute a painting for maximum impact.

Finally, in Part III you'll examine the personal and philosophical side of the art-making process. There, via numerous exercises and examples, you'll learn how to tap into your personal vision of the world and successfully capture the mood and emotion that originally inspired you to paint a particular scene.

To better understand the process of capturing the mood and spirit of a place in your own paintings, it's often helpful to see how another artist has approached the same task. In this book you'll get an intimate look at how Robert Reynolds translates the world around him into evocative landscape paintings. As a working artist and professor of art at California Polytechnic State University in San Luis Obispo, California, Reynolds is especially well qualified; throughout these pages you'll get to look over his shoulder at each stage of the creative process as he moves from inspiration to final image. You'll be privy to his thoughts and ideas as he shows you how to blend your personal artistic vision with realistic scenes to create landscape paintings that succeed in capturing the mood and spirit of a scene.

A Collaboration

You'll find this book a bit different from those you're accustomed to in that it is a collaboration between Robert Reynolds and myself. In presenting our material in this way, we hope that as the adage suggests, our two heads will be better than one and that you'll gain more from our joint perspective than from either of us alone. As this book developed, my role came to be that of "devil's advocate"; on your behalf, I've questioned Reynolds in detail on points of technique and philosophy that are second nature to him but which might not be as obvious to artists who are still grappling with the task of capturing mood and place in their landscape paintings. In addition, I've written short intro-

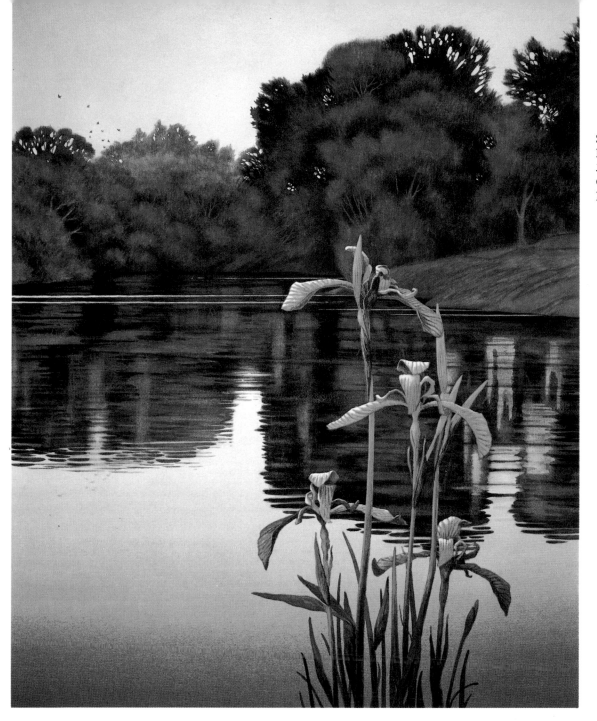

SYMPHONY SUITE:
INTERLUDE
35" × 24"
Collection of Julie
Hartmann Senn

ductions to each of the major divisions of the book in which
I've attempted to offer a broader perspective on what fol-
lows.

So as you make your journey of discovery through these
pages, we'd like you to think of us as your tour guides,
calling out interesting and useful points along the way. No
matter where you are on your personal artistic journey, we
feel this book is certain to provide new insights and new
techniques that will help you capture mood and a sense of
place in your landscape paintings and, in the process, create
better and stronger watercolors as well.

Patrick Seslar
La Jolla, California

INTRODUCTION

by Robert Reynolds

In the small California coastal town where I grew up, I had few chances to see great works of art. Nevertheless, as a child, I was always fascinated by the pictures of paintings I found in books. In retrospect, of course, I wish I'd had more opportunity to see great works of art firsthand—but I suspect that whatever I may have missed in that regard was more than compensated for by the abundant scenery where I lived, for I was always surrounded by subtle, seasonal changes of color and the ever-changing moods and movement of the ocean. In my early years, I was also blessed with teachers who recognized my interest in drawing and encouraged me with special projects that implemented my art even in non-art classes.

Movies were another significant influence on the course of my artistic development. Although I enjoyed and was no doubt influenced by the lush imagery of the color films that are the rule today, it was the strong sense of design and visual drama in the early black-and-white films that influenced me the most. I vividly recall sitting in darkened movie theatres as a child, being thoroughly entranced by the dramatic images that flashed across the screen. The directors of those films obviously had a love affair with the power of strong composition and the drama of light. Only when I studied art history in college, did I realize how many of those film images echoed the composition and lighting of paintings by the masters. Perhaps those early film-makers were influenced and inspired by many of the same paintings that later influenced and inspired me.

Although I didn't realize it at the time, it's clear to me now that all of my childhood visual experiences—from books, movies and the world around me—have become an integral part of my art.

At the Art Center College of Design, in Los Angeles, California, I finally had the opportunity to examine a vast array of original paintings at several nearby museums. During that formative period of my career, I discussed art eagerly and often with my artist friends and teachers, many of whom argued that the subject of a painting was unimportant, that the only things that mattered were artistic expression and the pictorial elements that made up the composition. In short, anything could be art. At face value, this seemed an accurate and convincing philosophy and one that could help artists appreciate all things as possible subjects, but it seemed to carry with it the danger of reducing the world to little more than a series of impersonal pictorial possibilities.

After graduation I returned to the central California coast, where I met two special people—artists Robert Clark and Arne Nybak. Both are consummate professionals who have been generous with their support, advice and friendship. I've also been influenced by other artists, including Winslow Homer, John Singer Sargent, Maxfield Parrish, James McNeill Whistler and Andrew Wyeth. The English and Pre-Raphaelite schools of art also attracted my attention and no doubt influenced my art on several occasions when I visited England to pursue my own study of Turner, Constable, Girten and Cox.

The one element shared by all the artists who have influenced me is that they were or are outstanding draftsmen who placed great importance on the ability to draw. In that respect, I am a traditionalist. I recognize the contributions of the artists that have come before me and draw on their explorations and various successes in all media. In addition, I'm influenced by many contemporary ideas and methods. At the same time, when I approach a painting, I add ingredients that reflect my own personal way of seeing, feeling and executing my art. As a result, my art is constantly evolving.

I have never been one to approach watercolor timidly. In fact, people often remark that my work doesn't look like watercolor. What I think they are trying to say is that in their minds, watercolor is normally a light, airy medium characterized by pastel colors. Of course, that conception could as easily apply to any medium, depending on the objectives and skill of the person holding the brush. By the same token, watercolor can be as bold and rich as any other medium—qualities that are, in fact, enhanced by the wonderful, luminous quality of overlaid transparent glazes.

Over the years, as I've tried to arrive at my own understanding of what made paintings both moving and enduring, I realized that pictorial possibilities, good draftsmanship and skilled brushwork are all highly desirable, but that something more is necessary. In reality, the indefinable spark that imbues a painting with life and meaning is a natural outgrowth of each artist's sincere involvement with his or her subject. To put it another way: A truly successful painting tells viewers as much about the artist as it does about the subject.

Perhaps not surprisingly, my approach to art has become a synthesis of all these influences: solid technical skills, good design and composition, and artistic sincerity. On one hand, I believe that a successful representational painting is only as strong as its abstract design; on the other, a painting's capacity to move viewers emotionally depends, not on the school of painting that's currently in vogue, but on the intrinsic quality of the concept that inspired it and on the sincerity with which it is executed. Therefore, in my paintings, I try to create images that are well executed both technically and compositionally, and that have a deeper substance; that is, images that capture something of the inner spirit of my subjects and their moods.

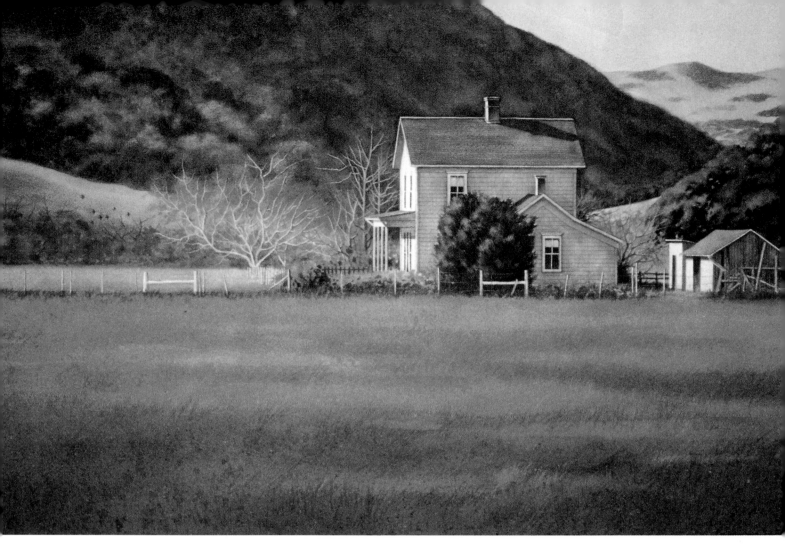

EAST OF CAMBRIA, 24" × 35", Collection of Mary Alice Baldwin

My own transition from a preoccupation with technique and composition to an emphasis on mood and sincerity has been gradual. Despite a strong desire for well-executed images, I've slowly discarded certain objectives I'd once thought important and have become less concerned with surface appearances. Instead, I've attempted to confront more meaningful values in my life. In the process, my paintings have become an inextricable part of the fabric of my everyday life; if I'm not actively painting a subject, I'm almost certainly involved with it in myriad other ways, always observing and absorbing.

For me, one of the keys to successfully capturing mood and a sense of place in painting lies in making a conscious effort to paint subjects with a definite meaning in or relationship to my everyday life. I don't attempt to doggedly copy everything in front of me, nor do I believe that it's particularly important that viewers recognize the exact location — that misses the point. As artists, we deal with essences and interpretation. Each of us sees the world with a different inner vision, and when the sub-

jects we paint have personal meaning, the sincerity that inspired our efforts will almost certainly be felt by those who view our paintings.

In the end, however, you may discover as I have that the truly lasting satisfactions of being an artist come not only from the images we create but also from what we learn about ourselves in the process.

Robert Reynolds
San Luis Obispo, California

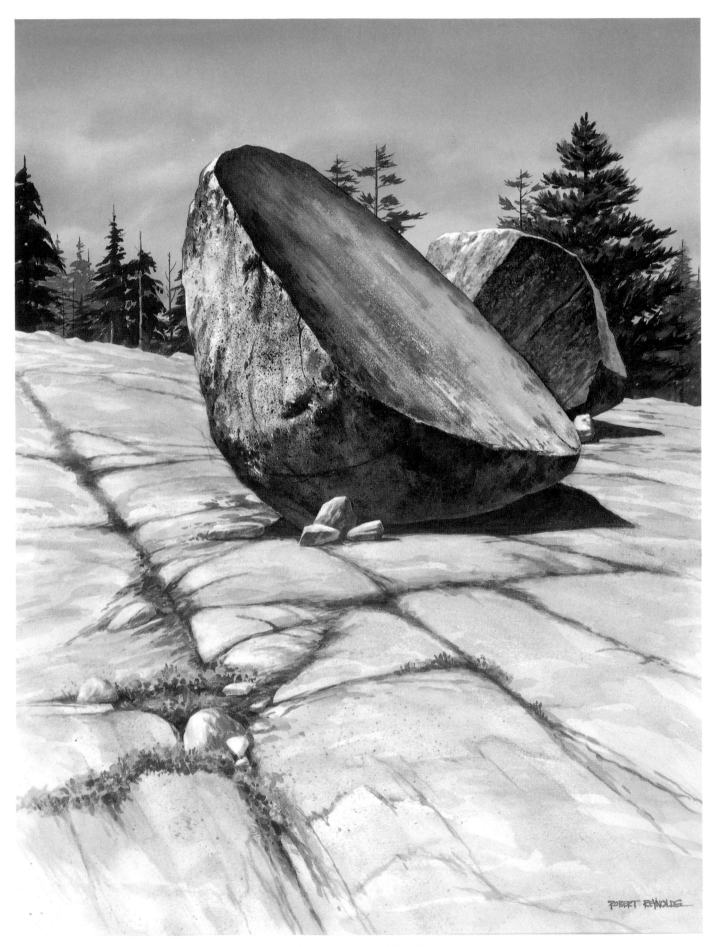

GRANITE GIANTS, 39″ × 25″

PART I
STUDIO, MATERIALS AND WORKING METHODS

Clearly, a watercolor painting that successfully captures the mood of a landscape scene is much more than the simple sum of the materials and "twists of the wrist" that go into it. A successful painting is the sum of the artist's unique life experience as well as a reflection of that artist's preferences regarding colors, materials, specific techniques, choice of subject and point of view. Thankfully, no two artists see the world in quite the same way.

The results of these individual differences are obvious in some ways—in the subjects we choose and in our painting style, for example—but more subtle in other ways, as in the design of studio work spaces, choice of materials and paint-handling techniques. Though essentially "invisible" in the completed image, these less obvious aspects of the creative process are no less important in determining the final image because they exert an irresistible influence on what is ultimately created. Therefore, to fully understand how any artist creates the type of image that he or she does—and how you can discover your own personal form of artistic expression—you need to know how that artist works, what he works with and why.

In the following pages, Robert Reynolds describes the materials, work space and techniques he uses to capture his vision of landscape moods in watercolor. You'll find his comments, insights and recommendations helpful in making your own choices. Keep in mind that this information is not intended as a rigid formula, but rather as an aid to help you understand how the materials and techniques Reynolds uses affect the imagery he creates. This is simply what works for him; if it works for you, use it. If not, adapt it until it does.

—Patrick Seslar

STUDIO

My studio is approximately 20 feet by 20 feet, with tall north-facing windows along one side. My easel sits in the central area to take advantage of the north light and to allow me plenty of room to sit or stand as necessary during the course of a painting. The roughly 12 feet between my easel and the large windows allows enough space for me to move back to reflect on and evaluate each watercolor as it progresses.

After years of experimentation, I've settled on a drafting table as my "easel" because it provides an incredibly flexible work surface. For the past couple of years, I've been using a D&D brand hydraulically assisted drafting table, which can be raised or lowered easily, rotated 360 degrees on its vertical axis, tilted at any angle, or used horizontally like a conventional table.

I usually stand when I begin a painting, but as it progresses, I'm able to sit at least part of the time. For those periods when I am able to sit, I have a swivel chair on wheels, which allows me to move forward or backward in one quick motion.

To the right of my drafting table, I've positioned another worktable. The forward portion of the tabletop provides space for my palette, brushes, pencils and other odds and ends I might need while painting. At the rear of the table sits a pigeonhole storage unit of my own design that I had constructed by a local carpenter. This storage unit has forty-two deep compartments that I use for pigments, masking agents, cotton tips—in short, just about anything I might conceivably need while painting.

I paint under north light from the large studio windows whenever possible because it provides a reflective, somewhat cool light that I prefer when mixing colors. Painting in a room with large windows also gives me a psychological lift, and I always find it stimulating to be able to look out at the sky or landscape while pondering my next passage. Even so, the demands on my time frequently make it necessary for me to paint in the evenings or on overcast days when I have no choice but to work under artificial light. For those times, I use a combination of fluorescent "daylight" bulbs and conventional incandescent bulbs mounted overhead as well as additional incandescent track lighting above and behind my easel.

Fortunately, since my paintings are based on a strong basic value structure, it isn't important that I duplicate each color faithfully from session to session. As a result, any minor shifts in color resulting from north or artificial lighting aren't detrimental to a painting in progress. In fact, I suspect that paintings created under a combination of natural and artificial light may prove more versatile than paintings created under a single light source. Once a painting leaves my studio, I have no way of knowing under what light it will be shown. In galleries or private homes, for example, it may hang under natural, incandes-

Photo by Mark Kauffman

This shows the location and size of the large north-facing windows in my studio. Also note the overhead track lighting.

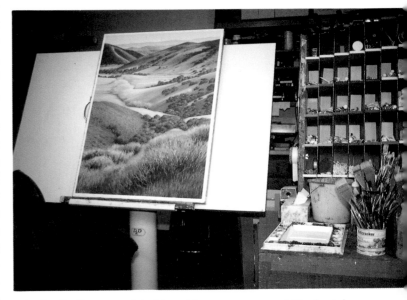

A hydraulically operated drafting table serves as my easel. To the right is a worktable and storage unit with multiple pigeonholes for pigments, masking agents, cotton swabs, etc.

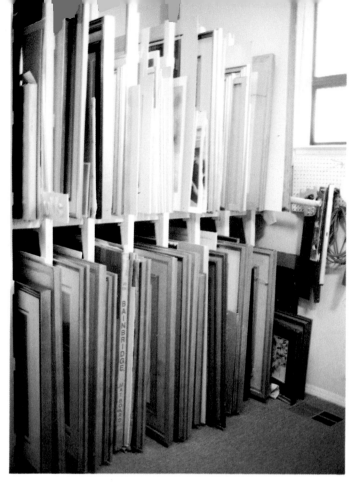

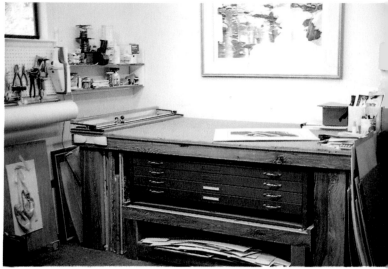

Here is the mat-cutting area with blueprint-style storage drawers below, which are used to store loose drawings and sketchbooks. The carpet-covered top of this 4′ × 7′ cutting table is one of my most useful studio accessories. When not cutting mats on it, I use it to lay out and sort various reference materials, and as a convenient place to stretch watercolor paper, remove staples from finished works, and assemble frames, glass and mats.

Vertical racks occupy another corner of the studio and provide convenient and compact storage for a variety of sizes of unframed and framed paintings.

cent or fluorescent lighting, or any combination of these light sources. All in all, everything seems to even out.

In addition to primary work areas, my studio provides space for a mini-office, additional storage for completed works, reference materials, a sink, and an area for matting and framing.

Since my studio isn't especially large, I try to make the best use of the space I have. For example, the tall walls in my studio (necessitated by the large north-facing windows) provide excellent shelf-storage for my library of reference materials. I also keep photographic reference materials in cardboard boxes, each labeled according to subject. I keep correspondence and other important papers in several four-drawer file cabinets. Even with all this varied storage space, I must continually review my collection of older paintings and drawings to eliminate any that no longer represent exhibit-quality work or that I've kept for sentimental or other reasons. Parting with work that is no longer pertinent is always difficult, but the alternative, alas, is slow entombment in a cluttered studio and a crowded work space that soon begins to interfere with my creative efforts.

A studio library is an important part of my painting process. There I'm able to refresh my memory regarding specific techniques, confirm the markings of a particular bird, or simply gain inspiration from reading the philosophy of artists I admire. In addition to books, my reference shelves contain slide carrousels and boxes of photographs, each labeled according to subject.

COLORS

With as many as eighty different colors available in each of several brands, there is no simple way to choose the "correct" colors for your palette. In fact, most artists find that the list of colors they use regularly is in a constant state of evolution as their tastes, working methods and subject matter change. If you're new to watercolor, take time to experiment with a wide variety of colors and with different brands of the same color until you find both the brand and selection of colors that best fits your painting sensibilities. If you're more seasoned, make an effort to experiment periodically with new or different colors; you may find a color that has better handling characteristics or one that captures a nuance of color better than others you're now using or mixing.

When choosing a palette, color appears to be the most important factor, but several other characteristics should be carefully considered as well. For example:

PERMANENCE. Although many people think of watercolor as rather "delicate," the pigments used in this delightful medium are as permanent and as resistant to fading as those in any other medium. As a safeguard, however, be sure to check the permanency ratings for individual colors on the tube or label or in literature available from the manufacturer. With proper care, completed paintings are also equally durable. Simply avoid excessive exposure to moisture or direct sunlight.

TRANSPARENCY. Part of the unique appeal and vitality of watercolor is the way the white of the paper glows through even the most intense colors. Watercolor pigments, however, vary tremendously in transparency. Dye-based colors such as phthalo blue will remain transparent in all but the most dense applications, while colors in the cadmium family, for example, become semi-opaque in heavier applications. Of course, as you gain experience, you'll learn to allow for these variations. In the meantime, you may want to create a series of test swatches on scrap watercolor paper, in mixtures ranging from highly diluted to pigment rich, to judge the relative transparency of each of the colors you wish to include on your palette.

OPAQUE COLORS. In my watercolors, I rarely use white opaque paint. On rare occasions, I will add gouache or Chinese white, provided I feel certain that it will improve a small area and not be obvious. During several visits to England, I learned that most British master watercolorists in the past used some form of opaque white or, in some cases, colored gouache. Today, the use of opaque pigments in transparent watercolor is not condoned by most practitioners of the medium. Aside from that consideration, opaque colors generally look foreign and can detract from an otherwise transparent painting.

Occasionally, if an area such as a few small flowers has become visually "dead," I'll paint over their shapes with acrylic white and later, glaze with watercolor so that it still retains the transparent method and appearance. Be careful, however, because this procedure can create sharp edges, and it's only effective for very small areas. If a larger area needs attention and is resistant to lifting methods, it might be better to take a deep breath and start the painting over.

GRANULAR PIGMENTS. In most of my work, I prefer to create textures through the use of spatter, lifting, judicious use of sandpaper and, occasionally, by adding salt.

In addition to these methods, many watercolor pigments settle in a "granular" pattern when diluted with lots of water and allowed to dry undisturbed. On my palette, for example, cerulean blue and yellow ochre both have this tendency. Of course, if you aren't after this effect, a wash can be modeled or "charged" with denser pigment from the same color family to impede the granular effect. Some watercolor pigments, due to their physical makeup, have a greater tendency to separate when mixed with other colors. When burnt sienna is mixed with cerulean blue, for example, the resulting granular separation produces various interesting visual effects. Yellow ochre has a similar separating effect when mixed with cobalt or ultramarine blue.

When a subject demands a granular texture or a "soil treatment," I'll occasionally add raw umber to my palette. Raw umber is excellent for "antiquing" a building or interior walls. I also like to use it as a glaze or in scumbling techniques. (Just be careful that it doesn't get too thick and become opaque.)

Salt provides yet another way of providing a granular texture. All colors react to salt, as long as there is enough water in the mixture; if the color is too dense, the salt has a tougher time separating the pigment particles. If I notice that the salt effect doesn't seem to be working, I spray water from a spray bottle into the dense area of color. The added water helps the salt "move" the pigment and expose the paper (which is basically what happens with the salt method).

TINTING STRENGTH. Another important variation between colors is tinting strength — that is, the amount of pigment required to paint a passage of equal intensity or density using different colors. An easy way to understand this concept is to create a few test swatches using colors that vary widely in tinting strength. For example, try a color with maximum tinting strength like phthalo green or blue, then try a second swatch using a color with minimal tinting strength like green earth or cobalt violet. As you gain experience, you'll take tinting strength into account almost automatically, but a few minutes spent early on creating test swatches for each of the colors on your palette can take much of the mystery out of color mixing.

STAINING COLORS. In some circles, watercolor has a

reputation as an unforgiving medium. Many artists would dispute that assertion, but to the degree that it's accurate, it is probably the result of staining colors that, once down, are all but impossible to remove. To avoid that danger, many watercolorists prefer to work exclusively with nonstaining colors—those that can be removed leaving only the white of the paper behind—thereby allowing maximum freedom to rework and correct passages that don't come out as expected.

In general, whenever I paint, I simply try to be conscious of which colors are staining colors. For example, at one time I relied on a mixture of Hooker's green dark and alizarin crimson when creating the effect of tree foliage. Unfortunately, Hooker's green when mixed with alizarin crimson seemed to "lock" into the paper making the color difficult to lift or move around. Finally, after years of struggle, I began using mixtures of blues and yellows to create my own greens. On the whole, however, there's no reason to avoid staining colors. They pose no insurmountable difficulties for experienced watercolorists and can be quite useful when an area needs to be glazed with a second color without lifting the first color in the process. Quite often, for example, I'll use alizarin crimson as a glazing color to unify a number of elements in a painting.

The best way to determine the staining characteristics of the colors you've chosen for your palette is to make a test swatch for each color. Then, when the swatches are dry, see how close you can come to regaining the white of the paper by rewetting each swatch in turn and attempting to lift color off with a stiff brush or a dampened facial tissue. (Be careful not to tear or bruise the surface of the paper in the process!)

COLOR VARIATIONS BETWEEN BRANDS. Most of the colors I use are Winsor & Newton brand, but if I can't find what I need, I'll occasionally fill in with equivalent hues from the Holbein or Grumbacher brands of colors. My reasons for this have more to do with simple practicality than with brand loyalty; different brands of alizarin crimson, for example, are rarely identical in all respects, despite having the same color name. As a result, using the same brand of alizarin crimson consistently helps assure predictable results and allows you to become intimately familiar with how it performs in washes and in mixtures with other colors. Obviously this principle applies for all the colors on your palette. In time, you'll almost automatically compensate for color variations between brands when you find it necessary to substitute. You needn't select all your colors from the same brand, but for each color, try to choose one brand that suits you and use it consistently.

STUDENT-GRADE VS. PROFESSIONAL-QUALITY COLORS. Another important factor in your choice of colors is quality. The next time you're at an art supply store, take a moment to compare the prices of a less expensive student-grade watercolor like Grumbacher's Academy brand with the same color in a professional grade like Grumbacher's Finest brand. Outwardly the colors appear to be the same except for the difference in price, but the important differences aren't immediately obvious. Although it's difficult to make any blanket statement, student-grade colors typically differ from professional-grade colors in one or more important characteristics, such as tinting strength, permanence, and how fine the pigment is ground. In general, professional-grade colors simply handle better, produce better results and are more permanent. Since a little watercolor goes a long way, a good rule of thumb is: Buy the best, forget the rest.

TUBE VS. PAN COLORS. Colors of equal quality are available from most manufacturers as either moist colors in tubes or as dry cakes or pans. For small impromptu sketches in the studio or on location, the dry pan-type colors are convenient and portable, but for larger images that require lots of color for large washes, tube colors are easier to manipulate and replenish on a moment's notice.

I haven't used or purchased pan-type watercolors in many years, perhaps because I was always taught that the money saved on them would be lost through wear and tear on good brushes due to the abrasion that results from moistening dried pigments. Actually this is a rather minor consideration. Quite often, after I've finished applying the broad wet passages of color in a painting, I'll return later to moisten remnants of dried tube colors on my palette and use them to glaze and scumble smaller areas and finishing details.

Alizarin Crimson	Vermilion	Cadmium Orange	Burnt Sienna	Raw Sienna

Yellow Ochre	Cadmium Yellow	Cadmium Yellow Pale	Hooker's Green Dark	Viridian Green

Prussian Blue	Cerulean Blue	Cobalt Blue	Ultramarine	Mineral Violet

Payne's Gray

Here is my basic palette of about fifteen colors, all of which are fairly transparent when diluted with water.

Palette

My palette has changed in many ways over the years. For example, I used to include ivory black in my basic palette, but today I rarely use it because it doesn't produce the lively shadow tones and low-intensity colors that I now create using other colors. I also rely less on earth colors such as burnt sienna and burnt umber because they seem too "heavy" to capture the light and airy feeling of sky, clouds, fog and mist.

Of course there are exceptions. For instance, when a sky is golden yellow, I'll use cadmium orange, cadmium yellow light and perhaps a small amount of burnt sienna, raw sienna or yellow ochre. But when the day has an "atmosphere" that suggests a combination of blues, violets and cool reds, I generally keep away from earth colors.

Another reason for my reticence in using earth colors for atmospheric scenes is that I've always admired the airy quality of the French Impressionists. Although I can't document it, I believe the Impressionists kept to purer colors to a great extent when choosing pigments for atmospheric effects.

As I remove colors from my palette that are no longer useful, I'm constantly on the lookout for new colors that will work better than others on my palette. For example, I've recently begun using Holbein's mineral violet because no violet I've been able to mix from my basic palette produces the same richness of color.

All that said, my basic palette consists of about fifteen colors, all of which are fairly transparent when diluted with water. On the following pages are descriptions of each color and its unique qualities and uses.

ALIZARIN CRIMSON. A cool, intense, staining red. When mixed with a good amount of water, it makes a number of excellent pinks. When mixed in roughly equal proportions with Hooker's green dark, this versatile color produces a rich variety of near blacks that can easily be leaned toward green or red as necessary. When a small amount of alizarin is used to lower the intensity of Hooker's green, the result is a dark, earthy green. Caution: A little alizarin goes a long way.

VERMILION. A warm, brilliant red, with a hint of orange. One of the most expensive colors. Unlike alizarin crimson, vermilion is an opaque color that requires careful handling since it can become muddy rather quickly. When handled with care and authority, however, it glows like no other color.

CADMIUM RED LIGHT. (Not shown.) A warm red that's useful but lacks the glowing strength of vermilion. For artists on tight budgets, cadmium red light makes a good substitute for vermilion.

CADMIUM ORANGE. A bright, clean orange, slightly opaque. Excellent mixing qualities and a good choice when you want a bright, warm effect. Used with reds and yellows, it captures the quality of "light" at sunrise or sunset. Yellows and reds can be used to create orange, but not of the same intensity as cadmium orange straight out of the tube.

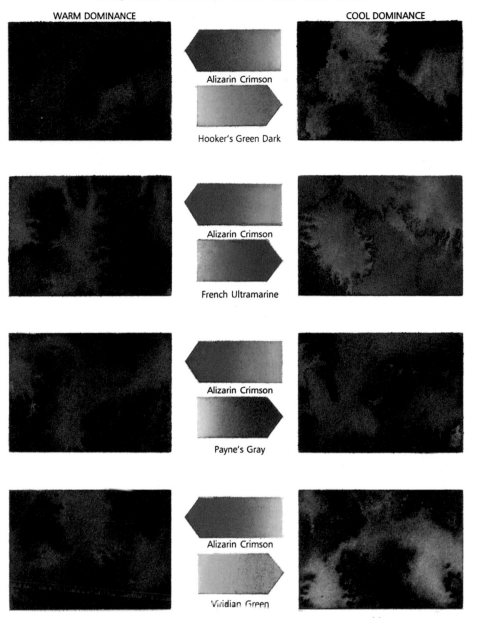

Alizarin crimson is an extremely versatile color that performs well as a highly diluted glaze, or in more pigment-rich mixtures with other colors, such as Hooker's green dark, French ultramarine blue, Payne's gray and viridian green.

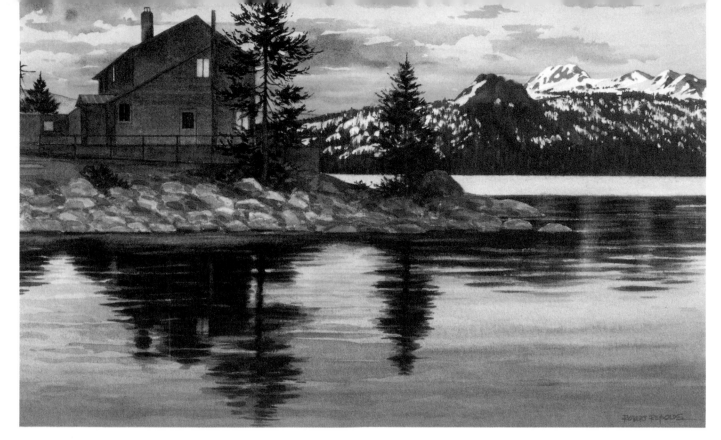

REFLECTIONS AT CAPLES, 22″ × 28″, Collection of Geoffrey and Melene Smith
This completed painting illustrates the use of various cadmium colors (red, orange and yellows) to capture the mood at sunset.

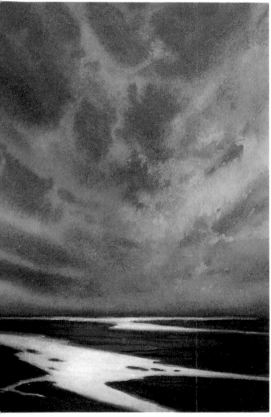

Here is a study of various sky-color combinations using mixtures of cadmium red light, cerulean blue, cadmium orange, French ultramarine blue and cadmium yellow medium.

BURNT SIENNA. A bright, permanent orange-brown with excellent working qualities. When mixed with Prussian blue, it makes a beautiful warm, dark green; by increasing the amount of blue in the mixture, it produces a cool, dark green (excellent for the cool shadow side of tree foliage). As with raw sienna and yellow ochre, it is an excellent color for capturing earth effects (soil, dirt and so on). Also, I use it quite often when I want to deepen some of the cooler colors. Again, be careful; it can turn mixtures green. A small amount of alizarin crimson will counter this tendency.

BURNT UMBER. (Not shown.) An earth color. Darker, but somewhat cooler than burnt sienna. It doesn't mix as well as other colors, and I rarely use it, except when I want a dark, earthy color.

RAW SIENNA. A muted, semi-opaque yellow-orange, somewhat similar to yellow ochre but darker and more transparent. I use raw sienna quite often when capturing "soil" effects in landscape paintings. Occasionally, I'll glaze with raw sienna when I want an overall warm color to unite various elements in a painting. Be careful when glazing raw sienna over colors from the blue family because the resulting mixtures can turn to a muted green.

YELLOW OCHRE. A fairly opaque, muted yellow with a tannish cast. When mixed with blues, it produces low-intensity greens; with reds, it produces low-intensity oranges.

An earth color, yellow ochre is an excellent option when

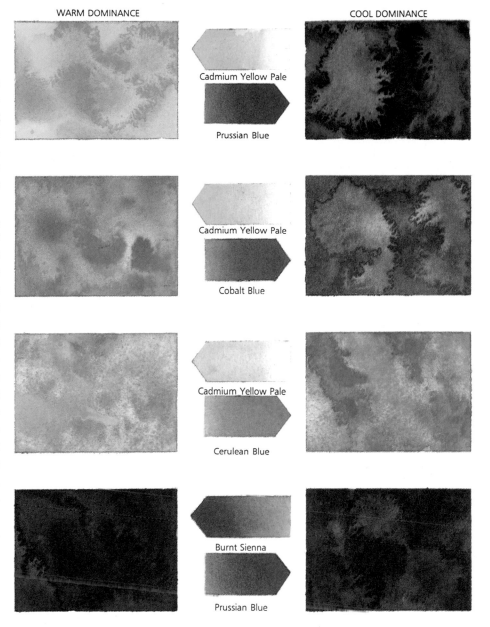

you need a less intense yellow than the cadmium pigments. I sometimes use yellow ochre as a "ground" color, applying various greens over it but taking care to allow the yellow ochre to glow through. A similar effect can also be achieved by applying the red family of colors over yellow ochre.

CADMIUM YELLOW. A warmer, darker yellow than cadmium yellow light. Like cadmium yellow pale, it is an opaque color. I don't use it as much as cadmium yellow pale, but it does make beautiful, deep, warm greens when mixed with either cerulean, ultramarine or cobalt blue. As with other cadmium colors, be careful not to allow it to become too opaque, but don't be afraid to use it to your advantage when you want to spark an area that needs more intensity. When the occasion arises, cadmium yellow medium is also excellent straight out of the tube for a painting that needs a bright, middle yellow. Like alizarin crimson, a little cadmium yellow goes a long way.

CADMIUM YELLOW PALE. A cool, sharp light yellow that mixes with great ease. Most of my greens are mixed from this delightful color in combinations with Prussian blue, cobalt blue and ultramarine blue. An unusual cool blue-green can be achieved by mixing cadmium yellow pale with cerulean blue, but again, be careful—both colors are rather opaque. Once greens have been mixed, they can be tilted toward warm or cool by varying the amount of blue or yellow in the mixture. If a still warmer green is desired, cadmium orange or burnt sienna will add a rich, warm effect to the color.

CADMIUM YELLOW LIGHT. (Not shown.) A bright light yellow that, although slightly cool by itself, produces lush oranges when mixed with reds. Mixed with blues, it produces rich greens. With Prussian blue, for example, it creates a variety of greens useful for rendering tree foliage and ground plants. For a warmer green, simply add more yellow to this basic yellow-blue mixture. To produce a bright blue-green, mix cadmium yellow light with cerulean blue—but use caution because the mixture can easily become too opaque since both are somewhat opaque colors.

These sample green mixtures are useful for shrubs and foliage and can be tilted toward warm or cool dominance by using various combinations of cadmium yellow pale, Prussian blue, cobalt blue, cerulean blue and burnt sienna.

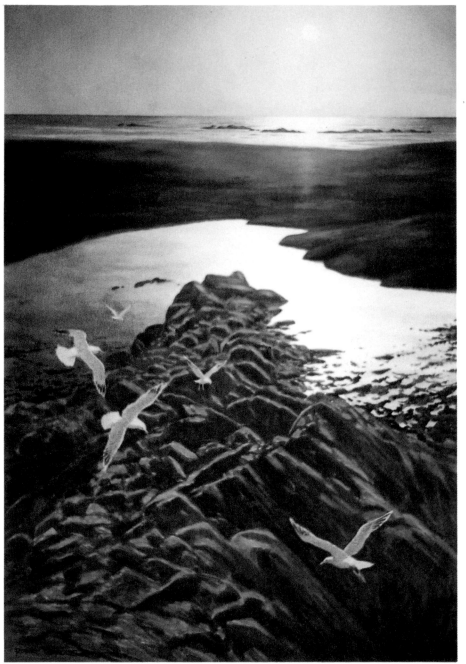

For rock and foliage colors and textures, Prussian blue can be used, along with other palette colors such as burnt sienna, alizarin crimson, Payne's gray and cadmium orange.

CAMBRIA COASTLINE
28″ × 22″
Courtesy of Visions Art Gallery, Morro Bay, California

When a sky is golden yellow, I'll use cadmium orange, cadmium yellow light, and perhaps a small amount of burnt sienna, raw sienna or yellow ochre. But when the day has an "atmosphere" that suggests a combination of blues, violets and cool reds, I generally keep away from earth colors.

HOOKER'S GREEN DARK. A warm, transparent green and an excellent mixing complement for reds. Hooker's also comes in two other shades, depending on the brand: Hooker's green and Hooker's green light. All three are excellent to work with, but Hooker's green dark seems to do it all without need of the other two. When mixed with alizarin crimson, it produces deep, rich, dark greens or dark reds, depending on which of the two colors dominates. Excellent for areas that demand a warm, earthy green, especially with the addition of burnt sienna.

Although not classified as a staining color, I have experienced difficulty removing or lifting it from the paper, so I'm cautious when using it. For example, I only use it for foliage effects when I know it will not be modified later; otherwise, I mix my own greens.

VIRIDIAN GREEN. A transparent, nonstaining blue-green of moderate tinting strength. Viridian doesn't mix well with other colors, but for on-location work, I've found it to be useful for mixing cool, intense greens. It also works well as an accent color for capturing certain shades of green vegetation that cannot easily be rendered using greens mixed from various blues and cadmium yellows.

PRUSSIAN BLUE. A cool and transparent blue, Prussian is a staining color that tends to produce a grainy texture in washes. Having Prussian blue on your palette is like living on the edge of catastrophe, but the results are worth the risks. Mixing Prus-

Even though cerulean blue is the most opaque of the colors on the Reynolds palette, it can be highly diluted and used with great finesse, as shown here, to create a misty atmospheric mood in a painting.

PAINT BRUSH & GRANITE, 28″×22″, Private collection
A fully rendered painting illustrates the use of Prussian blue and other palette colors.

sian blue with various yellows produces a variety of rich and visually interesting greens. For example, Prussian mixed with burnt sienna produces a deep, cool green that's excellent for the cool shadow sides of tree foliage or ground shrubbery. A note of caution: Too much Prussian blue in mixtures can leave dried passages of shiny pigment that are unattractive and difficult to change.

CERULEAN BLUE. A light, bright blue—the most opaque of the blues. A beautiful color that can be used in many ways throughout a painting. Cerulean blue is slightly more green than cobalt blue. Because of its opaque nature, cerulean blue must be mixed with care since it becomes opaque much sooner than other watercolor pigments.

COBALT BLUE. A middle blue similar to ultramarine blue, sometimes referred to as "sky blue." Cobalt blue mixes well and has excellent glazing qualities. When painting skies, I sometimes use it in combination with cerulean blue, because its color embellishes and complements the more greenlike cerulean. Also, a good choice for cast shadows on a bright, sunny day.

ULTRAMARINE BLUE. A dark, somewhat transparent blue that leans toward purple. Produces a wide range of greens when mixed with yellows and a wide range of subtle grays when mixed with burnt sienna.

This warm blue has excellent mixing qualities. Different brands vary in color, so it pays to stick with one brand to ensure consistency. Ultramarine blue is a good choice for deep cast shadows, because it has a glowing quality that keeps the shadows lively and interesting.

MINERAL VIOLET. This color, new to my palette, is an intense violet with excellent mixing qualities. Generally, I've always mixed my own violets, but I've found that Mineral Violet, straight out of the tube, is a more intense violet than any I can mix. It's also an excellent accent for skies and its clarity and strength also make it a good choice when you need to "beef" up the color in a wash that's gotten too anemic.

SUGGESTED COLOR MIXTURES FOR VARIOUS SKY EFFECTS

Graded washes: Alizarin crimson followed by cobalt blue.

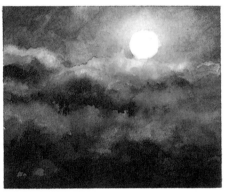

Graded washes: Cadmium orange followed by Prussian blue.

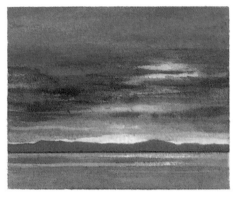

Sky/water: Cadmium yellow pale followed by alizarin crimson and then cerulean blue (alizarin in foreground).

Sun/clouds: Cadmium yellow pale followed by cadmium orange and then burnt sienna. Final stages: Burnt sienna mixed with ultramarine blue for darks. Lights lifted with tissue.

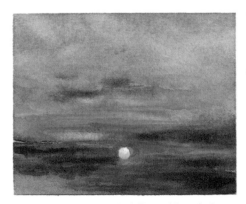

Sunset: Cadmium pale followed by a light wash of cerulean blue. This followed by cadmium orange and then vermilion. Lights lifted with tissue.

Clouds: Cobalt blue mixed with cerulean blue followed by alizarin crimson mixed with cerulean blue. Lights lifted with tissue.

SILVER LIGHT, 22″ × 30″, Collection of Dale Evers
Here you can see why cobalt blue is sometimes referred to as "sky blue."

PAYNE'S GRAY. A neutral gray with a slight bluish cast. By adding burnt sienna, it becomes a true middle gray. An excellent color for creating clouds or foggy and misty effects. By adding a small amount of alizarin crimson, it is able to capture the essence of the various surface colors of tree trunks and limbs. A valuable addition to any palette.

For the trunks and bark of red fir trees found in the High Sierra, for example, I often use mixtures of Payne's gray and alizarin crimson to produce a warm, violetlike color; if necessary, I counter this warm element by using various blues, usually ultramarine or cobalt. I don't use Prussian blue to modify the Payne's-alizarin mixture, however, because it gives the mixture a greenish cast that just doesn't work for the bark on the red firs.

Sometimes if I need a gray other than Payne's, I'll simply work around in the remnants of leftover mixtures on my palette until I get what I need.

BRUSHES

I use a variety of expensive and inexpensive brushes, ranging from high-quality sables costing several hundred dollars each to inexpensive synthetics costing only a few dollars each. When selecting brushes, I always weigh performance and durability against cost. My techniques tend to be rather rough on brushes since I frequently use them to scumble when softening outlines or blending one color over another. Unfortunately, when subjected to these working methods, no brush lasts as long as I'd like it to. Even so, I lean toward the more expensive, high-quality sables because I feel their superior performance is more important than their cost or durability. If you're on a tight budget, however, synthetic brushes are a quite acceptable and less expensive alternative; they don't hold as much paint as natural sables, but they will definitely do the job.

Rounds, in nos. 2
4, 6, 8, 10, 12

No. 6 bamboo

1-inch flat

2-inch hake

I use a variety of expensive and inexpensive brushes, including a hake brush, a 1-inch flat brush, a no. 6 bamboo and assorted rounds.

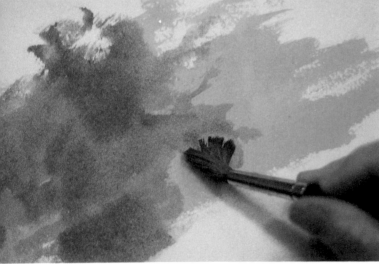

"Scumbling," traditionally linked to oil painters, means working a layer of semi-opaque color over an existing color so that the first color is only partially obscured by the second. This produces a broken color effect. For watercolorists, scumbling produces an effect somewhere between semi-opaqueness and transparent "glazing," and consequently it's very important that the second layer of color doesn't become so opaque that the transparent quality of the painting is lost.

Rounds

The hairs of a good quality round brush should form a bulletlike shape that tapers evenly to a pointed end. Even after considerable use, it should return to its original shape and retain its pointed tip. It should be capable of painting a thick or thin line, and should move between those extremes with ease.

The best brushes are pure sable, and individual prices vary considerably according to the quality and availability of sable hair, but you won't be sorry if you can manage to set aside several hundred dollars to buy a few top quality sable brushes. Though it's a small consolation, when my expensive sable brushes become worn or dog-eared, I never throw them away because at that stage, their "splayed" ends make excellent tools for creating all kinds of interesting visual textures found in nature.

I experiment with many brands of brushes, but for my larger rounds (sizes 12, 10, 8, 6), I prefer high-quality red sables, such as the Winsor & Newton Series 7 brushes; for smaller rounds (sizes 2 through 6), I often use the Liquitex Kolinsky Plus series of brushes. Although relatively inexpensive, the Kolinsky Plus brushes perform well and are fairly durable.

SAMPLE TEXTURES CREATED WITH ROUND BRUSHES

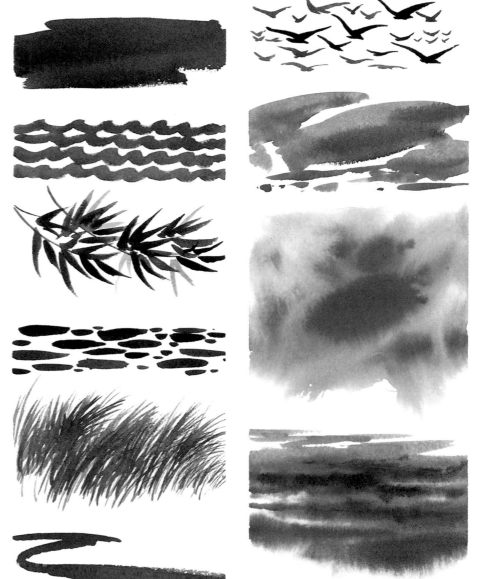

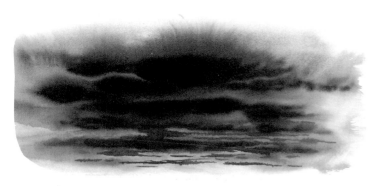

A sky study was created using round brushes in a wet-into-wet technique.

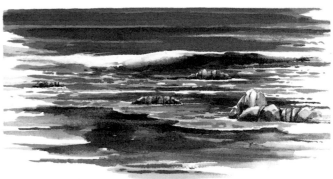

An ocean study was created using round brushes to apply various layers and values of blue in a calligraphic manner.

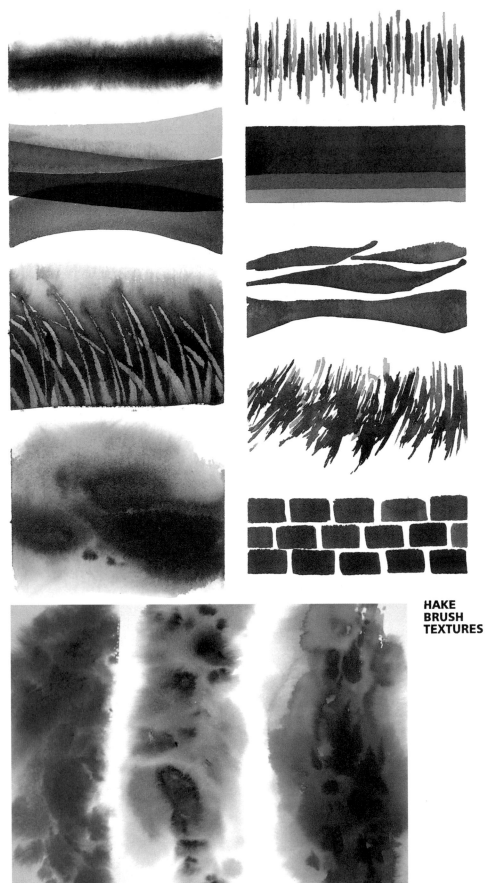

Flats

A top quality flat brush has characteristics comparable with those of a quality round brush—that is, it retains its shape after repeated use and forms a sharp, flat end. In addition, the hairs shouldn't separate when applying a graded wash or when being used in other ways where absolute control is essential. However, a good flat brush should be able to be splayed in order to achieve various textural effects and still return to its original shape (at least for a while!).

I make extensive use of flat brushes, so I always keep a number of them on hand. However, I'm always careful not to allow the effects produced by any one type of brush to dominate my paintings. Otherwise, the results can appear quite choppy.

Hake Brushes

Throughout my paintings, I make frequent use of oriental hake brushes ranging in width from 2"–3½". I find that these brushes are especially effective when I need large, watery skies or expansive fields of grass (see the sample hake brushstrokes at right). One caution: Be careful that the wooden part of the brush doesn't come in contact with your paper. Hake brushes have rather short bristles and the wooden shank can easily scratch or bruise the surface of your paper. It can be singularly disheartening to accomplish a beautiful sky only to discover a long, unattractive bruise amidst your "strokes of genius."

HAKE BRUSH TEXTURES

Oriental Bamboo Rounds

Occasionally I use an oriental round bamboo brush made of hog hair. Thanks to its long hairs and somewhat coarse inconsistencies, this brush is quite different from traditional round sable brushes. When the hair bristles of a bamboo round are splayed to create uneven ends, it is a marvelous tool for creating textures such as tall grass, tree foliage and various other textures found in nature.

In oriental painting and in the work of many contemporary watercolorists, individual brushstrokes are valued for their intrinsic meaning or for their part in the overall design pattern. Artists following that approach tend, wherever possible, to leave their brushstrokes undisturbed, and I certainly respect this philosophy of painting. However, my approach is somewhat different because few of my brushstrokes ever remain undisturbed for long. As I paint, I constantly overlay earlier brushwork with newer washes until, in most cases, individual brushstrokes are no longer recognizable but mesh into larger naturalistic forms.

This technique demands a delicate balance because if overused, it can quickly become repetitive and uninteresting. Quite often, one or more clean, clear brushstrokes within the area are necessary to lend interest, direction and variety.

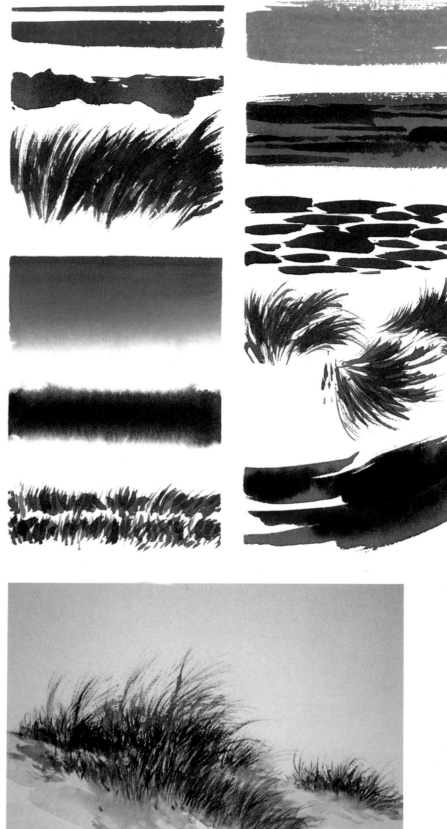

A dune and grass study shows effects created with a bamboo brush.

BRUSHSTROKES

As you can see from the many examples of brushstrokes on the previous pages, each brush I use is capable of creating a wide variety of strokes, and in many cases, similar effects can be created using different brushes. In other words, the brush you use is seldom as significant as how you use it.

To be honest, when I work, I don't think about individual brushstrokes per se anymore; they've become practically instinctive. This is because learning to express yourself with a brush and paint is much like learning to write longhand. At first, you must pay close attention to the shape of each individual letter, but in time you instinctively recreate the necessary curves and sweeps that not only form individual letters but also form words and sentences. With that in mind, on these two pages are examples that demonstrate how individual brush-strokes made with a variety of brushes gradually integrate into larger forms—in this case, a series of small landscape studies.

These studies should give you an idea of the range of effects each type of brush can produce and how each one can help you create the various spatial illusions and textures found in nature. As you paint, learn to let each brush work for you, and avoid being seduced by the cleverness of individual brush-strokes. Once you've mastered the "mechanics" of each of your brushes, you should strive to make sure that your brush-strokes—like the other parts of your painting—conform to sound principles of design. For example, brushstrokes should convey variety and direction, describe interesting forms, add to the overall rhythm of the composition, and combine to create an interesting and unified image.

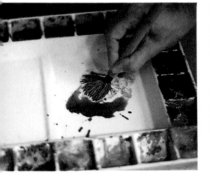

By forcing the bristles of a bamboo brush downward onto a palette, the bristles become slightly splayed.

Upward strokes with a splayed bamboo brush are effective for creating the varied look and texture of tall grasses. A small round (no. 4 or 6) is used to refine details and add highlights.

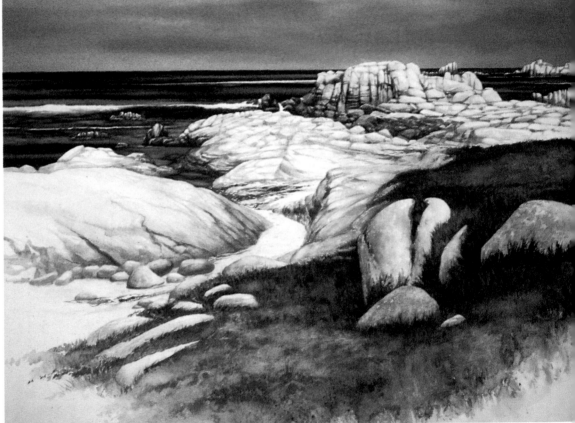

PACIFIC GROVE COASTLINE, 27½" × 37½", Collection of Sally Mingo

Brush Care

Regardless of whether you purchase expensive sables or moderately priced synthetic brushes, it's wise to take good care of them. A brush works hard enough in the course of a normal painting when scumbling or being splayed; don't be tempted to ask more of it than is reasonable by using it with India ink or acrylic paint. Inks tend to make brush hairs brittle, and acrylic paint is simply too hard on soft sable brushes. It's cheaper in the long run to have separate brushes for separate needs.

When painting indoors, I keep my brushes corralled, bristle end up, in several jars. After each painting session, I gently wash the brushes with soap and water and allow them to dry with the pointed tip in place. When painting outdoors, I carry them in a bamboo table mat modified with string or elastic loops to hold the brushes in place. Once the mat is carefully rolled up, the brushes can be safely stored in my case or bag. Unfortunately, moths love fine brushes, so if you plan to store them for any length of time, you might consider a metal case with a few moth balls thrown in for good measure. Art stores also sell a variety of cases that are specially made for transporting brushes.

When storing brushes in your studio or en route to an outdoor location, always make certain that nothing sits on or pushes against the bristles that could distort the brush. If caught quickly, a distorted brush can often be washed and reshaped. However, if the brush stays distorted over a long period of time, it may be misshapen beyond recovery.

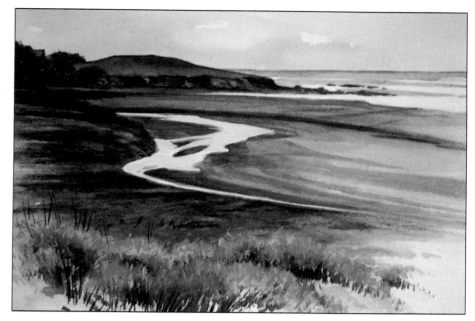

In this beach study, the sky was completed using a no. 12 round brush and the background water with a 1-inch flat brush. The beach was then rendered using a combination of strokes made with the 1-inch flat and a no. 10 round brush. Finally, the foreground grasses were executed with a bamboo brush and then detailed with a small round brush.

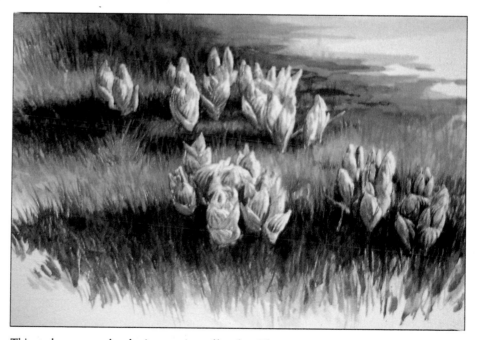

This study was completed using a variety of brushes. The grass area was executed with a bamboo brush, then detailed with a small round. The corn lilies were painted using various round brushes.

PAPER

Like most watercolorists, I have difficulty finding one paper that does everything I want. Each brand has unique characteristics: Some are especially absorbent, some are delicate, while others can really take a beating and still perform well. In the beginning, it's best to try as many papers as possible. Get to know how each one performs, and be prepared for the fact that, in the end, any paper you choose will be a compromise in certain respects.

The best papers are acid-free and 100 percent rag. Most manufacturers offer these papers in three surfaces (hot press, cold press and rough) and in a variety of weights and sheet sizes. I prefer to paint on Arches cold-press paper (in 140-, 300- and 555-lb. weights) because its texture, though slight, provides just the right "tooth" for my techniques.

In general, when I paint on 22″ × 30″ sheets, I normally use either the 140- or 300-lb. weights; when I paint on "double-elephant" size sheets (29½″ × 41″), I normally choose the 555-lb. weight of paper—which feels much like 300-lb. paper. Of course, when manufacturers refer to the "weight" of a watercolor paper, they are actually referring to the weight of one ream of paper (500 sheets), without regard to the dimensions of each sheet. While this may seem perfectly logical to a paper manufacturer, it can be quite confusing for artists. Hypothetically, if you purchased a ream of 555-lb. double-elephant sheets and systematically cut each one down to 22″ × 30″ and then weighed those 500 smaller sheets, your new ream would weigh close to 300 lbs.

Once I've decided on the size of sheet for a particular painting, I still weigh several other considerations before settling on the most appropriate weight of paper to work on. For example, 140-lb. paper responds more readily to textural effects than heavier papers and requires less water and pigment. It also allows me to lift out color more easily. On the other hand, 140-lb. paper buckles more easily than heavier papers during very wet washes.

When working outdoors, I generally use 140-lb. paper and avoid larger sheet sizes simply as a matter of convenience. During the workshops I teach and on my private painting outings, I usually bring along a block of 140-lb. cold-press watercolor paper for quick color studies—but only for studies. I avoid blocks larger than 10″ × 14″ because buckling during wet washes becomes more of a problem as the sheet size increases.

I tend to favor heavier papers for larger works simply because they are more likely to remain flat once they are framed, whereas lighter papers are more prone to buckle in a frame when exposed to heat or changes in humidity. In addition, paintings executed on 300-lb. or 555-lb. paper are less likely to tear or puncture and will probably last longer.

As I said earlier, choosing a paper nearly always requires some compromises. Working on different brands and weights of paper requires a willingness to explore and understand the properties of various papers, but with the proper attitude and enough determination, an artist can use practically any watercolor paper and still get good results.

Stretching

My techniques require that my paper remain flat and smooth during the entire painting process, so stretching is a must. Stretching also removes the surface sizing from the paper, which in turn, makes the paper more receptive to my first washes of color. Before stretching my paper, I hold it up to a light to locate the front by making certain I can

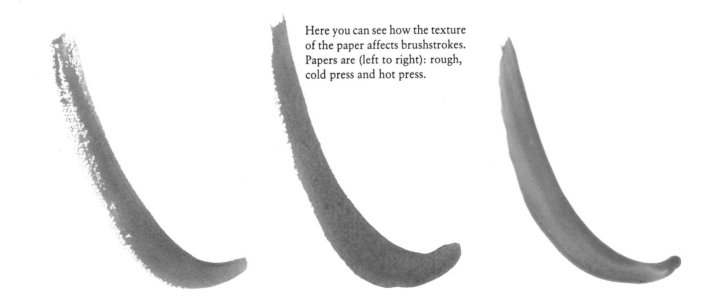

Here you can see how the texture of the paper affects brushstrokes. Papers are (left to right): rough, cold press and hot press.

read the watermark in the corner. Could you paint on the back of the paper? Certainly. In the past, the back might have contained blemishes that wouldn't show up until painted on, but today this is rare, especially in good quality handmade papers.

I stretch all my watercolor paper, even though many artists feel that the heavier 300-lb. or 555-lb. papers need not be stretched. I simply enjoy working on a perfectly flat surface and stretching is the only way to ensure that the paper will remain flat and smooth as I work. My techniques use many controlled washes; the slightest buckling during washes can interfere with the results I'm after.

To stretch my paper, I usually soak it in warm water for about fifteen minutes, then staple it to a board using ¼″ staples. Although I once used gummed tape to secure the paper as it dried and stretched, I've changed to staples because they work better and, unlike gummed tape, they can be removed easily. What's more, gummed tape occasionally breaks or pulls up, making it necessary to restretch the paper. Finally, gummed tape is made with wood pulp, and nitric acid is used in the manufacturing process. In time this acid residue will attack the watercolor paper where the tape touches it.

Quarter-inch staples work best for securing the paper; longer staples will work but are more difficult to remove. When removing staples, be extremely careful not to tear the paper. One way of avoiding this danger is to place a metal straightedge just inside the row of staples, and then, while resting one hand on the straightedge, carefully lift out the staples.

After the paper dries and stretches, I run a strip of masking tape all around the edges to preserve a white margin around the image and prevent the staples from rusting.

I long ago abandoned using expensive basswood drawing boards to stretch my paper in favor of cheaper and lighter weight boards that I cut from hollow-core interior doors. Hollow-core doors measuring 6′8″ × 30″ are available at almost any lumberyard and usually cost twenty dollars or less. Just be sure the doors you purchase are covered with luan plywood rather than Masonite. Masonite doors won't easily take a staple or pushpin and they're extremely heavy.

I cut each door in half to yield two boards, each of which will accommodate a sheet of watercolor paper up to 25″ × 41″. Occasionally a brown stain from chemicals in the wood will transfer onto the back of the watercolor paper. To keep this from happening, simply apply one coat of white shellac to seal the wood.

These are my hollow-core door halves atop the storage rack.

I've attached my watercolor paper to the hollow-core door half with a series of ¼″ staples placed about two to three inches apart. This board is 30″ × 40″. Along one side I've attached an inexpensive metal handle to make the large board easier to transport.

OTHER USEFUL ITEMS

PALETTE. I paint on a white plastic palette with twenty-four paint compartments and two separate mixing areas. The white surface is ideal because it allows me to judge color mixtures accurately. A snug cover is useful as an additional mixing area and is convenient for storage and transport to and from on-location painting sessions.

Once I've placed my colors into their respective palette slots, I simply freshen them at the beginning of each painting session with a drop of water or add new pigment on top of the old. When I'm working regularly, not much pigment builds up in the slots between sessions; if it does, I simply hold the palette under the faucet and "flush" away the excess.

I arrange my colors around my palette in families of related hues (blue, red, yellow and earth color families) with the exception of Payne's gray, which, because I often confused it with other blues, is now placed across the palette from the blues. Likewise for violet—I place it in a corner by itself.

Using a standard arrangement for the colors on your palette is much like touch-typing: After a time, you become familiar with the location of each color and automatically reach for the desired hue without having to think about it. The time you save by not having to hunt for colors means that much more time to paint and makes for fewer breaks in the concentration of the moment.

FACIAL TISSUES. I use only white facial tissues out of concern that colored facial tissues might transfer their dyes to my painting. In the course of a single painting, I'll often use an entire box of facial tissues for blotting, rubbing and controlling the spread and flow of glazes. I use them to soften edges and to lift damp paint from the paper, as well as to create texture, stencil and, of course, to clean the mixing areas of my palette. Facial tissues are great for creating the effect of soft, transitional clouds. Although I've tried them, paper towels don't work as well as facial tissues because they aren't as absorbent;

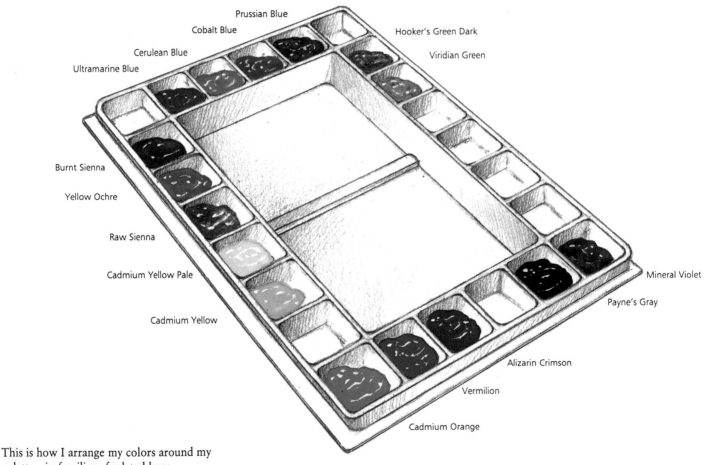

This is how I arrange my colors around my palette—in families of related hues.

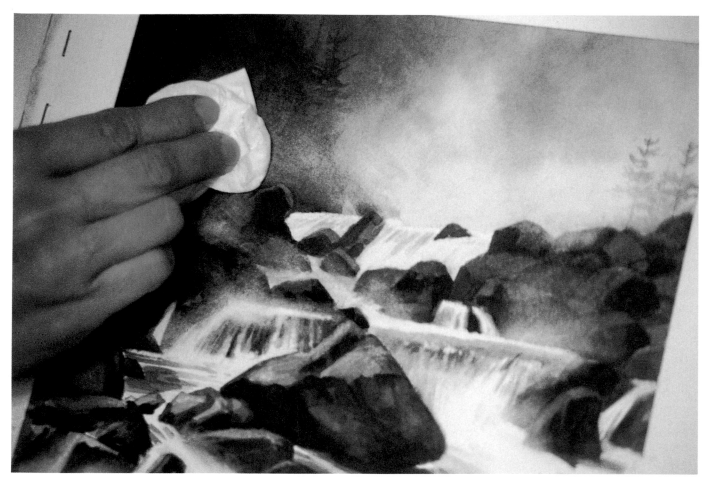

In nature there are no hard edges around mist, smoke or water spray. But as watercolor dries, it has a natural tendency to form hard edges, so I use facial tissues to rub, blend or lift color around an area, such as the mist shown here, as it dries so that its edges will remain "soft."

In reality, what I'm trying to do is make a gradual transition from the generally lighter value of the mist (or other soft-edged form) into a darker background color without leaving an apparent edge.

toilet paper might work except that it disintegrates in water.

SPONGES. I seldom use sponges for texture, perhaps because I overdid it years ago. Because of their consistent texture, sponges tend to flatten an area and interfere with the illusion of depth. Beyond that, I simply dislike the rather obvious appearance of the technique. I do use sponges when I need to remove color from a large area on the paper. Likewise, when I need to lift deeply set pigment off the paper, I use small pieces of a dampened sponge because facial tissues simply aren't strong enough.

SPRAY BOTTLE. I always keep a spray bottle filled with clear water nearby in case I need to rewet an area that's drying too quickly or to dilute a wash or glaze that seems too intense or simply to create texture by spraying clear water into an area just before it dries. A spray bottle is a convenience in the studio and a must on location during hot days.

HAIR DRYER. A useful accessory to speed the drying of just completed passages. When using a hair dryer in this manner, vary the direction of the airflow, and be careful not to get the hair dryer too close to a fluid wash or it might literally chase your wash off the paper. After drying a passage with a hair dryer, wait a few minutes for it to cool before applying additional paint; otherwise, the heated paper will "grab" the new color, impeding the flow of your new passage of paint.

ELECTRIC ERASER. An electric eraser can be a great tool for making minor corrections and for recapturing whites if the area in question isn't too large. Just be careful not to "erase" through the paper! Also keep in mind that once the area has been erased to recapture the whites, it won't take new passages of paint as well as before because the paper's surface will have been significantly altered in the erasing process. Generally, it's better to avoid attempting to repaint areas that have been erased and to limit your use of an electric eraser to regaining highlights.

Masking Fluid

I use masking fluid sparingly because it leaves hard edges that can be detrimental to a painting. In general, I only resort to masking fluid for areas that would otherwise require me to alter the natural movement of my brush—for example, the edges of areas reserved for snow or other colors. Masking fluid seldom works well for shapes with soft transitional edges like soft, billowy clouds or reflective shapes within water. Along the edges of water, however, it leaves me free to concentrate on flow, patterns and interior reflections without having to worry about the shoreline and rocks until later.

The illustrations on these two pages show how I use masking fluid to mask shapes that would otherwise interfere with the natural movement of my brush as I paint a stream.

After completing a pencil study of the scene directly on my watercolor paper, I quickly decide which shapes should be masked out. Usually, I mask out shapes to reserve the white of the paper for later applications of color. It also helps to temporarily "eliminate" shapes that would otherwise interfere with the natural flowing movement of my brush. Here, for example, by masking out the rocks in the stream and along the shoreline, I avoid the distraction of having to tediously paint around them. Instead, I can concentrate my entire attention on capturing the flow and color of the moving water.

Having decided which shapes to mask, I prepare a brush by dipping it into a solution of soap and water. Some watercolorists simply wet the brush and scrub it into a cake of Ivory soap until the hairs are lightly covered. Either way, the soap seems to help keep the rubberlike liquid frisket from congealing on the brush and ruining it. Nevertheless, for this it's always wise to use an inexpensive brush or one you no longer need.

Choose brushes for masking according to the size of the area you need to cover or the fineness of detail you need to capture. Most liquid friskets can be thinned with water for finer lines, but check the label instructions to be sure. In any event, once you've finished using a brush, always wash the frisket out immediately with soap and water.

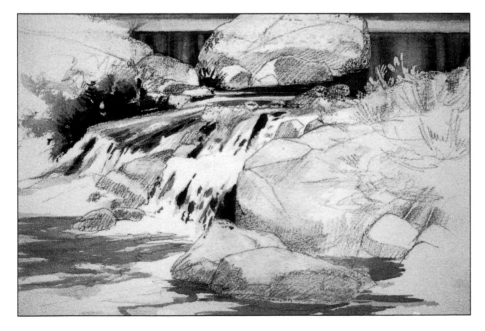

Liquid frisket or masking fluid comes in pale yellow (Winsor & Newton), phosphorescent pink (Grumbacher) or neutral gray (Luma and other brands). All will produce similar results, but I prefer the pale yellow because it has just enough color so that I can tell where I've masked, yet it is relatively unobtrusive when I paint over it. Occasionally, you may want to apply two thin coats of frisket to make certain the area you've masked is completely covered. In any case, allow the frisket to dry thoroughly (about fifteen to twenty minutes) before painting over it.

As you can see in this example, once I masked the rocks out, it was a comparatively simple task to develop the flowing water's major colors, forms and movement right over the rocks' shapes.

It's best to remove dried frisket as soon as possible after you've finished painting since it seems to adhere to the paper more vigorously with time. To remove it, first make certain the paint and paper are thoroughly dry—otherwise, the frisket may take some of the color or paper's surface with it as it is removed. It's often useful to remove dried color from the top of the frisket with a damp tissue so that you don't inadvertently rub unwanted color onto the white paper as you remove the frisket. The easiest way to remove frisket is with a rubber cement pick-up (available at any art supply store), as I've done here, or with a ball of masking tape. If you use masking tape, simply press the sticky side against the dried frisket and lift; change the tape frequently for best results, and repeat the process until you've picked up the last stubborn bits of frisket.

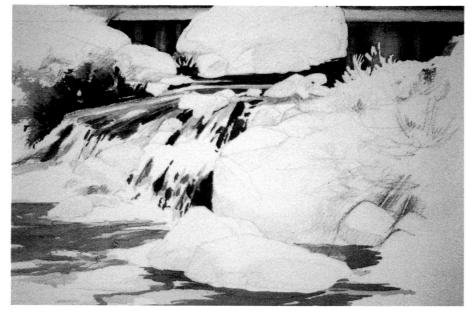

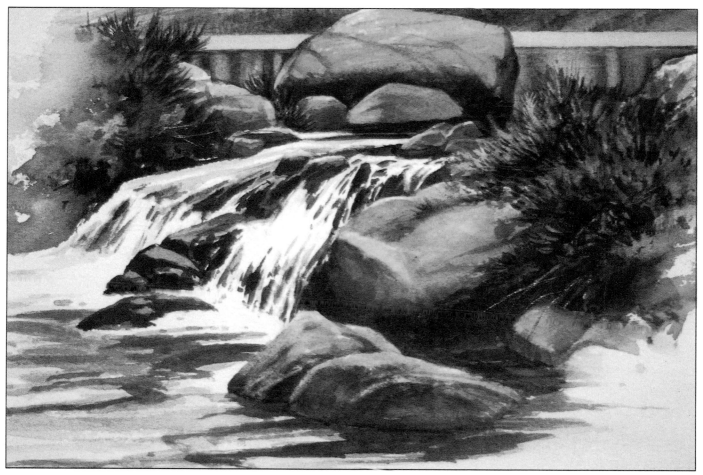

Once the masking has been removed, it's a comparatively straightforward process to paint in the necessary colors and details of rocks and vegetation. As a general rule, I use masking fluid sparingly because it tends to leave hard edges. As an alternative, especially in any areas where hard edges would be inappropriate or distracting, I often use facial tissue to blot away or lift out color to keep the paper white, or nearly so, without leaving an unwanted edge.

Transparent Tape

Although it's always better to plan ahead so you don't need to lift out color later in your painting, I must admit I use the transparent tape lift-out method quite often! Sometimes when I'm well into a painting, I discover that it's necessary to lift color from an area to add interest or a bit of detail — a flying bird, perhaps. One way to do this is to cut the desired shape out of a piece of acetate, and then use the acetate, like a stencil, lifting color from the opening with a damp, stiff brush, a sponge or facial tissues. Acetate works well in most cases, but if I need to lift out an image that will require a return to the white of the paper, I normally use transparent tape, which I keep nearby just for this purpose.

I prefer Scotch brand Magic Tape no. 810 because it adheres to the surface of the paper beautifully and comes off cleanly when I've finished, without damaging the paper. Cutting stencils from transparent tape requires a sharp X-Acto knife, and I find the no. 11 blade works best for cutting and obtaining detail. Just be careful not to cut too deeply into the paper!

Here's the area of the painting to be lifted.

First I drew the shape to be lifted onto tracing paper and transferred it directly onto the area where the color is to be lifted.

I applied the tape directly over the drawing.

I then cut out the exact shape with an X-Acto knife, using my drawing for a guide.

I lifted color out of the area masked with transparent tape, using sponges, facial tissues, bristle brushes, etc.

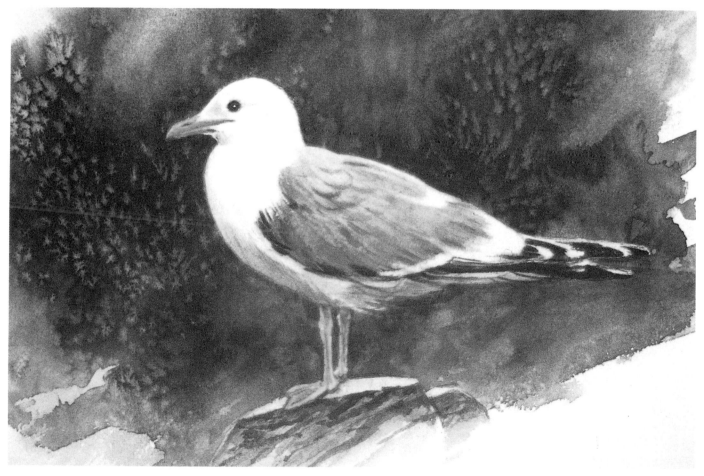

I then removed the tape and painted new details into the lifted area.

Salt and Spatter

In nature certain textures lend themselves to the effects created by sprinkling salt into damp passages of color. For example, the salt technique seems ideal for suggesting the glistening look of wet snow; for granite, it seems to capture the look of rocks that have weathered for centuries; and sometimes it is useful for adding interest to otherwise unrelieved areas of foreground soil.

Despite its many uses, salt texture should be used with care and thoughtfulness because throwing on salt to portray a texture that is in the distance will usually create the opposite effect: The interest and texture will visually bring the object closer to the foreground. Like most artists, I've gone through periods of using and overusing the salt technique. Although I still use the salt technique where I feel it's appropriate, I now prefer to build up my textures through rubbing, scumbling and spattering.

Generally, spattering with a toothbrush should be the final textural effect used because scumbling over it with a brush or rubbing it with a facial tissue will smear the texture. If the spatter texture becomes too sharp and dominant, however, it can be removed or subdued using a damp facial tissue or an additional scumble of color. Again the objective is a delicate balance of textures.

Razor Blades

Occasionally I use a no. 11 X-Acto blade to scrape out light accents and highlights. A razor blade dragged broadside over the paper surface is also useful for creating a variety of textures such as the surface of a rock, the side of a building, a fence, a tree trunk or whatever. Sandpaper can also be used to create similar textures, provided it is used sparingly and with care.

A toothbrush can be used to spatter texture onto a granite boulder. Note that a sheet of tracing paper with a "window" cut for the granite boulder was used to keep spatter off other areas of the painting.

Occasionally I use an X-Acto knife to scrape out highlight areas, such as on this granite boulder.

FIELDWORK

For years I've sketched and painted at various locations in the High Sierra and along the California coastline. Over the years, I've accumulated a tremendous number of sketches and memories of those areas, which I draw upon each time I begin a larger or more fully developed image back in my studio. Yet, no matter how intimately I know those areas, I return again and again for new insights because nature changes constantly; the same scene looks dramatically different from season to season, from morning to evening, and even from hour to hour. Returning to the outdoors helps keep my paintings from becoming stale and predictable. Each time I hope to be surprised and inspired, and I'm seldom disappointed.

In the field, I'm eager to find new scenes that can be developed into paintings or old familiar scenes that can be presented in new ways. Generally, I look for interesting lighting and colors and for a variety of shapes. Once I've located a promising subject, I document it with a series of "photo sketches," pen-and-ink sketches and small color studies that help me choose the best vantage point and become intimately familiar with the shapes and forms I'm painting. My field sketches, studies and photographs also help me work out the basic design and color relationships that will form the foundation for the larger and more detailed painting (or paintings) I'll complete later in my studio.

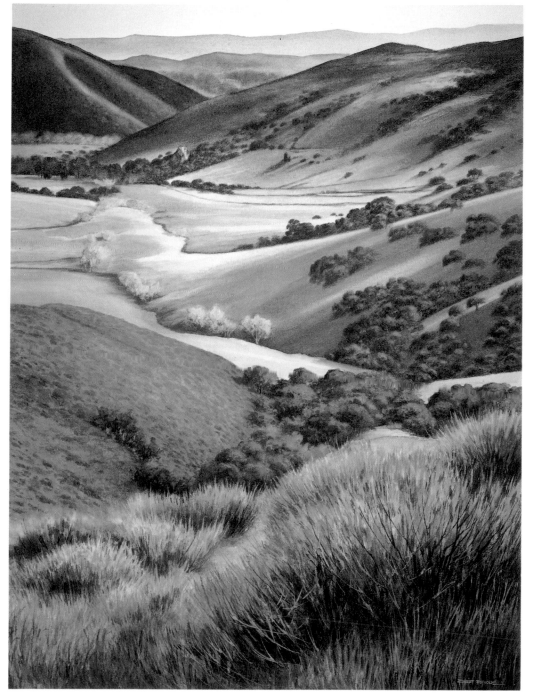

SAN LUIS OBISPO RURAL/
LA CUESTA RANCH
37" × 27"
Courtesy of Harold Miossi

PHOTO SKETCHING

I regard photo sketching as a vital part of the creative process, although I never transcribe a scene literally from a photograph because camera lenses and film have a very different range of sensitivity than the human eye. More specifically, lenses distort perspective, and photographic film is incapable of accurately recording values in scenes that contain both strong light and deep shadow. Furthermore, color rendition varies between brands of film, and there are even minor differences in processing from lab to lab. For me, however, these inaccuracies aren't a problem because I have no desire to copy a photograph exactly.

In most cases, a photograph, like the scene itself, is only a starting point. As a painting idea develops, I use ink sketches and small color studies to work out the best composition and to decide on the color temperature and values that suit the particular mood and feeling I'm trying to express in the final painting.

Still, after spending a lifetime studying light and form, I'm amazed that so much can still be discovered each time a particular effect occurs in nature, and trying to paint entirely from memory can lead to a generalization of the forms. So using photo sketches allows me to examine the effects of different

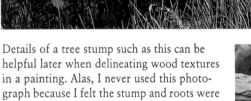

Whereas the final painting might encompass a more expansive view, this close-up provides me with valuable details of water reflections and tree foliage.

Details of a tree stump such as this can be helpful later when delineating wood textures in a painting. Alas, I never used this photograph because I felt the stump and roots were too static and possibly a bit too "cute."

A clear, detailed photo such as this almost gives *too* much information, and that can sometimes be detrimental. Too much detail can be seductive — a photographic reference should only be a starting point. The somewhat less-sharp resolution of an instant-photo camera is often preferable because the lack of clear detail encourages artistic interpretation.

lighting, points of view and seasonal changes in detail; in the studio, photo sketches enhance my creative efforts by refreshing and stimulating the thoughts, feelings and images that originally inspired me in the field.

Many artists are uncomfortable using a camera in this way — as a sketching tool. They feel it is tantamount to cheating. Yet art history contains numerous references to highly respected artists who have relied on photographs in one way or another to aid their creative process — Degas, for example, not to mention Delacroix, Manet, Cézanne, Gauguin, Remington, Rossetti, and even Picasso. These artists regarded the camera as simply another art-making tool. Clearly then, in the end, it is not the tool itself, but rather the way it is used that counts.

Problems typically arise when artists come to rely too literally on photographic reference and not enough on a basic knowledge of drawing, composition and color. At the worst, using someone else's published photographs and copying them literally is not only obvious, but also unethical and quite illegal under copyright law. Beyond that, it is simply creative laziness. Relying on someone else's photograph means surrendering your artistic judgment in selecting the viewpoint, capturing the light, and creating the composition.

On the other hand, taking your own photographs for reference is perfectly legitimate and practical. In selecting and roughly composing each scene through your camera's lens, you bring to bear your own unique sensitivities and point of view. Although photo sketches can never substitute for the experience of being outdoors — hearing, smelling, observing and feeling what is special about a particular place — they can provide immeasurable assistance in recording fleeting effects and in filling the gaps that memory or on-the-spot sketching have difficulty capturing.

If I had unlimited time, I'd prefer to sketch each location that caught my interest. But that is seldom possible, so when

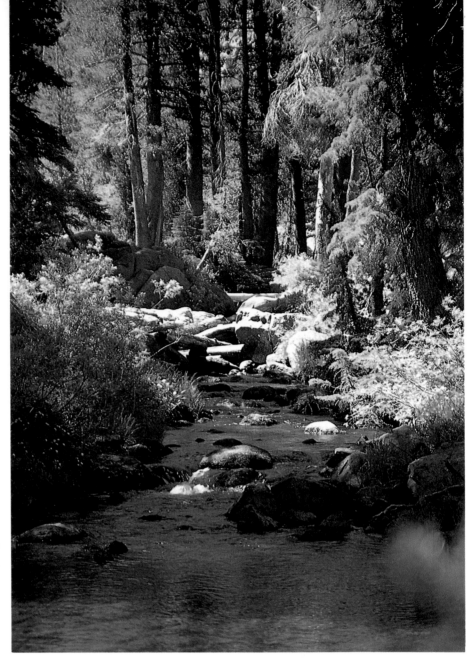

I'm in an area for only a short time, I often "canvas" potential subjects with my camera. To capture the sense of a location, I'll often shoot elements of the scene to the left and to the right of the principal subject. This gives me a feeling for the entire area, and later I might incorporate elements from these peripheral areas into my painting.

It's much like painting a portrait; sometimes when you are to paint a front view of a subject, it's also a good idea to walk to the side and look at it in profile. This frequently makes it easier to understand the form and allows for a different point of view. At an outdoor location, the logic is similar. The composition might work better if a particular tree that is outside the immediate subject area is included. Also, examining the subject from another point of view helps establish the spatial relationships between various objects that are to be included in the composition. The bottom line, though, is: It is better to have too much information than not enough.

Strong contrasts between light and shadow in woodland scenes can "trick" a camera's light meter, resulting in loss of important details and textures as light values are washed out and shadows go quite dark. If you have sufficient film, bracket your shots with one overexposure and one underexposure to ensure that you capture important details in both light areas and deep shadows.

A photo sketch such as this provides good reference for shape and viewpoint. Unfortunately, the sun is so strong that it has washed out the color and texture. That's not a serious fault, however, because the concept might work better, after all, with a warm ochre sky and softer contrasts.

Sketches

I prefer to sketch in ink rather than in pencil because once dry, the ink doesn't smudge. Furthermore, although ink is unforgiving, its directness sharpens my awareness and encourages me to think in terms of design as I sketch.

I also use fountain pens, ballpoints, felt tips and even sticks dipped into ink—anything that will give me an expressive line. "Thumbnail" sketches done in this manner take about five minutes to complete, while more detailed sketches take about thirty to forty minutes. In the course of working out the concept for a painting, I'll often complete several thumbnails as well one or more detailed sketches before selecting a composition I want to carry through to a finished painting.

Sketches (both thumbnails and more developed drawings) obviously provide a value plan and design for the composition, but they also produce another important benefit—focused concentration. The simple act of sketching a scene helps me understand what's there—not in generalities, but in intimate detail. Granted, I don't always create a preliminary sketch before each painting, but invariably when I do, my work benefits immensely. And normally once I've sketched a subject, the sketch becomes a part of me; I can put it away and begin a painting with little, if any, further reference to it. For me, then, the purpose of sketching is as much to experience a scene as it is to record it.

Color Studies

I'm basically a studio painter who knows and respects the importance of painting on location. So to supplement my photographs and pen-and-ink sketches, I usually paint one or more small color studies (11″ × 14″ to 14″ × 18″) on location to test various color relationships. Up to this point, the process is largely one of logical choices in design, drawing, values, rhythms and patterns. But when it comes to color, the choices are more subjective; I seldom attempt to replicate the colors I see. Instead, I use colors remembered from another time of day or from different atmospheric conditions to enhance the drama of the scene.

Before deciding on the colors for the study, I ask myself what the mood and time of day will be—whether I want long shadows for drama, a backlit composition that lets light dance throughout it or something else. Beyond conveying

On-location ink sketches, such as this one (left), allow me to organize the value patterns without being influenced by color. Afterward, in a color study like the one on the right, I determine the colors that will best express the scene's clean, untouched mood, without being overly concerned with rendering extensive details.

feeling and mood, color can also suggest atmospheric conditions (fog, mist, clouds and so on) or distance (atmospheric perspective). It can also unify disparate elements in a painting. For example, if the rocks, water, trees and sky don't seem to work together, a dilute wash of alizarin crimson or yellow ochre over the whole surface may bring everything into harmony. To resolve questions such as these, I usually paint several small color studies per painting. These are relatively loose and take about an hour each to complete.

These small color studies are invaluable when I return to my studio to paint the second, typically larger, version of the composition. Why bother redoing it? Usually, because my outdoor color studies don't have the control and detail that I prefer in the more fully developed works I exhibit and sell. On location I must work quickly, putting down thoughts and ideas in a kind of visual shorthand; whereas in my studio, I'm free to devote the days or even weeks it takes to complete a more complex painting. Like the photographs and ink sketches, these color studies are not an end in themselves but are simply another step in the creative process.

DEMONSTRATION
Winter Interlude

STUDIO WORK. In my studio, armed with my sketches, color studies and reference photos, I'm ready to begin a full-sized painting on Arches 555-lb. cold-press paper. After the sheet is stretched and stapled to a board, I run masking tape around the outer edges to preserve a white margin and prevent the staples from rusting.

Once I've drawn the composition onto the paper, I use liquid frisket to mask out any shapes that would get in the way of my brush—when I lay in a large wash or render the sinuous course of a stream, for example.

BLOCK-IN SEQUENCE. In general, I paint the largest shapes first, then progress to the smaller ones. Many times the sky is the largest shape, so I often paint it first. It, in turn, influences all of the other colors. One exception to working from large to small is when a darker element, such as a stream, cuts through a lighter area, as often happens in snow-filled landscapes. In that case, the white paper, which represents the snow, becomes the largest shape and is painted last.

VALUES. Generally, I place the lightest and darkest values on the paper right away. This enables me to concentrate on intermediate values without losing sight of the range of values I had in mind when I began. As I develop one area, I constantly relate it to the rest of the painting. For instance, when painting the illusion of water, value differences within the water are important, but what establishes credibility is a variety of shapes within the water and along the water's edge.

TEXTURES. As a painting progresses, I seldom apply a color and leave it untouched. I constantly alter the tint, shade, temperature and texture of each successive color by glazing with thin washes of transparent color. I also modify the texture and color by lifting paint with dampened tissues or a sponge to re-

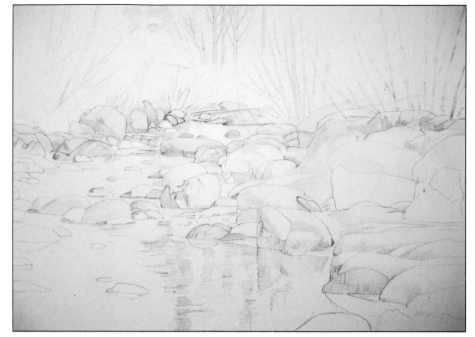

STEP 1. I draw the composition full size onto a 29½"×41" sheet of 555-lb. cold-press paper, keeping the marks light so the graphite won't dirty later washes. For this scene, I've masked out the snow below the trees so that I can paint the area above without resorting to the labored brushstrokes otherwise required to preserve the highlights atop the rocks.

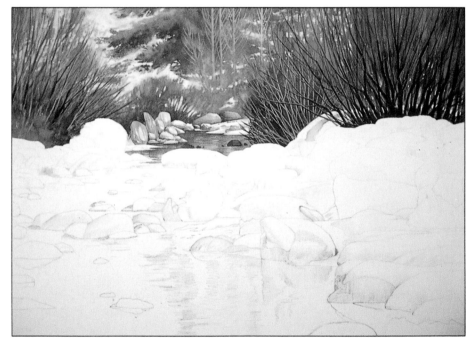

STEP 2. With a round brush, I paint the upper third of the paper—the background. My chief concern is balancing cool and warm hues, which I accomplish using various values of cadmium yellow light and medium, cadmium orange, vermilion, burnt sienna and Prussian blue. The background forms are rather soft to keep the viewer's attention on the middle and foreground elements. The vegetation is basically a pattern of color and shape, rather than well-defined forms. First I establish middle tones in the background, then lift out thin tree branches before painting darker tree shapes over some of the lighter forms.

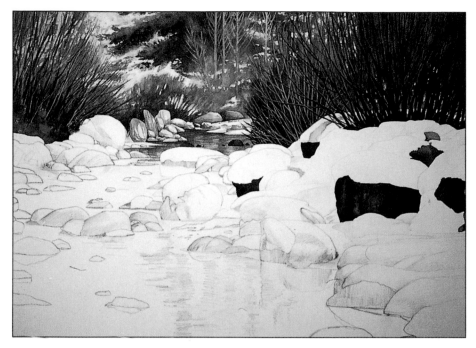

STEP 3. Next I remove the initial masking below the background area and paint the darkest areas to set up the value range for the rest of the painting. The darker rocks on the right side (located within the snowbank) are painted as free-form shapes using no liquid frisket. After that I mask out the rock shapes that are located in the stream so I can begin painting the water and the reflections.

STEP 4. Next I render the water with various colors and values to represent the reflections of sky, snow and rocks, while also suggesting the lazy movement of the stream. Where I want the stream to sparkle, I play dark values against light. When the water is dry, I remove the masking and begin painting the rocks within the stream and along its banks.

Because reflections often appear as rectangularlike shapes within the water, I begin painting the frozen water and reflections using a flat hake brush, then change to a round brush for the details. Frozen water looks different than water that isn't frozen—reflections and contrasts are more muted.

To make the rocks more interesting, I give each rock its own set of individual textures, even though all the rocks are affected by the direction of the sunlight. It's important to avoid using the same arrangement of textures on each rock. Note that on the sun side, the rocks have a warmer, lighter valued look about them.

During this phase, most of my painting is done with a no. 12 or 10 round brush.

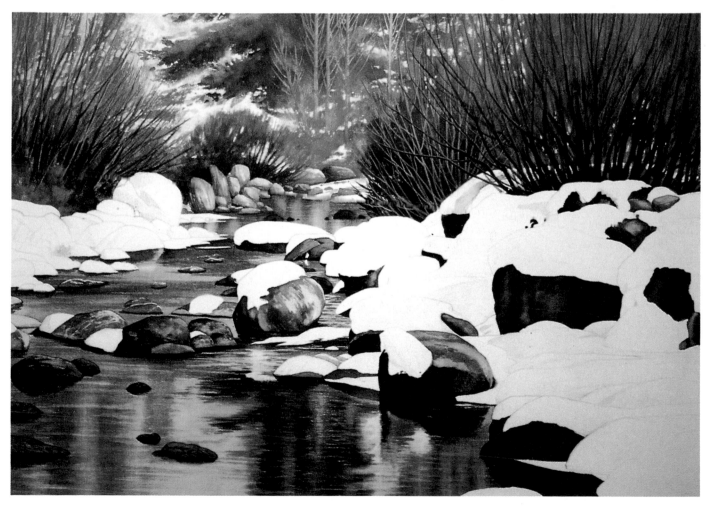

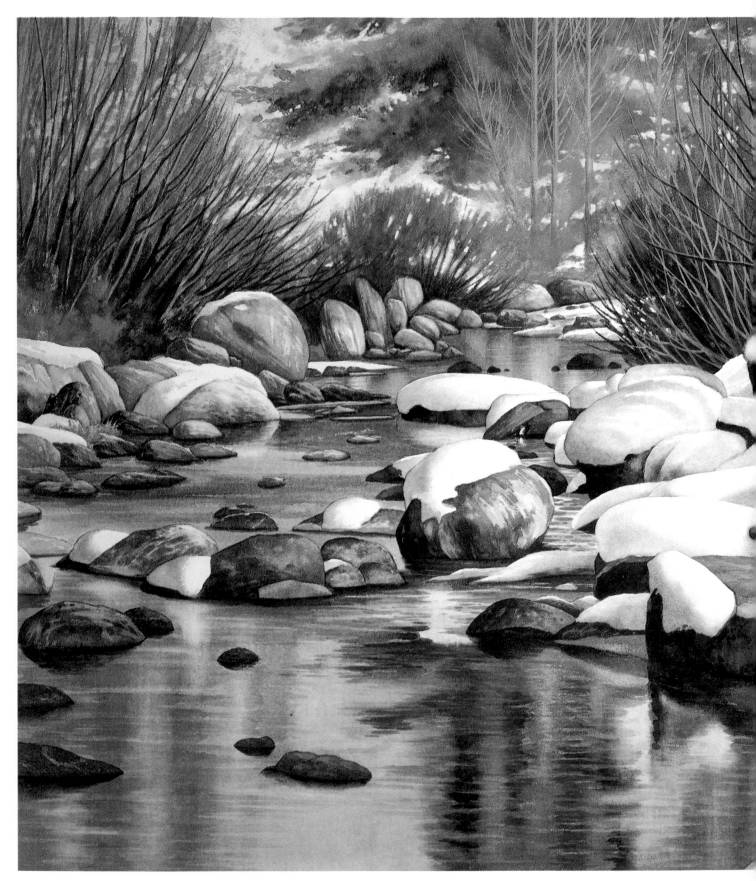

WINTER INTERLUDE, 29½" × 41"

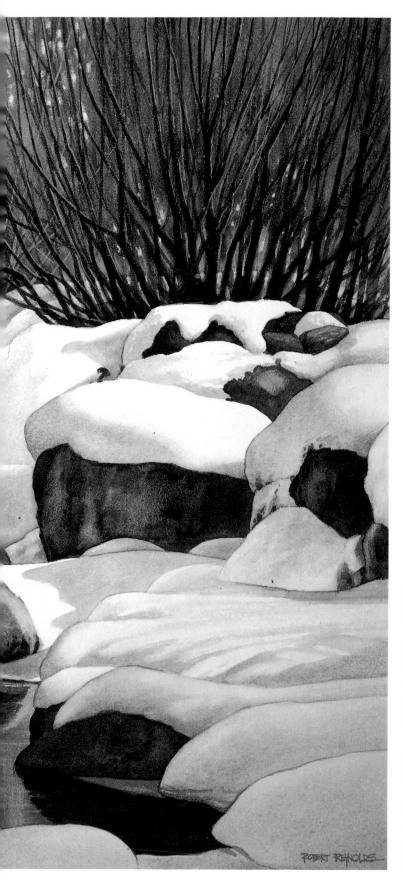

veal interesting subdued textures and colors. I keep a spray bottle filled with clean water close at hand for diluting glazes that seem too intense, for creating textural effects by spraying into nearly dry passages, or simply for keeping the paper moistened if the weather is uncooperative. I also keep a hair dryer handy for drying the paper between washes so I can keep the image moving steadily toward completion.

When the painting is finished, I remove the masking tape border. The clean, white margin it reveals allows me to examine the composition more objectively and locate areas in need of further work. Even at this stage, I may add shapes, intensify areas or remove unwanted passages with tissues, transparent tape (used as a stencil) or even an electric eraser. Unwanted passages can't always be removed, but they can usually be lightened enough to be covered with new colors and textures. I also pass judgment on natural details and textures; a viewer needn't be an outdoor expert to notice poorly executed elements in a realistic painting.

In addition to assessing a completed painting for believability and accuracy, I'm also evaluating its mood and feeling. What I'm after is a balance: I want each painting to be well executed but not to the point that the technique distracts from the statement I had in mind when I began the painting.

STEP 5. To complete *Winter Interlude*, I render the remaining rocks and snow, often using a sponge or damp facial tissue to reveal interesting textures or to soften edges and create transitions.

To render the sunlit areas of snow, I use warm yellow ochre glazes; for the shadows, I use glazes mixed from combinations of blues, such as cerulean, ultramarine and cobalt mixed with alizarin crimson to create the light, purple effect. If the snow becomes too purple, I use a light glaze of yellow ochre or cadmium orange to diminish the purple and warm the color. By the final stage, little of the white paper remains completely white.

To render the rocks, I use pieces of sponge and facial tissue to "lift" and reveal texture—much like nature's own seasonal forces do to rocks. I also use facial tissues to soften some of the reflective shapes within the icy water.

In this painting, as in most of my paintings, when an area color seems too strong, I apply a glaze of a complementary color to diminish the intensity of the first color. How many glazes do I apply? There is no set number, because when I'm finished with a painting, virtually every color passage has been modified by one form of glaze or another—a procedure that is basic to my technique.

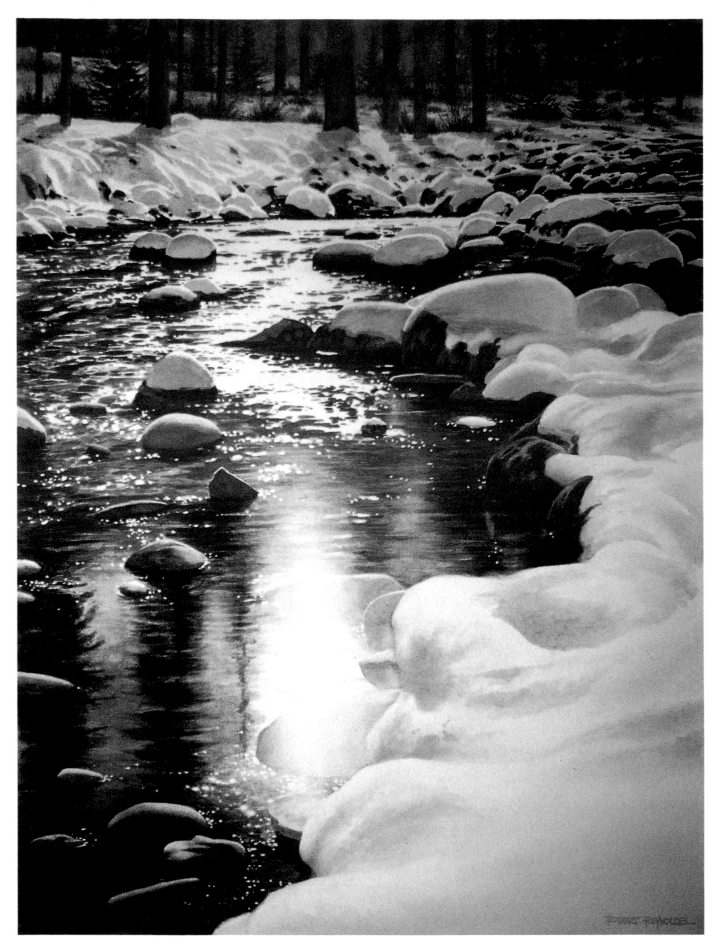

DECEMBER MORNING, 37" × 25"

PART II

DESIGN AND COMPOSITION

The words *design* and *composition* are often used interchangeably when discussing paintings. This can be a bit confusing, but it isn't terribly surprising because, in some respects, every work of art operates at two interrelated and inseparable levels—rather like the conscious and unconscious mind.

At a conscious level, we are aware of a representational painting's composition, that is, the spatial relationships between things we can name, such as buildings, trees or rocks. Through a variety of techniques, such as linear and atmospheric perspective, we attempt to create a three-dimensional illusion of "volume" for the objects themselves and of "distance" for the space they occupy. The goal of a "good" composition is simple: It should attract the viewer's eye and lead it easily through, around, and even seemingly behind the objects it depicts, all without leaving the boundaries of the painting.

Yet, even as we move through the composition, we are at the same time reacting at an unconscious level to the painting's design—the mostly two-dimensional relationships between its purely abstract elements of line, shape, space, value, color, texture and direction—without regard to the things they represent. Together they form the underlying "abstract structure" or design of the painting. It's always desirable, of course, for the subject of a painting to be interesting, but good design should weave all the components of an image together into a fabric of shapes, colors and space divisions that are visually interesting and satisfying purely on their own merit.

What makes discussions of composition and design confusing is that each term describes similar characteristics that are common to both good composition and good design. Furthermore, in a painting, each of the elements of design interact with and influence each other in myriad ways. For that reason it's difficult, if not impossible, to discuss any one of them without some reference to the others or, for that matter, without some reference to composition. Nevertheless, in Part II Reynolds will guide you through the elements and principles of design, explaining each one in plain English before letting you look over his shoulder as he shows you how it all comes together in the "real world" via two thorough step-by-step demonstrations.

—Patrick Seslar

LINE

Lines can be created in a variety of ways, including the obvious (pencil or brushstrokes) and the not-so-obvious (abrupt changes in value, color or texture). From a design standpoint, lines are the most basic means of visual representation. Compositionally, they are one of the most powerful tools for moving the viewer's eye through an image.

When combined in an organized manner as drawings, lines function representationally (as composition) and abstractly (as design) at the same time. In other words, in addition to defining recognizable objects, the lines in a drawing subtly express various abstract qualities such as balance, movement and mood in a variety of ways—through long, graceful, sweeping arcs, for example, or abrupt, jagged strokes, through even and con-

trolled movement or lines that vary in width and intensity.

LINE LANGUAGE. Generally, drawings should communicate with and emotionally touch the viewer, but preliminary drawings have one main objective—to provide a record for the artist of essential information about a scene in a kind of symbolic visual shorthand.

The line drawings reproduced below are small sections excerpted from some of my larger ink sketches. Examining these sections makes it much simpler to consider the nature of the line used without being influenced by what it is depicting. Quite frankly, I enjoy looking at them purely from an aesthetic point of view because each one forms an interesting abstract pattern in and of itself.

Jagged lines are appropriate for various kinds of vegetation.

Cross-hatching and straight lines are good ways to depict rocks.

Thin lines are appropriate for vaporlike effects, especially clouds.

Dark and light forms can capture sunlit objects in front of shadowed areas.

The free stroke is good for grassy areas.

These lines capture various segments, such as rocks, stone walls, etc.

The horizontal line depicts various kinds of flat planes, such as calm water.

Jagged horizontal lines can convey choppy water.

Lines of varying thickness suggest foreground willowlike vegetation.

Lines of varying length suggest a wood grain.

Jagged, angular lines depict thick vegetation with limbs.

Dark accents aid the effect of a ground covering.

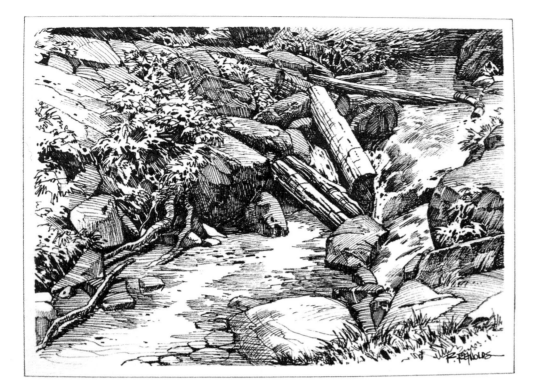

It's important to have a solid understanding of the relationships between various forms in a scene before attempting a painting of it. When I came upon this logjam in a Sierra stream, I was so fascinated with its interesting interplay of directions and shapes that I drew this sketch to better understand its complex natural design. Using various forms of line, I attempted to lead the viewer's eye from the upper left corner diagonally across and down the composition, before reversing direction for the return trip diagonally back across and still farther down the image. In addition, by varying the density or spacing between lines, I was able to clearly define the various rock and tree forms while providing a suggestion of depth and volume.

Study each section and you'll have a better idea of the symbolic "line language" I use to capture representational subjects. My vocabulary of line is built of many traditional pen-and-ink techniques, such as cross-hatching, straight horizontal lines to convey flat planes, jagged lines to depict tree branches and vegetation, and various dark accents to aid the illusion of depth. See if you can recognize these square sections from some of the drawings that are reproduced elsewhere in the book. It shouldn't be hard.

Drawing

During many years of teaching drawing and painting, I've discovered repeatedly that when artists become frustrated or unhappy with their painting progress, the "culprit" is usually a lack of basic drawing skills, rather than an inadequate grasp of painting or compositional techniques. To put it as simply as possible, the ability to draw (i.e., to manipulate the drawn line) is the basis of good design and composition because drawing, by its very nature, is an analytical activity that requires artists to consider and resolve questions of design and composition.

Fortunately, drawing is the most easily acquired of the visual skills because it is based on specific measurements and proven techniques. Learning to see size, shape and space relationships and developing the eye-hand coordination

necessary to record these things accurately enables you to convincingly translate the three dimensional world you see in nature onto a flat piece of paper.

Drawing well is important for another reason as well: It helps viewers discover and better understand you—the artist behind the art. This is truer of drawings than paintings because as we paint, we often cover our tracks, so to speak; but in drawings there are fewer places to hide, so we reveal ourselves in more obvious ways. In time and with sufficient motivation, your drawing skills will allow you to use line the way a poet uses words—to communicate accurately, with sensitivity and feeling, from a uniquely personal point of view.

Drawing and the expressive use of line, then, is much more than a way of recording and ordering subject matter— a landscape scene, for example. It is also a means of expressing the intangible—a thought, an idea or a mood. Clearly, a sound grasp of drawing principles is essential for either purpose. Artists who draw well are simply better equipped to express themselves.

There is, of course, no right or wrong way to develop a drawing. Successful paintings and drawings are intensely personal, the result of numerous subjective decisions that reflect the individual sensitivities, emotions and interpretations of each artist. Because of this, artists approach draw-

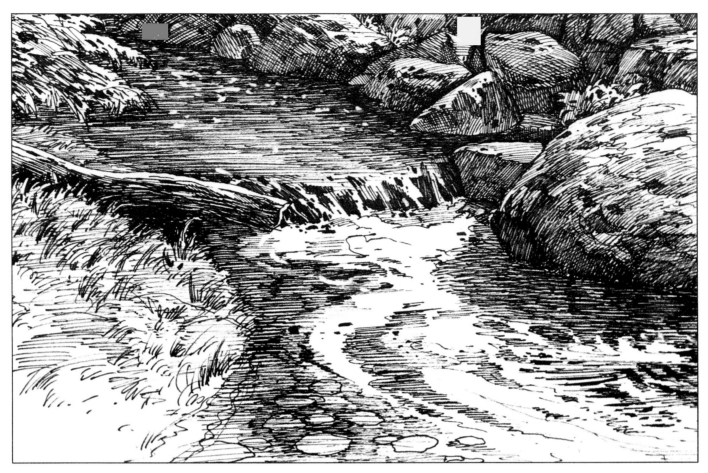

The scene that inspired this drawing had a small amount of moving water, but otherwise it seemed somehow lacking. Under the circumstances, I felt obliged to take a few artistic liberties as I sketched — a case of creating a lie to tell a truth! In other words, this drawing was based more on what I knew than on what I actually saw. Compositionally, I used line to surround the "white" areas of water in order to show movement and direction.

ings in different ways. Some prefer to resolve most uncertainties at the drawing stage. Using a logical, or "left brain," approach, they analyze a scene and gradually reorganize it according to their own set of compositional rules. Others follow a more intuitive, emotional or "right brain" approach. They deliberately keep their drawings minimal, leaving uncertainties intact so they can be surprised and make discoveries as they develop a composition for the final painting.

My approach combines both philosophies. I attempt to resolve major compositional questions at the drawing stage; yet I don't so fully develop my initial drawing that I feel compelled to follow it faithfully. To accomplish this, I follow a fairly conscious organizational approach while look-

ing to my intuition to provide the necessary emotional momentum to sustain and guide me. As a result, I sometimes need only a minimal drawing before starting to paint; at other times — for more complex subjects — I'll develop a drawing to a more finished state, with various passages and surface textures delineated more completely.

Generally, I prefer to execute these sketches in ink, using a variety of inexpensive pens such as the Pilot ultra-fine point permanent-ink pen, Penstix pen with black India drawing ink, or sometimes even an ordinary round ballpoint pen. Be forewarned, however, that the inks in these inexpensive pens occasionally do odd things when water touches the paper — such as turning blue!

To supplement my use of line in this example, I darkened the sky with a watered down wash of India ink to establish a contrast between it and the light rocks in the foreground. To draw the viewer's eye toward the center of interest, I designed the composition so the most intricate parts of the line drawing are concentrated in the vicinity of the rock forms, while those areas farther away have noticeably less complexity and detail.

This sketch is a fairly straightforward depiction of the actual scene. My primary concerns were to use line to create interesting divisions of space, and to provide a variety of subtle visual cues. For example, the flatness and expanse of the lake is suggested by horizontal lines that grow closer together as they recede. The illusion of distance is also suggested by various forms, such as the trees, which overlap the shoreline rocks and distant mountain as well as each other.

Beyond this the simple act of drawing this sketch provided me with a wellspring of intimate knowledge and inspiration that has allowed me to paint several versions of this scene by varying the light, color and time of day.

SHAPE

When lines cross or come together they become shapes, but shapes can also be defined by changes in value, color, texture or innumerable combinations of these elements. For design purposes, a shape can be regarded as a flat or two-dimensional form, much like the outline of a piece from a jigsaw puzzle.

In a painting, the most basic shape is that of the paper itself—a rectangle—and any shape created on the paper must nec-essarily relate to that first and most basic shape. As a result, your initial design and compositional task is to select a paper with a size and shape appropriate for what you plan to paint.

SIZE. Although a well-conceived de-sign and composition should be satisfy-ing no matter what its size, the size of the paper itself immediately sets a certain tone or mood. We tend to think of paint-ings in such terms as "small and inti-

Various image formats have different attri-butes:

A. Square. A square format can be interesting, but it's relatively static and can be difficult to use effectively for landscape subjects.

B. Circle. A circular format lends itself to more designed or stylized approaches. Al-though I seldom use it anymore, I have used circular formats in the past when I wanted to highlight a subject within an abstract back-ground.

C. Long rectangle. A long rectangular format is especially good for landscape subjects. Many outdoor scenes can be effectively dram-atized via a wide format.

D. Standard rectangle. A standard rectangular format (three-to-four ratio) is generally the most useful and versatile format for landscape subjects. Since this proportion seems most in accord with my approach to painting, I com-plete many of my paintings on 30″×40″ sheets of watercolor paper, in either horizontal or vertical orientations. I also enjoy the way an image of this proportion looks when it's framed and displayed.

E. Tall, narrow rectangle. A tall, narrow for-mat provides a great way to stimulate your thinking because it forces you to confront the design elements in a more dramatic way. If you're becoming bored or feel you're overus-ing a particular format, try this one.

EFFLORESCENCE, 37″×25″

mate," for example, or "large and expansive." But the possibilities don't end there. Another way to give an image an immediate and striking presence is by painting the subject larger than life—a technique used effectively by Georgia O'Keeffe. In *Efflorescence*, for example, I took what would normally be thought of as a "small" subject—a pine cone—and painted it on a 37″ × 25″ piece of paper to encourage viewers to see it with new awareness and appreciation.

FORMAT. Once you've determined the most appropriate size for your subject, you must next choose a format, that is, a shape and orientation for the image. In doing so, you'll also communicate other subtle messages about mood and emotion to your viewer.

In *Sierra Brook* (seen at right and on page 95), for example, I chose a narrow vertical format to emphasize the direction of the falling water and to "play" with the interesting, interacting negative and positive shapes created by the narrow rectangle of the paper. Working with an atypical format led me to explore and discover new design possibilities.

For *Summer Wind Patterns* (seen at right and on page 99), I selected a long horizontal format to suggest a mood of tranquility and strength. I also wanted to dramatize the long horizontal patterns of wind-stirred water on the surface of the lake. In this composition, the long design elements (of wind-stirred water) cross behind and above the yellow catamaran where they are interrupted by the boat's mast. The boat, like a dancer in a Degas composition, faces the right side of the painting looking outward. This, however, is balanced by the strong horizontal elements (water and mountains), the tilt of the boat, and the "weight" of the remainder of the image that extends to the left of the boat.

For *Young Corn Lilies*, I decided on a more standard, and therefore more stable, shape to convey the solidness of the earth. To focus attention on the corn lilies, I chose a point of view that looks somewhat downward to create a more intimate illusion of shallow space.

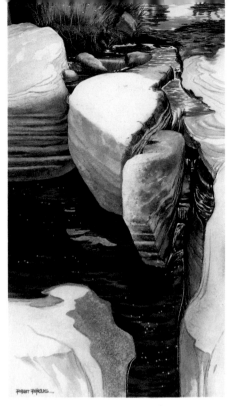

SIERRA BROOK
38″ × 20″
Collection of the artist

SUMMER WIND PATTERNS
22″ × 39″
Collection of Mary Alice Baldwin

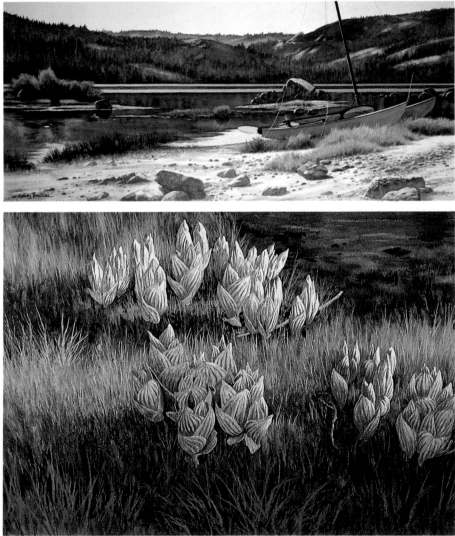

YOUNG CORN LILIES, 25″ × 39″

Subdividing the Primary Shape

Once you've settled on the shape of the paper to draw or paint on, your next design decision is how to subdivide it into interesting smaller shapes. In landscapes this means deciding where to place the horizon line and any prominent vertical elements, such as trees or mountains. There are many popular, and sometimes complex, methods for dividing the primary shape, but usually, I simply break it into four quarters as I did with *Winter Still Life* (below).

ASYMMETRICAL SUBDIVISIONS. I usually arrange the principle elements in my landscapes asymmetrically. In other words, rather than putting my main subject smack in the middle of the rectangle, I try to make sure that the shapes, values, colors and details of the composition are *un*equally (asymmetrically) distributed throughout the quarters of the rectangle.

In this case, I placed the large rock to the left and slightly above center to create an interesting asymmetrical arrangement. To counter this large shape, I added several smaller rocks that move away and diagonally downward. The number, arrangement and more complex shapes of the smaller rocks counterbalance the single, large, simple shape of the big rock.

The dark background is a good negative shape (see pages 54-57) that complements the foreground shapes. While the dark background "reads" as a single shape, the light-valued aspen tree trunks break it into an interesting and more varied pattern of smaller shapes.

SYMMETRICAL SUBDIVISIONS. In *Winter Sun* (at right), I divided the rectangle into almost equal halves where the top of the frozen lake meets the base of the fir trees. Com-

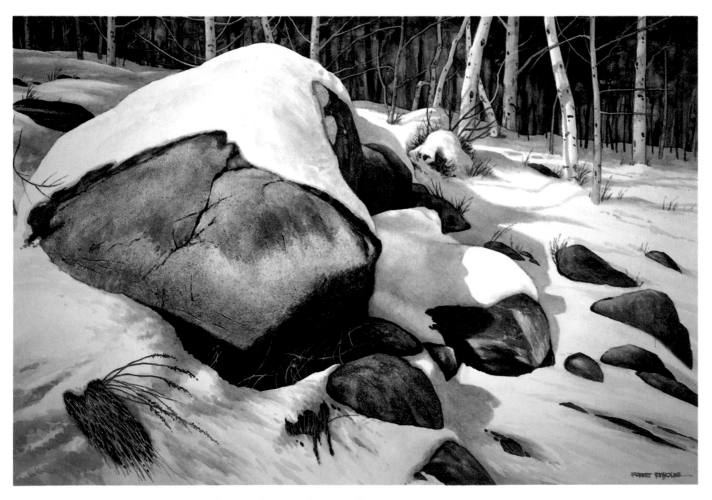

WINTER STILL LIFE, 25″ × 39″, Collection of Mr. and Mrs. Jack Martinelli

positions like this can be awkward and difficult, but it is possible to make them work by counterbalancing the symmetry of the design. Here, for example, the major horizontal division is broken by a second, smaller horizontal division slightly higher on the right. This minimizes some of the inherent difficulties of the static division. The vertical trees and the land mass on which they sit diffuse the symmetry somewhat further.

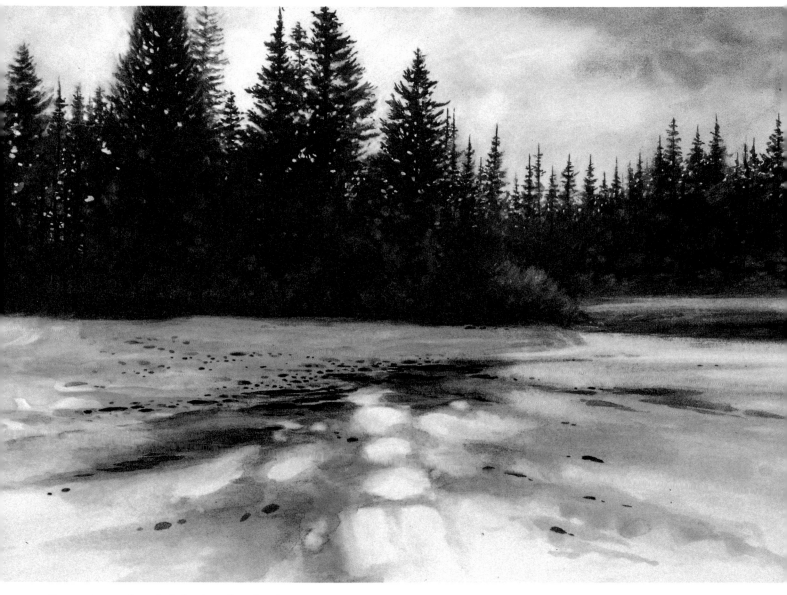

WINTER SUN, 20″ × 28″, Collection of Brad and Ximena Pearson

Positive and Negative Shapes

The moment you define a shape, you also define the shape or shapes that surround it; this is the phenomenon of positive and negative shapes in a nutshell. The dominant shapes in a painting—a tree, a building or a fence, for example—

are called the positive shapes. The areas between them and the borders of the image as well as any "holes" where the sky shows between the branches of a tree or the rails of a fence, for example, are the negative shapes.

When painting from nature, there's often a strong temptation to paint things exactly as they appear. Unfortunately, nature is not always graphically ideal—unless we make it so. Many paintings of trees, for example, are hampered by a weak pattern of negative shapes in and around the tree forms. If the clumps of foliage are too symmetrical, they become static and uninteresting shapes. The same holds true for the negative sky shapes. Both the positive tree foliage and the negative sky shapes need to be well-designed shapes to create interest and to establish a harmonious relationship.

This diagram of *October Sky* (at left) is a good example of how negative shapes can be used to support and complement positive shapes. Needless to say, negative shapes should be considered as carefully as positive shapes everywhere in a painting, not simply in tree forms!

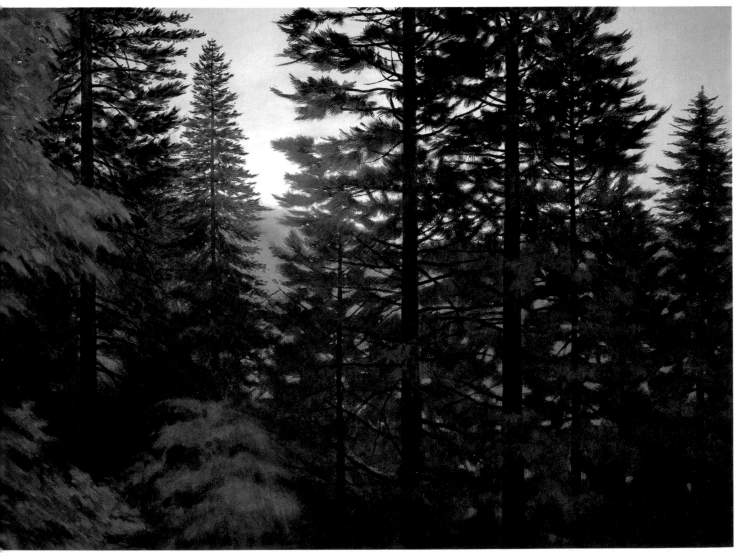

OCTOBER SKY, 25" × 39"

Although we have been talking about real objects, the secret to creating interesting positive and negative shapes is to consider them as equals from a design standpoint. Geometric shapes tend to be balanced and static. Asymmetrical shapes, on the other hand, tend to be unbalanced—they suggest movement and tension.

The key to an interesting arrangement of positive and negative shapes is to establish a balance between dissimilar shapes that causes the eye to move rather than rest. In *Sierra Sentinel*, for example, tension is created by arranging rock shapes so that the angles of their sides encourage the viewer's eye to move through the composition. The positive and negative shapes around the rocks also repeat those angles and, in the process, create unity. In a similar manner, the shapes and directions of the vapor behind the rocks also echo the rock's angles. Finally, the shape of the reflection below the main rock adds unity by repeating the rock's shape and pulling the eye down from the complexity above, where it can pause briefly before moving on.

The challenge here or in any painting is to create sufficient tension to move the viewer's eye through the image, but not so much that the viewer turns away.

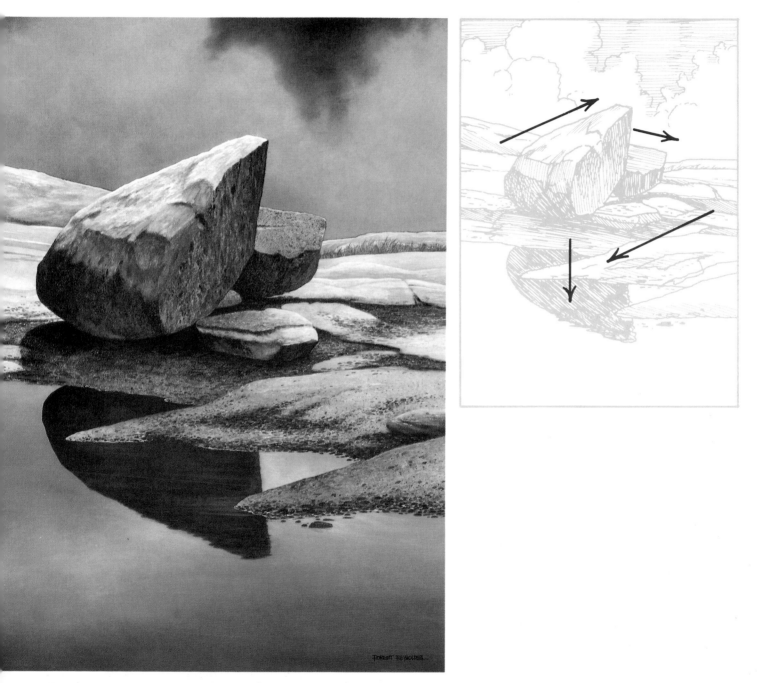

SIERRA SENTINEL, 39″×25″, Collection of Mr. and Mrs. Douglas F. Murdock

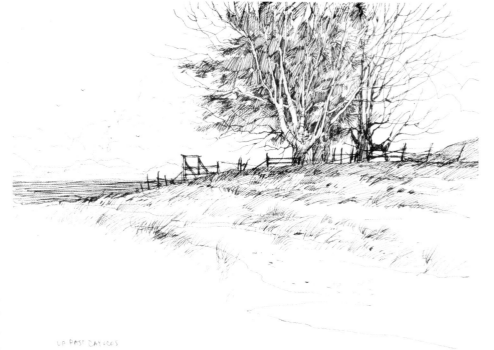

USING SKETCHES TO DEFINE POSITIVE AND NEGATIVE SHAPES.

Vignette drawings can be helpful and instructive, but their lack of formal boundaries can present problems. With no boundaries, vignettes focus almost entirely on the subject or positive shapes, while the areas that surround them—the negative shapes—are only minimally defined, as shown in the sketch at right.

However, when a sketch is placed within a rectangle (below), the negative shapes immediately become more defined. Therefore, whenever I'm drawing a preliminary sketch for a painting, I outline a rectangle in my sketchbook in the same proportion and format as the painting. This simple act forces me to consider both the positive *and* the negative shapes and also helps me avoid inadvertently creating shapes that would appear awkward or distracting when confined within the rectangular format of the finished painting. Triangular corner shapes are typical problems of this type, as are lines that exit the rectangle at one of the corners.

We tend to think of negative shapes as voids or, if you will, air. In fact, "solid" objects that support the main subject can also be considered negative shapes. In the schematic pattern of positive and negative shapes for *Fir and Penstemon* (shown below), the sky is a negative shape, but so are the flat, diagonal rocks that trail off toward the bottom right corner and serve as supporting shapes.

UP PAST CAYUCOS—Ink sketch

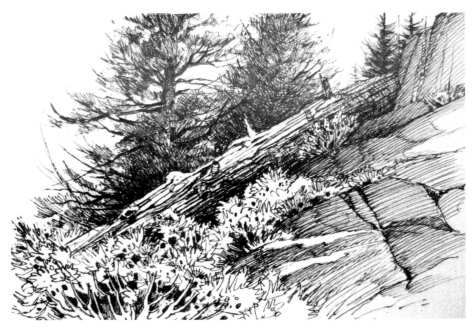

FIR AND PENSTEMON—Ink sketch

This schematic shows how I arranged the positive and negative shapes in the painting, *Fir and Penstemon*, shown at right.

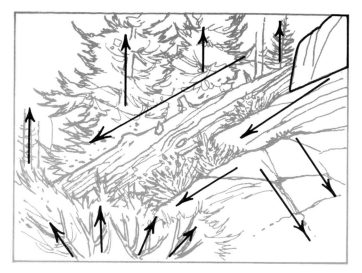

Overall, *Fir and Penstemon* had an unusual design that might have spelled disaster — a strong diagonal that could have easily split the rectangle from the upper right corner to the lower left corner. I countered this potential problem in four ways: (1) I kept the fallen tree above the visual "line" between the two corners. (2) I established a relatively calm space below the fallen tree and made certain the Penstemon flowers moved counter to the diagonal of the tree. (3) I added vertical tree forms in the upper half of the composition to help counterbalance the diagonal. (4) Finally, to keep the viewer's eye from following the tree form out of the image, I added a clump of willows at the bottom left corner and a rock in the upper right corner.

At left is a diagram of the visual movement in *Fir and Penstemon*.

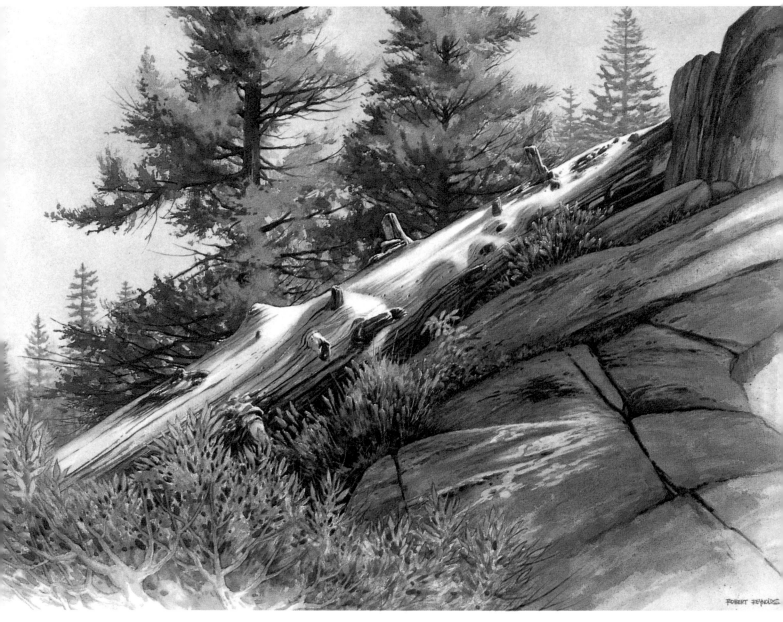

FIR AND PENSTEMON, 25″ × 39″

Designing Shapes—Some Cautions

I have difficulty with terms as final as "do" and "don't," so here, instead, are a number of cautions which should help you design stronger shapes:

A. Dividing a composition into equal parts horizontally or vertically can lead to a static composition. Be alert for horizontal lines that slice a painting in half, as well as trees, posts, masts of ships, or other elements that dissect your composition vertically into equal parts.

B. Dividing your design into too many similar shapes is apt to produce an uninteresting painting. Likewise, be sure the negative spaces between objects aren't all the same width or height.

C. Unless it is your intention, be careful not to include so many tension-creating shapes that the composition becomes busy or irritating.

D. When using converging lines, be careful you aren't "capturing" the viewer's eye and preventing it from moving through the painting.

E. Be aware that placing interesting shapes or elements at the edge of the composition could steal attention from the center of interest.

F. Creating perfectly shaped "triangles" in the corners of your composition can draw the viewer's attention away from the center of interest. If triangles are unavoidable, soften the edges or stagger the form.

A

B

C

D

E

F

G. "Visual traps"—lines, values, or shapes that meet at the same point (such as a tree, a road and the horizon)—can be detrimental to your composition. If your composition includes something with a strong perspective, such as a road, it's usually best not to show where the converging lines of perspective meet; otherwise, the viewer's eye is likely to follow the perspective path to a visual dead end at the vanishing point.

H. Be careful not to change technique in the middle of a painting. If you've begun a scene using mostly tonal changes (value against value), adding an outlined line drawing (such as the boat in this example) will almost certainly draw attention to itself and look "out of key" with the rest of the painting.

I. Be aware of "static" shapes. Here, for example, the dark, opened doorway into a building creates a static shape that immediately becomes a "visual trap." When you encounter a static shape such as this, modify it with a graded tone, or a cool-to-warm transition. The difference will be apparent immediately.

J. Cast shadows can be effective as design shapes, but if they are too dark and sharp-edged, they can easily become "visual holes." So if the shadow of a tree, for example, falls across vegetation and rocks, exercise a little artistic license and lighten it to allow the rocks and vegetation to be seen more clearly. You may want to emphasize highlights and contrasts within the shadow for clarity as well.

K. Watch for edges of planes or lines that exit at the corners of your composition. Always be aware of where you are leading the viewer's eye.

L. When laying in your initial washes, block in the largest shapes first. Defining smaller shapes too early can fragment the image and make it difficult to create visual unity.

G

H

I

J

K

L

SPACE

From a design standpoint, the arrangement and balance between flat, two-dimensional shapes is quite important, but landscape compositions also require that attention be given to the three-dimensional illusion of space and volume.

Creating Depth Using Linear Perspective

Artists have a variety of tools at their disposal for this purpose, but linear perspective and atmospheric perspective (which is discussed on pages 75-77) are two of the simplest and most effective ways of creating the illusion of three-dimensional volume or distance on a two-dimensional surface.

Linear perspective can be complicated, but surprisingly, for landscape artists, a basic understanding is usually all that's necessary to noticeably improve the believability of landscape drawings and paintings. Even so, it's hardly a substitute for creativity and artistic judgment. A perfectly drawn landscape scene isn't automatically a work of art—something to keep in mind if you're tempted to rely on mechanical aids such as opaque projectors, which appear to circumvent the need for drawing but discourage creativity in the process.

Basically, linear perspective is the name for the illusion of volume or distance created when parallel lines appear to converge at a point in the distance—as in this classic example of railroad tracks.

This illustration of railroad tracks is a classic example of linear perspective, where parallel lines appear to converge at a point on the horizon line called the "vanishing point."

Vanishing Point

Horizon Line

KEY PERSPECTIVE TERMS AND CONCEPTS.

Horizon Line or Eye Level. Here's a simple trick that will make it easier to establish your horizon line or eye level: With your arm outstretched in front of you, look straight ahead and hold a pencil horizontally, level with your eyes. Then, close one eye and without moving your head or eyes, visually determine whether key objects in your field of vision, such as trees, mountains or clouds fall above, below or on the horizon line indicated by the pencil.

Vanishing Points. Creating the illusion of depth using perspective is based on the principle of convergence—i.e., that lines extended from the edges of objects (other than those whose sides are exactly parallel to the viewer) will eventually converge, like the railroad tracks, to meet at a point somewhere along the horizon line. The point at which these lines meet on the horizon line is called a vanishing point—the point at which the lines effectively vanish from view.

Picture Plane. Imagine that someone has erected a wall at about an arm's length in front of you. Also imagine that this

wall has a window in it level with your eyes, through which you are able to see a portion of the scene before you. This imaginary window is called the picture plane.

If you could take a pencil and trace the outlines of each of the objects in the scene onto the "glass" in that window, you'd successfully transpose those three-dimensional objects onto a two-dimensional surface. If you then transferred that drawing from the "glass" onto your sketchbook, you'd establish correct perspective and proportion for each of the objects in the scene.

Although you obviously can't draw lines on an imaginary window, the picture plane concept does help define the limits of the scene and, at the same time, provides a framework for measuring the relative sizes and placements of objects within that framework. In other words, the picture plane—like the edges of your sketchbook or watercolor paper—defines the limits of the scene. In a similar manner, the imaginary top, bottom and sides of the picture plane provide convenient reference points in relation to which you can locate the position and relative sizes of all the key elements in a scene.

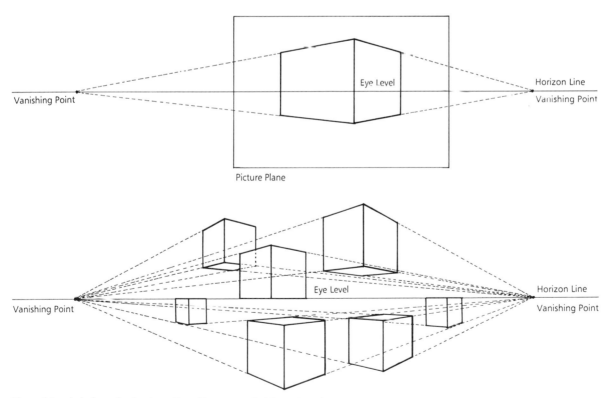

If an object is below the horizon line, lines extended from its edges converge, like the railroad tracks, *upward* toward a vanishing point on the horizon line; if the object is above the horizon line, lines extended from its edges will converge *downward* toward a vanishing point on the horizon line.

HOW TO LOCATE VANISHING POINTS. Once you've located the horizon line, it's relatively easy to locate the vanishing points for an object such as a fallen tree. Simply align a pencil with one edge, and then follow the line it suggests until it crosses the horizon line. That is the vanishing point.

HOW TO MEASURE OBJECTS. You can also use a pencil to measure the relative height and width of objects seen through the "window" of your imaginary picture plane. For example, by holding a pencil vertically in front of you at eye level, you can quickly determine the relative height and size of any object in the picture plane. The relative width of objects can be determined in a similar manner by holding a pencil horizontally. Then by comparing heights with widths and vice versa, you can accurately determine the shapes of various objects in a scene.

Remember: Always hold the pencil at the same distance—usually at arm's length—from your eye to ensure consistency and accuracy.

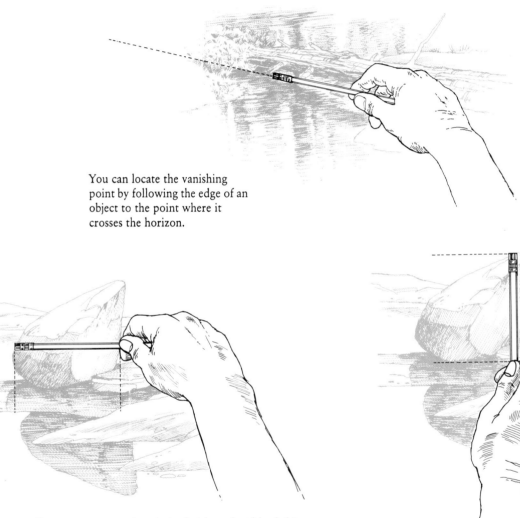

You can locate the vanishing point by following the edge of an object to the point where it crosses the horizon.

With a pencil, you can measure the relative height and width of objects through the "window" of your picture plane.

One-, Two- and Three-Point Perspective

Perspective is described as one point, two point or three point, according to how many of the three variables describing three-dimensional volume, or space, it depicts—i.e., depth, width and height, respectively.

ONE-POINT PERSPECTIVE. This is the simplest and most basic form of perspective because, of the three variables that describe volume—depth, width and height—it attempts to create only the illusion of depth. In one-point perspective, the front face or plane of the subject (i.e., its width and height) is parallel to the viewer. Lines extended from each of the object's sides—representing its depth or volume—would appear to converge toward a single point along the horizon line (eye level).

Forest or mountain streams are "naturals" for one-point perspective because, with numerous shapes parallel to the picture plane, one-point perspective quickly lends unity and draws the viewer into the painting. Since natural forms rarely assume exact geometric shapes, it's often helpful to visualize them as enclosed within "boxes," in the manner described on page 66.

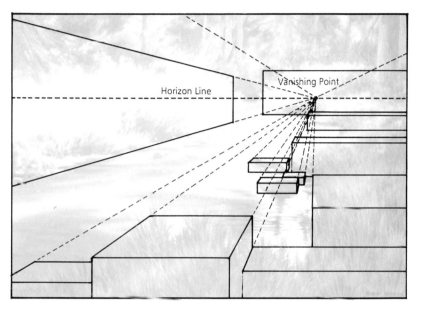

Quiet Stream is a good example of one-point perspective, but without the overlay diagram to illustrate the parallel faces and converging lines, it might not be immediately obvious. If you become confused about the perspective in your paintings, go back to the vertical-horizontal method of measuring within your imaginary picture plane, using your pencil, as described on the previous page. It can save the day.

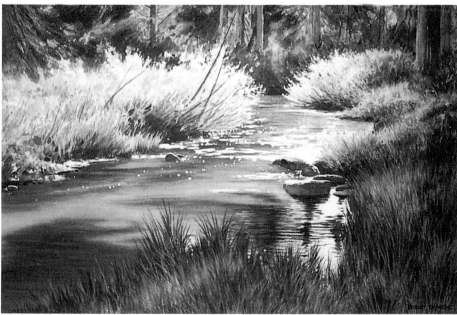

QUIET STREAM
22″ × 30″
Collection of Robert and Lynn Schweissinger

TWO-POINT PERSPECTIVE. Two-point perspective is still more sophisticated because, of the three variables that describe volume, it creates the illusion of the first two—depth and width. In two-point perspective, the front face or plane of the subject (in this case, a boat) is no longer parallel to the viewer. Notice that the vertical lines (representing height) remain vertical; the horizontal lines along the front and sides, however, appear to converge toward one of two points level with your eyes at either side of the subject. This is two-point perspective, the method most commonly used in landscape paintings.

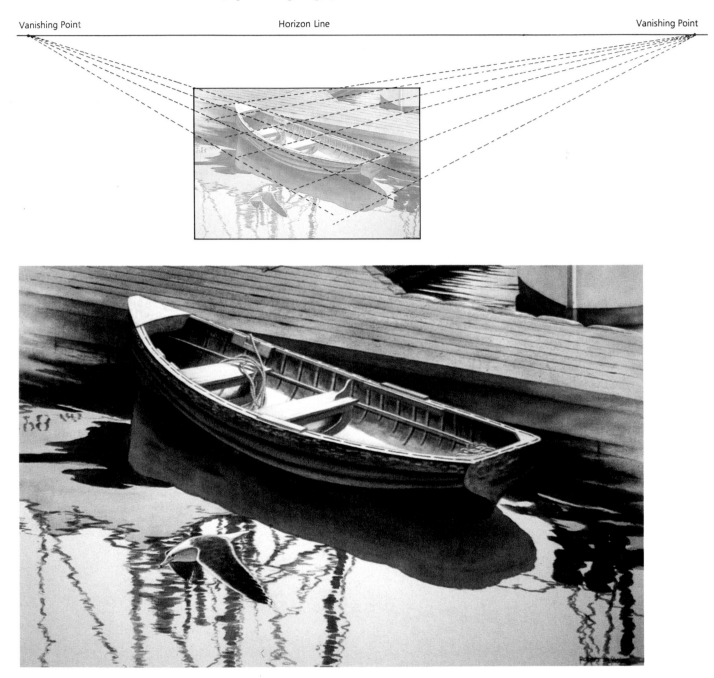

Vanishing Point Horizon Line Vanishing Point

STORM AT SEA, 24″×35″, Collection of G.A. and Ruth Wallerman

Storm at Sea shows two-point perspective, the most commonly used perspective in landscape painting.

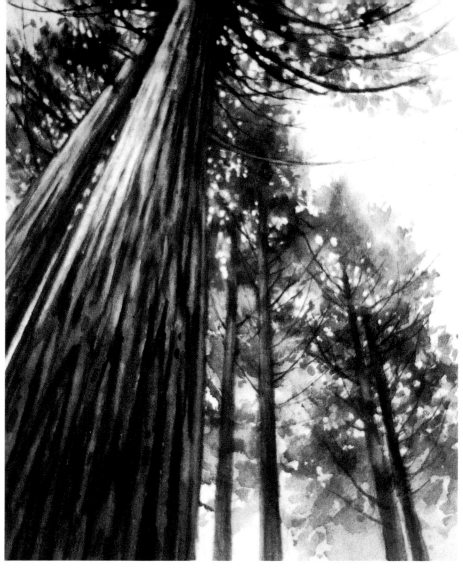

THREE-POINT PERSPECTIVE. In three-point perspective, all three variables (depth, width and height) are used to create the illusion of volume. Here lines describing each variable converge toward three different points—two of which are, as before, level with your eyes and a third that appears above or below. Three-point perspective is relatively complex but can occasionally be useful in outdoor painting—when painting a dramatic upward view of a building, for example, or a towering tree, where its use would add tension and interest to the composition.

This tree study shows three-point perspective. The volume of all three dimensions is shown.

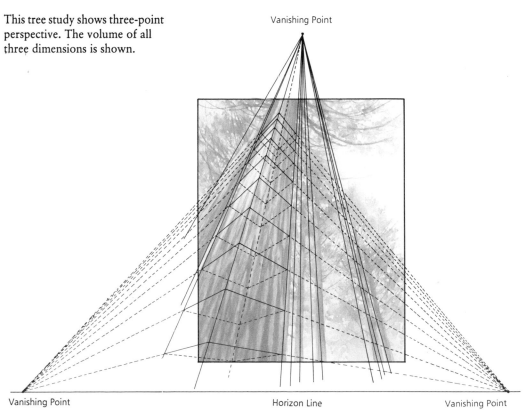

Vanishing Point

Vanishing Point

Horizon Line

Vanishing Point

Other Ways to Create Depth

Linear perspective is not the only means artists have to create the illusion of three-dimensional space and volume on a two-dimensional surface.

OVERLAPPING. The overlapping of forms is perhaps the simplest way to suggest depth in a painting; it can convey the illusion of depth across a shallow space, such as when rocks or trees overlap, or it can suggest deeper space, such as when several mountain ranges overlap in the distance.

In nature, the spatial relationships between closely spaced rocks or trees may not always be apparent; confusing spatial relationships can be resolved with a bit of artistic license, by making one form overlap the other slightly. Not only will this improve the "readability" of the image, but it will also add variety and create a more interesting arrangement of shapes.

NATURAL VS. GEOMETRIC FORMS. Unlike architects and engineers, landscape artists are seldom required to depict boxlike shapes such as buildings. But because these shapes are easily rendered using rules of perspective, artists usually find it helpful to relate objects in nature to various geometric forms, such as cones, cylinders and cubes. A group of rocks, for example, can be viewed as a unit of related shapes that appear above, below or across the horizon line. Then to create a believable sense of volume, the rocks can be "visually" enclosed in boxes to determine where the top, sides and bottom are located in relation to the horizon line.

Other objects such as fallen trees, can be visualized as "cylinders"; cross contours can be used to suggest their volume, location and direction, and to relate the cylinder shape to the horizon line and picture plane.

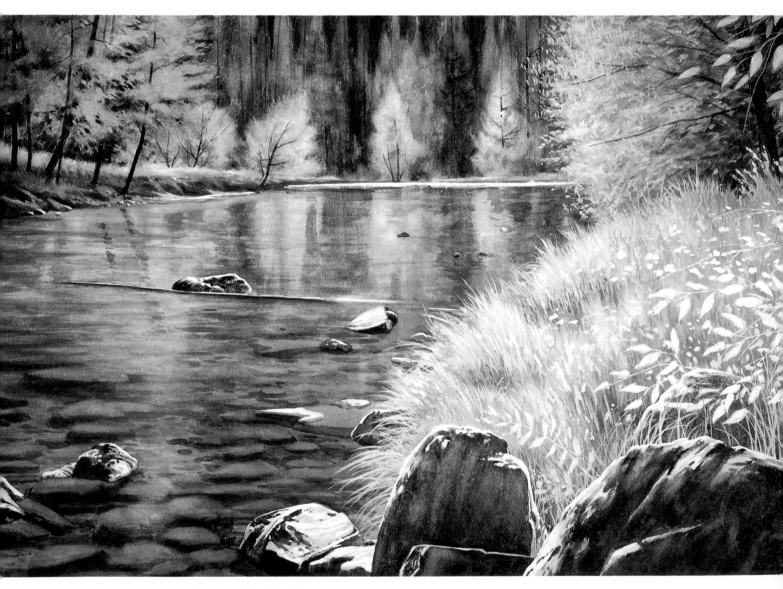

AUTUMN GOLDS, 25" × 39", Collection of Carol Todd
To convey depth in this painting, I used overlapping forms as well as "lost-and-found" edges.
I also contrasted the soft edges of the background trees against the sharpness and detail of the foreground elements.

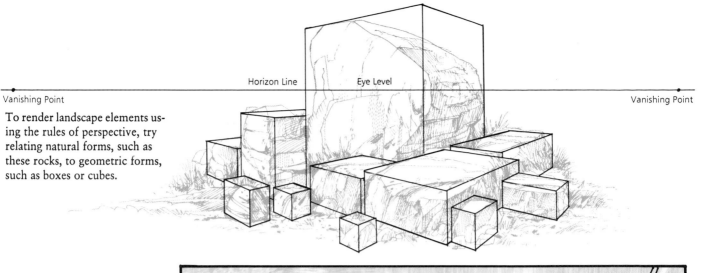

Horizon Line Eye Level

To render landscape elements using the rules of perspective, try relating natural forms, such as these rocks, to geometric forms, such as boxes or cubes.

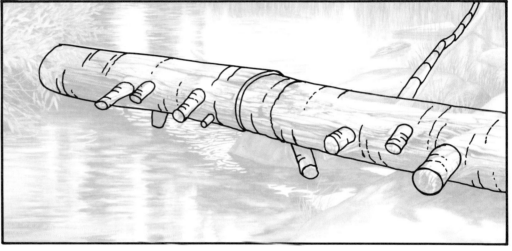

In this detail of *Shimmering Water*, the three-dimensional quality of the log is conveyed by the various "cross-contours" that describe the position and angle of the log. Light and shadows falling across the bark also describe its form. Occasional "notches" or cross-sections of the bark's edges also convey the elliptical form of the log. Finally, broken limbs extending at various angles support the illusion of depth and help convey the foreshortened form of the fallen tree.

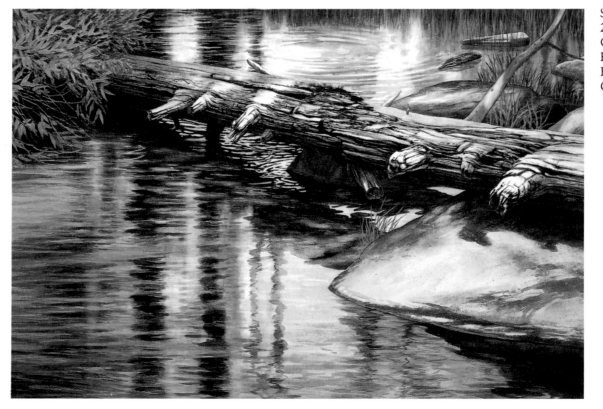

SHIMMERING WATER
25″ × 39″
Collection of
Kirkwood Ski
Resort, Kirkwood,
California

FORESHORTENING. Foreshortening is a term often associated with life drawing that describes the way a subject's arm, for example, looks when it is extended toward the viewer. Outdoor landscapes present artists with similar situations that require an understanding of foreshortening. The limbs of a tree jutting out in all directions are a prime example. A few limbs would likely appear in a profile position, but others would project forward in the picture plane toward the artist.

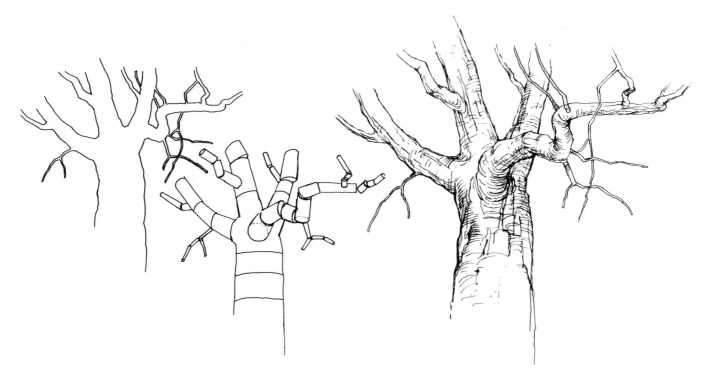

Many beginning painters incorrectly decrease the width of cylinder forms, such as tree limbs, that are oblique to the picture plane. Once again, an evaluation of the height and width of oblique forms is vital to maintain the volume of the cylinder form. Note how the cross-contours in this diagram of a tree (above) convey the various positions of the cylinder forms as they turn in space.

Being able to work with cross-contours is extremely important when trying to obtain a sense of volume in a form that is foreshortened, as you can also see by looking closely at the fallen tree in *Snow Pond* (below).

SNOW POND, 25″ × 39″, Courtesy of Visions Fine Art Gallery, Morro Bay, California

VALUE

From a design standpoint, value describes a range of colorless tones ranging from black to progressively lighter shades of gray to white. In any painting, the overall arrangement of shapes and values (without regard to the things they represent, such as sky, trees or foreground) forms the underlying abstract structure or design and is called the "value plan" of a painting. Compositionally, a well-thought-out value plan is one of the most effective tools for creating the illusion of light, volume, distance and mood in a painting.

In finished paintings, I use a full range of values (far right), but for ink sketches and color roughs, I work with four values (right) and concentrate on distributing them throughout the image in a dramatic way.

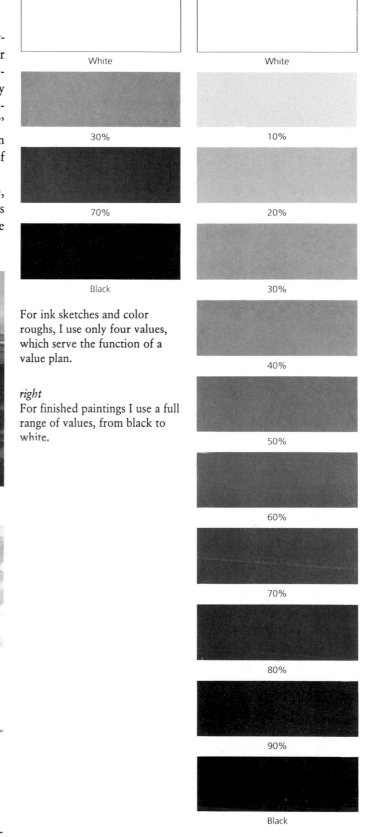

For ink sketches and color roughs, I use only four values, which serve the function of a value plan.

right
For finished paintings I use a full range of values, from black to white.

BACK BAY LIGHT

CARMEL MISSION

A painting with predominantly dark values, such as *Back Bay Light*, will likely convey a somber mood or one of high drama, whereas a painting with mostly lighter values, such as *Carmel Mission*, will suggest a more airy, upbeat feeling.

Clearly then, the time spent developing a value plan is critical because it provides an opportunity to solve basic design problems and build a strong foundation of interesting divisions of space and movement *before* you begin to paint. If the underlying pattern of light and dark values isn't unified and interesting, no amount of color and clever brushwork will bring a painting together.

To develop a value plan, you must first learn to see the value of each color or object in a scene. This is easier if you break the scene into three to four large areas, or shapes, of similar value, such as sky, trees and foreground. Look past minor variations within each larger mass and choose the middle, or average, value, not the highlight or the deep shadow. Squinting often helps. So, too, does comparing the values of one area with the values of another to determine which is lightest, next lightest, and so on.

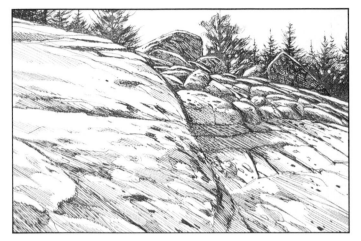

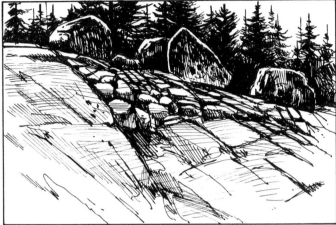

In my painting process, pen-and-ink sketches double as "value plans." They don't necessarily have every value I'll use in the final painting, but they do describe the placement of key values throughout the image.

This first sketch for *Sunlit Granite—Autumn* bothered me because one of the main divisions in the rock area fell in the middle of the composition; I also felt the composition was becoming too static.

In the second sketch, I resolved these composition/design problems by (1) moving the viewpoint farther to the right of the rocks, and (2) strengthening the dark contrasts behind the rocks with additional trees to capture the light on the granite boulders in a more dramatic fashion.

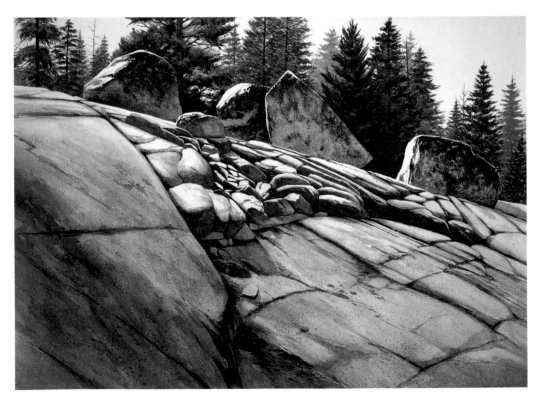

SUNLIT GRANITE—AUTUMN
25″ × 39″
Collection of Kirkwood Ski
Resort, Kirkwood, California

Values and the Illusion of Volume and Distance

Up to this point, the value plan has been mostly concerned with two-dimensional shapes, but it can also describe the design element of space (i.e., volume or distance). In both cases, value changes and contrasts describe the effects of light, which, in turn, describes the illusion of volume or distance.

LIGHT. As expressed via changes in value, light is one of the most useful tools for creating dynamic, interesting compositions. It can provide a subtle "rhythm" or "repetition" that links various forms and "dances" through and around them; it can also highlight an area or focus the viewer's attention on a particular object.

VOLUME. Values that gradually lighten or darken (graded tones) describe the structure and volume of an object as well as the direction of the light source. More definitive contrasts describe where one form ends or overlaps another. Together, graded tones and contrasts help create the three-dimensional illusion in a composition.

DISTANCE. Whereas volume describes a scene in rather intimate terms, distance is more expansive. To create the illusion of distance, you'll need to consider the effects of aerial, or atmospheric, perspective. In simple terms, atmospheric perspective is the phenomenon we observe when distant trees appear to melt into a morning fog or mountains appear hazy near the horizon. These effects are the result of particles that reflect light and partially obscure our vision — the dust, smoke, moisture and smog suspended in the atmosphere. In practical terms, aerial perspective means that as objects recede in space, contrasts between values are reduced and edges become softer, while dark values get lighter and light values get slightly darker. This

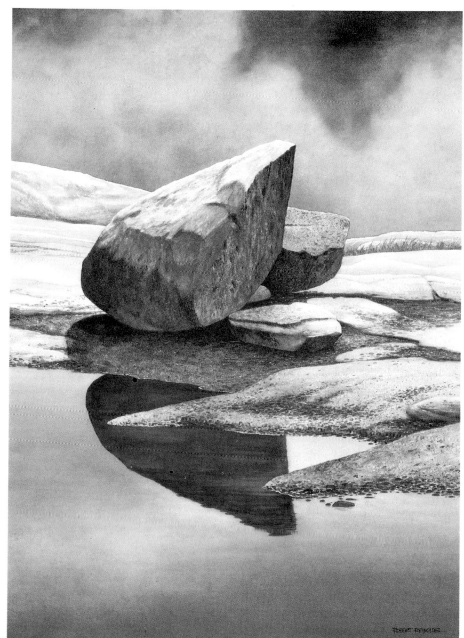

In *Sierra Sentinel* I wanted the rocks to have such a believable sense of volume that viewers could "feel" the heaviness. By using overhead lighting, I created light values on top of the rocks that gradually became darker toward the base of the rocks. Since dark values feel heavier, this light-to-dark value progression helped convey the weight of the rocks.

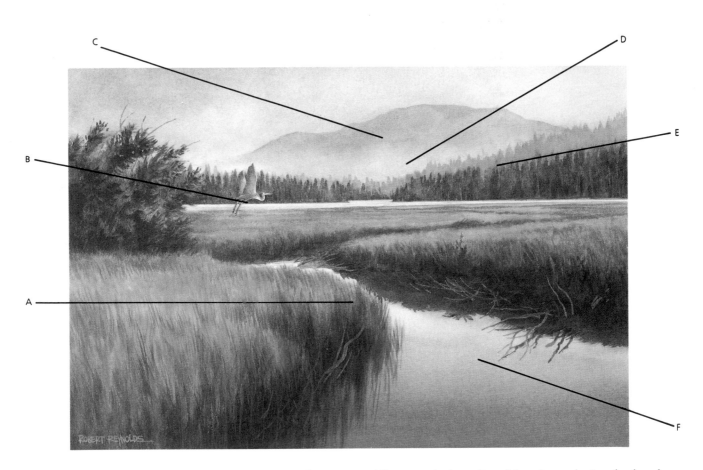

Here are a few of the key cues to distance in *Silver Lake Marsh*:

A. Sharply focused subject matter in the foreground (grass, roots, etc.) contrast with the softer edges of distant shapes.

B. The Great Blue Heron directs the viewer's eye into the painting and counters the strong right-to-left angular movement of the foreground water.

C. The mountain is soft edged, lighter in value (high keyed), and cooler than foreground elements to convey the illusion of distance.

D. The atmospheric quality of the mist emphasizes depth and provides additional contrast with the sharpness of the foreground. The mist also delineates another overlapping form—one of the key techniques for suggesting volume and distance (see page 66).

E. As trees recede, they diminish in size, value and color, and their edges become less definite.

F. Sky colors reflected in the foreground water add unity and balance to the composition.

is why a distant tree line, for example, appears lighter than trees in the foreground.

Fortunately, when you sketch from an actual scene, your value plan will almost automatically incorporate aerial perspective, if you've correctly analyzed and identified the values for each area of your composition. As you sketch, and later as you paint, you may wish to exaggerate the value effects of aerial perspective to clarify or dramatize a composition. If you do, be careful that the value you use for each object places it at the proper point in the three-dimensional illusion of space. In the middle distance, for example, a tree that's too dark or that has

edges that are too definite will fight to come forward to the foreground where its value indicates it should be.

If you have difficulty seeing the value structure in a painting or in nature, there are several ways to make it more apparent. Try closing your eyes halfway so that the scene is slightly out of focus to reveal the major shapes and values. A Polaroid camera loaded with black-and-white film is another alternative since the values immediately become apparent once the color is removed. In the same vein, a yellow-glass filter can also produce a similar result (available at most camera stores for under ten dollars).

Utilizing Value—Some Cautions

A. Caution. An equal distribution of light and dark values is static and lacks emphasis.

Solution. Instead, as in this example, use a variety of values to make your underlying abstract designs definitively lighter or darker.

B. Caution. Isolated spots of light and dark values can create unintentional emphasis, which, in turn, can lead to tension and confusion.

Solution. Group and connect major shapes and values. Large, bold shapes result in stronger designs than small, isolated, "busy" arrangements of shapes and values.

C. Caution. Using too many forms with similar shapes and values can become visually boring.

Solution. Create variety by varying shapes and values.

D. Caution. Unless it's your intention, be wary of using too many middle values; otherwise, your value plan and painting will lack snap and drama.

Solution. To create a more interesting design and composition, emphasize a range of stronger dark and light values.

E. Caution. Be wary of becoming repetitious with too many equally spaced or similar shapes and values.

Solution. To create variety, use unequal spacing, and subtly repeat shapes (both positive and negative) in different scale.

F. Caution. Watch for awkward or repetitive shapes along the borders of your image that can trap the viewer's eye.

Solution. Carefully examine shapes along borders of your image. Take care to vary length and positions of exit points.

G. Caution. Avoid making the values of adjacent shapes too similar; otherwise, they may mesh together and interfere with the illusion of depth.

Solution. Use a variety of values to define spatial relationships between objects in your composition. If an area, such as a group of foreground rocks, becomes too "busy," then reverse the process and use close values to subdue it and allow the forms to mesh.

H. Caution. Avoid uninteresting designs that fail to make use of value and other contrasts.

Solution. Always think in terms of contrasting light against dark (value), large against small (scale), angular against organic (variety, contrast) and active against stationary (contrast).

A

B

C

D

E

F

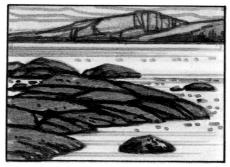

G

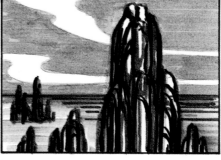

H

COLOR

Compositionally, color's most obvious function is to provide a means of approximating the colors found in a landscape, such as water, rocks, foliage or tree bark. Of course, the actual colors of a landscape can be altered, subtly or boldly, to suggest a particular mood or emotion. Warm colors, for example, are apt to evoke positive emotional responses, quite independently of the subject, while cool or drab colors may have just the opposite effect. Such alterations might be as simple as heightening the colors of a sunset or as dramatic as changing the colors of a scene from day to night or from winter to spring, all while maintaining a credible illusion of reality.

From a design standpoint, color also has a variety of useful functions. For example, careful combinations, contrasts and distribution of colors throughout a design can balance and unify a painting as well as direct the eye, clarify volume and establish spatial order—all without reference to realistic objects.

At a purely psychological level, humans are attracted to warm, inviting colors—perhaps because warm colors carry with them unconscious and usually pleasant associations, such as the warmth of fire, home and hearth, sunshine, and the vitality of living things—like new leaves in spring and the rosy cheeks of healthy children. Cool colors have their own psychological connotations, too, such as the physical discomfort of the cold or the gloom of an overcast winter day.

For these reasons, and perhaps for others not fully understood, we are attracted first to warm colors and only then to cool colors. Perhaps for the same reasons, warm colors also appear to come forward, while cool colors appear to recede. Compositionally, this characteristic can augment the illusion of volume. For example, warm colors can make the sunlit side of a form come forward, while cooler colors make other areas recede into shadow.

These bars illustrate how color recession (from warm to cool) creates the illusion of depth or distance.

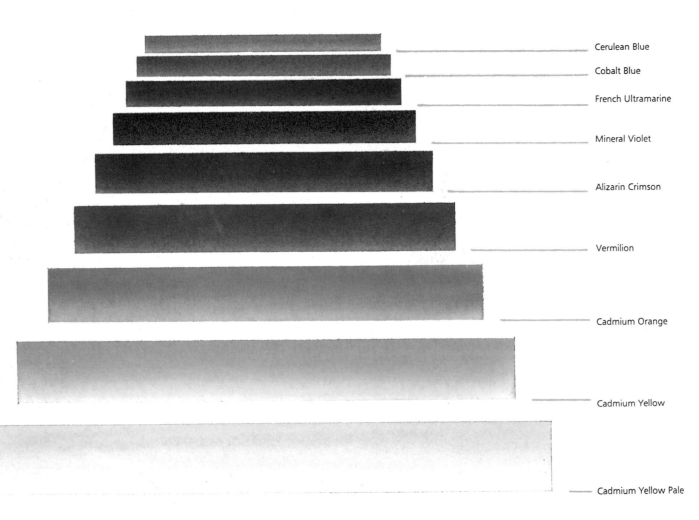

Cerulean Blue

Cobalt Blue

French Ultramarine

Mineral Violet

Alizarin Crimson

Vermilion

Cadmium Orange

Cadmium Yellow

Cadmium Yellow Pale

Color and Atmospheric Perspective

Color can also define spatial order or the illusion of distance through atmospheric or aerial perspective. The value changes associated with atmospheric perspective have already been described in the previous section, but while value alone can create the illusion of depth, the illusion becomes considerably stronger when teamed with color. Typically, color suggests the illusion of depth in two ways: (1) by changing from warm to cool and (2) by changing from pure to muted. In landscapes, colors generally move from warm greens, ochres and siennas in the foreground to cooler lavenders and blues in the distance, which is why distant mountains are often painted in those colors. At the same time, though perhaps less apparent, colors become less saturated (i.e., muted or more grayed) as they appear to recede in space, which is why mountains and other distant forms often appear somewhat chalky or hazy.

Distance in a painting can be simulated through atmospheric perspective by consciously diminishing the intensity and values of your colors as they recede toward the most "distant" areas of the composition. Details and edges should also be softened concurrently.

Here's an exercise that'll help you better understand warm-to-cool color recession and atmospheric perspective. In the process, you'll get valuable practice using graded washes and learning to modify the intensity of colors by varying the amount of water in your color mixes or by adding an opposing color.

Using just two or three colors (be sure you have at least one warm and one cool color), create several imaginary landscapes like those below. I've used mountains and sky here, but any subject (blocks in space, icebergs, anything!) can be used to produce a similar result.

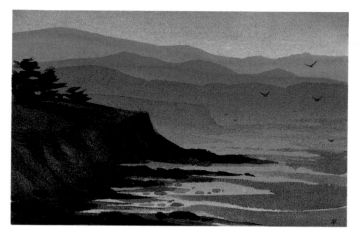

Graded washes of burnt sienna and French ultramarine blue were painted first. Cadmium yellow pale was mixed with the French ultramarine blue to create the green-blue of the water.

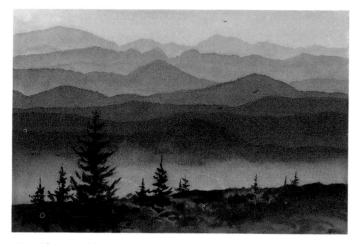

Here I began with a graded wash of alizarin crimson. After it dried, I created the distant mountains and headlands with successive graded washes of French ultramarine blue, adding a bit of burnt sienna each time. Midway down I began adding alizarin crimson to the mixtures.

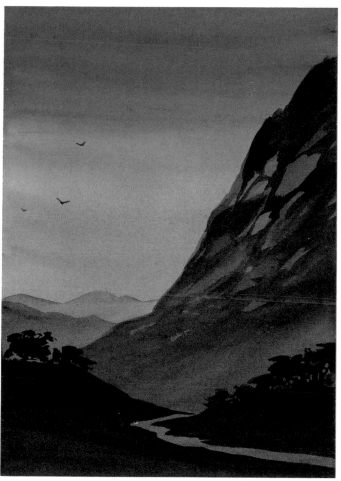

Again I used graded washes of alizarin crimson, cobalt blue and burnt sienna, but at the end of the process, I added a touch of yellow to the mixture of cobalt blue to create the foreground greens.

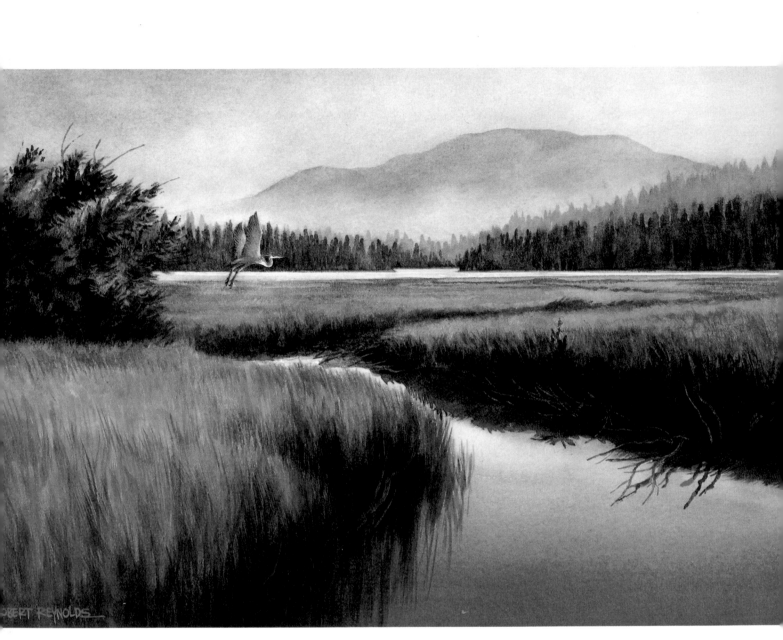

SILVER LAKE MARSH, 15" × 20",
Collection of Mr. and Mrs. Ed Bagshaw

In the black-and-white reproduction of this painting on page 72, I
described a number of ways the illusion of depth is suggested. Color
also plays an important role in creating the overall illusion of depth.
For example, compare the warm foreground greens with the cooler
colors of the trees, mist and mountain in the background. Thus, grada-
tion can convey the illusion of depth. Here, for example, the graded
reflection of the sky on the water in the foreground leads you into the
illusory depth of the painting.

At a design level, a carefully laid path of warm colors is an excellent device for directing the eye to the center of interest in a composition. In *Dusk/ Thunder Mountain*, for example, the rules of atmospheric perspective appear to be reversed since I've used warm colors to focus attention on the distant mountains. Nevertheless, despite the atypical color/distance cues, the illusion of depth remains strong because of the combined effect of other depth cues, such as overlapping, scale changes (foreground vs. distant trees), value changes (foreground darks vs. lighter values across the lake), and our own subtle psychological reaction that draws us irresistibly out of the dark shadows toward the light (in this case, across the lake). Finally, all of these depth/distance cues are aided by the viewer's own experiential knowledge of the normal spatial relationships of the various objects in a landscape.

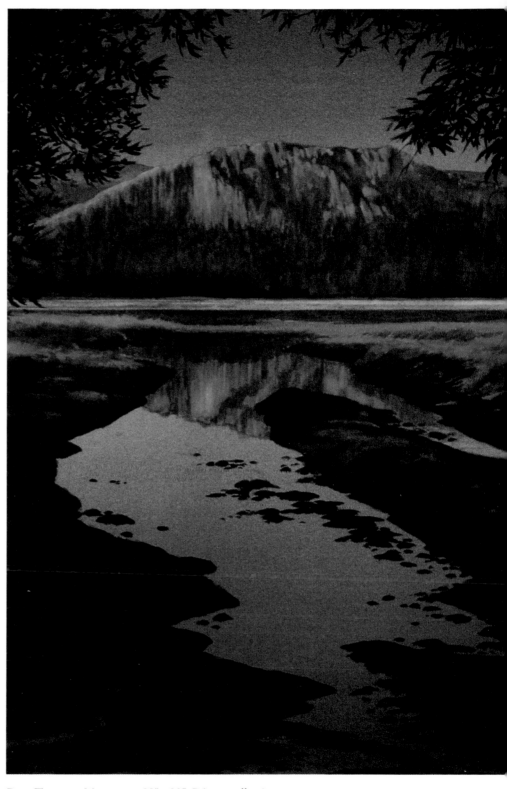

DUSK/THUNDER MOUNTAIN, 28" × 22", Private collection
Here you can see how color-depth can be "overridden" by other depth cues, such as overlapping, scale changes and value changes.

TEXTURE

Texture is one of the more subtle elements of design. It is expressive and emotional, and in many ways, it is often the telltale fingerprint of an artist. Compare, for example, the bold textures of a Hopper painting with the finely textured drybrush paintings of Andrew Wyeth. Texture, or the lack thereof, can set the stage for an agitated mood or a quiet one.

Creating Interesting Textures

We all work with a fairly similar and basic set of art-making tools: paper, pigments, brushes and other useful items. What distinguishes one artist's work from another, however, is not our tools but how creatively we learn to use them.

Earlier, in Part I, I showed how each of the four types of brushes I use are capable of creating a wide variety of lines and textures. But brushes are really only a starting point. Perhaps the following illustrations—which I call "textural minglings"—will give you some additional ideas for using

TEXTURAL MINGLINGS

Wet-into-wet/Rock Salt/Cadmium Orange and Burnt Sienna

Wet-into-wet/Rock Salt/Cobalt Blue, Alizarin Crimson and Mineral Violet

Tape Stencil/Wet-into-wet/Vermilion, Alizarin Crimson, Burnt Sienna

Wet-into-wet/Rock Salt/Alizarin Crimson and Payne's Gray

Lifting with Brush Handle/Vermilion, Alizarin Crimson and Payne's Gray

Brush Spatter with Liquid Masking Fluid/Cerulean Blue and Ultramarine

Plastic Wrap/Prussian Blue and Payne's Dry Brush/Mineral Violet/Stippling

Dry Brush/Mineral Violet/Stippling

Water Drops onto Damp Mixture/Mineral Violet and Cadmium Orange

your brushes as well as other materials to create an even wider variety of interesting and creative textures.

Basically, textural minglings are a means to explore and invent interesting combinations of colors, values and textures by using additives, lifts, resists, spatter, scraping and stippling (to name only a few of the possibilities). When approaching creative exercises like this, I try to maintain an inquisitive and even playful attitude. To keep from judging what is happening and instead simply enjoying the process of discovery, I avoid painting "things" — recognizable objects. Instead, I try to keep the compositions completely nonobjective and concentrate only on creating an interesting rectangle of texture and color. The purpose of these exercises, for me and for you, is simply to expand our un-

derstanding and knowledge of various techniques that could be used during the painting process.

Students in my classes and workshops who have participated in this exercise have nearly always become more innovative and creative as a result. There is certainly no guarantee that any of these textural exercises will ever be directly useful in a painting situation, but they frequently lead to new insights and a new awareness for each artist of his or her creative potential. I've seen students do this exercise and become so excited about a particular arrangement of texture and color that they soon enlarged their small rectangle and restated it as a serious work of nonobjective art. Beyond that, as a representational painter, I've found that sooner or later, bits and pieces from these exercises manage

TEXTURAL MINGLINGS

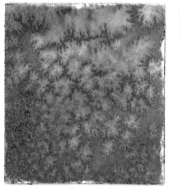

Plastic Wrap/Alizarin Crimson and Payne's Gray

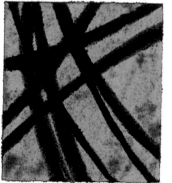

Wet-into-wet/Viridian and Prussian Blue and Burnt Sienna

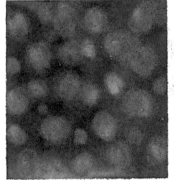

Lift Method/Mineral Violet and Prussian Blue/Cotton Swabs

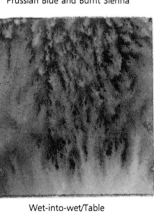

Wet-into-wet/Coarse Kosher Salt/ Cerulean Blue and Alizarin Crimson

Wet-into-wet/Table Salt/Alizarin Crimson

Wet-into-wet and Spatter/Cadmium Yellow Pale, Cadmium Orange

Wet-into-wet/Rock Salt/Hooker's Green and Prussian Blue

Toothbrush Spatter on Dry Color/Burnt Sienna and Cobalt Blue

Spatter using Masking Fluid/Vermilion, Alizarin Crimson and Payne's Gray

to work their way into my paintings, helping me to find a more creative or effective way of communicating one of the myriad textures or surfaces found in nature.

On the whole, the function of texture is to focus, simplify, clarify and provide visual order to the objects in a landscape. In realist landscapes, textures are often kept somewhat subtle so as not to detract from the overall illusion of reality. At the same time, "area" textures are used throughout an image to suggest the illusion of reality as in tree bark, moving water or foliage. In areas of flat tone,

subtle textural modulations often provide variety, visual interest and a more naturalistic appearance. On the whole, texture is a kind of shorthand language for "reality."

My objective when using texture isn't to faithfully and absolutely describe every twig, crack and grain of sand. Instead, I use texture as a way of communicating my own experience of a thing and my own emotional response to it. In other words, I use texture to communicate the essential spirit of each object in a landscape in the most economical and direct visual terms possible.

Believable foliage texture can be created in several ways. Patterns of darks and lights can be applied wet-into-wet, *or* as shown in this detail, texture can be applied in a more direct and controlled way using "brush calligraphy."

In this detail, I used a combination of spatter technique, lift method, and controlled, direct use of calligraphy to capture the illusion of rock textures. Note how I maintained the edges of the rock planes to support the form of the rock.

This detail from *Sunlit Granite—Autumn* (page 70) illustrates rock textures created using wet-into-wet texture—i.e., the surface is wet when spatter and direct calligraphy are applied to various areas on the rock.

In this detail from *Sierra Sentinel* (page 55), the foreground textural area of gravel was corrected by spatter, applied calligraphy, and the lifting out of light areas that represent the various colors of the pebbles. A combination of warm and cool colors was used in the method.

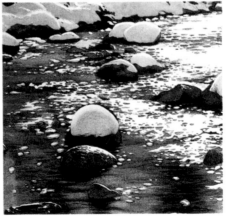

This detail from *December Light* illustrates the use of light as texture in still or moving water, how it conveys direction and surface planes. Some highlights/textures on the water's surface were reserved using liquid masking fluid. Others were lifted out using a flick of an art-knife blade (not too deep!) and, in a few spots, an electric eraser.

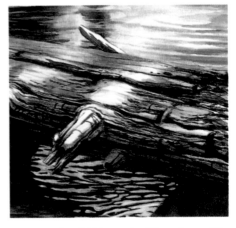

As I completed *Shimmering Water* (page 67), I "weathered" the fallen fir tree with various textures to suggest cracks in the wood, battered bark, and holes reflecting a season's wear and tear or perhaps the efforts of woodpeckers!

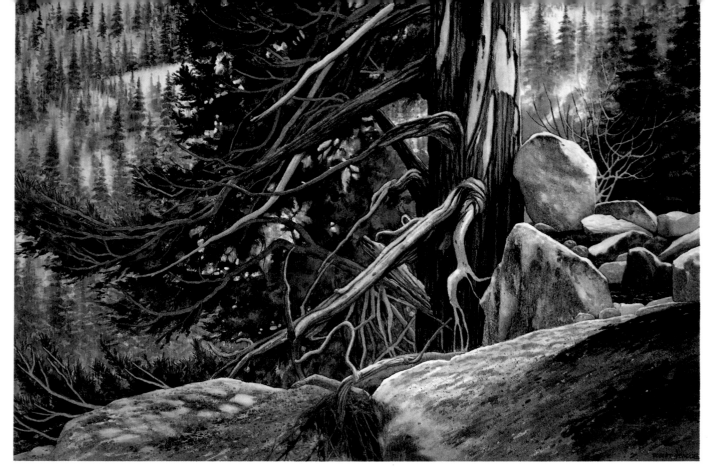

SIERRA JUNIPER, 25" × 39", Collection of Bill Todd

This detail shows the texture used to convey the illusion of distant trees located on the slope of the snow-covered mountain in the background. Brushstrokes were diminished in value, color intensity and detail.

When painting tree bark, it's natural to think in terms of creating an authentic texture, but it's equally important to think in terms of creating a strong design when breaking up the forms. Variety can be enhanced by changes of color, value and detail.

Foreground elements like these should normally be rendered in sharper textural detail than elements that appear farther back in the illusion of space or depth. Textures that are more sharply defined always tend to bring the area involved forward visually.

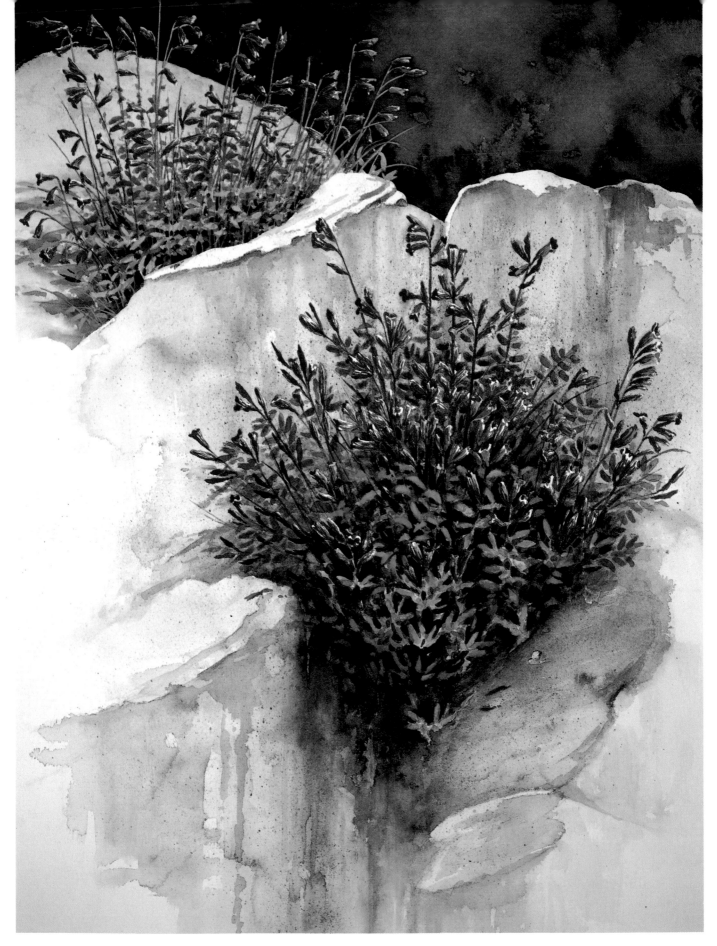

SIERRA PENSTEMON, 39" × 25", Collection of H. LeRoy Minatre

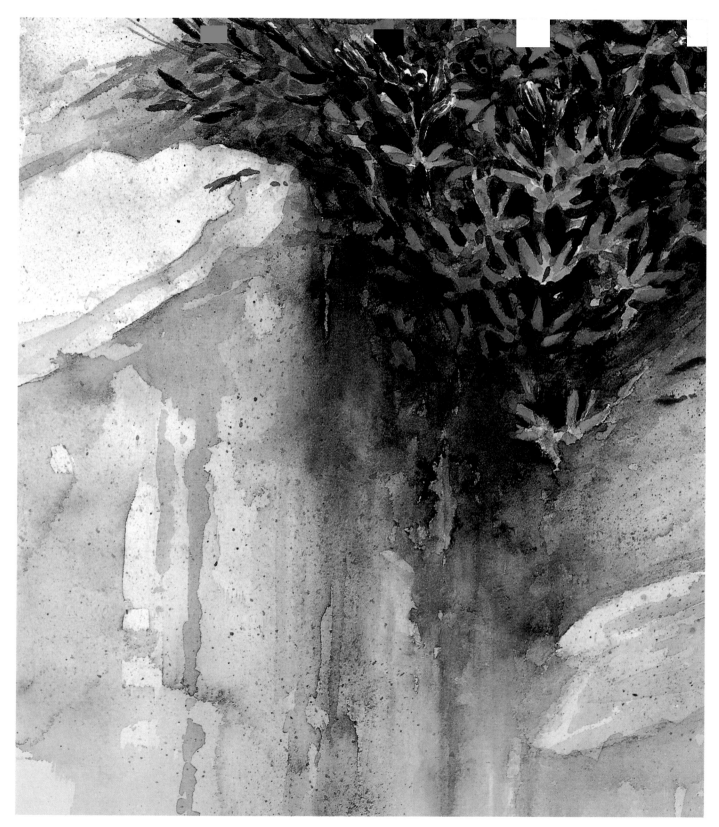

Detail of SIERRA PENSTEMON

Various textures in *Sierra Penstemon* were created by spattering and by "flooding" semidried washes with water to cause staining along the edges of the washes. Most artists are taught early on that such "stains" shouldn't happen in paintings; but under the right circumstances the textural result, especially on rock forms, can be quite effective.

DIRECTION

If the design element "line" can be described as a dot that has gone for a walk, then "direction" can be characterized as where it has been and whether the journey has been an interesting one. You won't find "direction" on many lists when searching for a consensus of what constitutes the Elements of Design, but it's an element that I confront each time I begin designing a composition. Thinking about the design element of direction usually prompts a string of questions: Are the movements in this composition going to be vertical, be horizontal, or perhaps lead to a dynamic oblique design? What kind of directional oppositions do I want? How do I want the eye to travel through the composition? Will the directional movements be slow or will they move rapidly across the picture plane?

Along the way, the Principles of Design (described in greater detail in Part III) will influence direction in the composition by adding opposing forces such as variety, rhythm, pattern, scale change and repetition. The other design elements, depending on where they are placed in relationship to the picture plane, can also influence the speed of direction. For example, similarities tend to catch the eye and move it along, while dissimilarities tend to slow down and weaken directional movement.

With the possible exception of geometric shapes, which tend to be rather balanced and therefore static, most shapes have an inherent sense of direction. In a composition, the inherent direction of any shape is affected by its placement relative to, and its relationship with, other design elements (line, shape, space, value, color, texture, and so on) and by how all the elements in a composition are influenced by the Principles of Design (unity, repetition, variety, dominance, balance, gradation, conflict and scale). Understanding these complex interactions is the key to controlling the various directional movements that occur in a painting.

Many unsuccessful paintings are made so by the presence of a number of unintentional directions scattered throughout the composition, which result from misplaced light sources, out-of-key value arrangements, uncontrolled color intensities and so on. For that reason, it's extremely important to recognize and control directional relationships within a composition. Because direction is the most subtle of all the design elements, it is also the most challenging concept to understand. You must train yourself to recognize and control the directions and counterdirections that develop by intent or accident as a composition evolves.

But, take heart! Here's a simple way to sensitize yourself to the design element of direction: Select a book on one of the Old Masters, such as Rubens. Then place a piece of tracing paper over one of the large reproductions, and with a soft graphite pencil, draw the directional angles, curves and straight edges that you see in the painting. This will help you learn to recognize direction and understand how each artist designed various directional movements in order to lead the viewer's eye in and around the composition.

To get you started, I've indicated the directional movements in my painting *Sierra Juniper* (at top right). When you've finished with it, see if you can identify the directional movements in *Back Bay Sunset*.

Alignment of shapes rapidly creates directions within a composition. These directions are tempered by other design elements such as color, value and texture. Design principles such as gradation, conflict, scale, dominance, variety and repetition also contribute.

This diagram of *Sierra Juniper* (page 81) shows that its design is based on a simple arrangement of recurring directions (30-degree diagonals). The verticals in this painting counter the 30-degree directions and repeat the picture-plane verticals to "anchor" the design to the rectangular format.

BACK BAY SUNSET, 12″ × 19″, Collection of Mr. and Mrs. Douglas R. DePalma

Back Bay Sunset uses directional forces in a most obvious way: Canals that channel the incoming and outgoing tide at various times of the day provide marvelous natural directional elements. Note the many recurring and opposing angles distributed throughout the composition. Although I painted this scene at a place not far from where I live and based it on what I saw in nature, I freely modified the directional movement of the canals to create an interesting design without sacrificing the scene's sense of place.

PRINCIPLES OF DESIGN

Naming and understanding the functions of each of the Elements of Design is like looking into a closet containing tubas, violins, flutes and cellos — identifying each instrument and what it can do is useful, but you still won't hear a concert. The Elements of Design, like the instruments in an orchestra, are interesting when considered individually, but they don't become truly useful until you understand how they work in concert with each other to produce successful paintings.

Applying Design and Composition to the Real World

Clearly, there is no single or simple "formula" for creating successful paintings. Nevertheless, almost from the beginning, artists began developing and refining a series of concepts that sought to classify the desirable characteristics shared by successful paintings. Those concepts have come to be called the "Principles of Design," and they seek to describe how the Elements of Design interact with each other in successful paintings.

Like the Elements of Design, the Principles of Design derive their strength and power not from their individual functions, but from the way they interact with each other. Although the specifics of a successful design vary from artist to artist, the following principles are fairly universal and can be used to measure or strengthen a painting's abstract design structure as well as its composition.

UNITY. A painting should be a complete statement, containing only related parts that contribute to the whole. If a painting lacks harmonious relationships between the design elements (line, shape, space, value, color, texture and direction), it will lack unity. Fortunately, unity can be achieved in an almost infinite

ATASCADERO DUSK, 22" × 15"

Reflections are one way to achieve unity in a painting. In *Atascadero Dusk*, for example, unity is created by repeating the colors and gradations of the sky and trees in the water reflections. To subtly support this form of unity, this painting uses classic one-point perspective to lead the viewer's eye from the front-on view of the boat, across the lake reflections, to the trees and sky.

In *Sierra Penstemon* (on page 82), the red petals of the penstemon create an interesting contrast against the light granite rocks. Because of value similarities, the dark shadows within the flowers create one form of unity by repeating the dark background. An overall sense of order is also achieved via the pattern of repeating vertical directions throughout the rocks. Variety is established by repeating angles that counter the vertical movements.

number of ways—a pervasive color or value scheme, for example, or a design based on related shapes or textures. In fact, there are so many ways to achieve unity in a composition that the concept defies simple illustrations or diagrams. When it comes to unity, a painting's success often depends as much on intuition as it does on intellect.

REPETITION. Repetition of any of the design elements can create an underlying rhythm that can be varied in limitless ways. When used appropriately, repetition contributes to the overall unity of a painting in much the same manner as a refrain does in music.

VARIETY. In paintings, variety adds visual interest—too much creates chaos; too little produces boring compositions. In other words, the principle of variety must be weighed against the principle of balance to achieve unity.

Variety can be expressed using any of the design elements. When I first started painting, for example, I always reached for a flat brush and, without thinking, used it throughout the painting. The result was a consistent brushstroke (a shape) that lacked variety. By repeating the same shape too often, it became boring.

Snow Pond (also shown on page 68) is a good example of repetition. Note, for example, how the vertical movements are repeated in the background trees and then again in their reflections on the water. Now place your hand over the fallen log that enters the painting from the bottom left corner—you're left with a rather static image because of too much repetition without any opposing elements to balance it. Remove your hand and you'll see that the log's shape, light value and diagonal movement provide an effective counterbalance to the strong repetition of vertical elements.

This drawing of a row of fir trees illustrates the principle of variety in both value and shape.

This detail of *Sunlit Granite—Autumn* (also shown on page 70) is a good example of how the principle of variety is applied to create an interesting arrangement of rocks and trees.

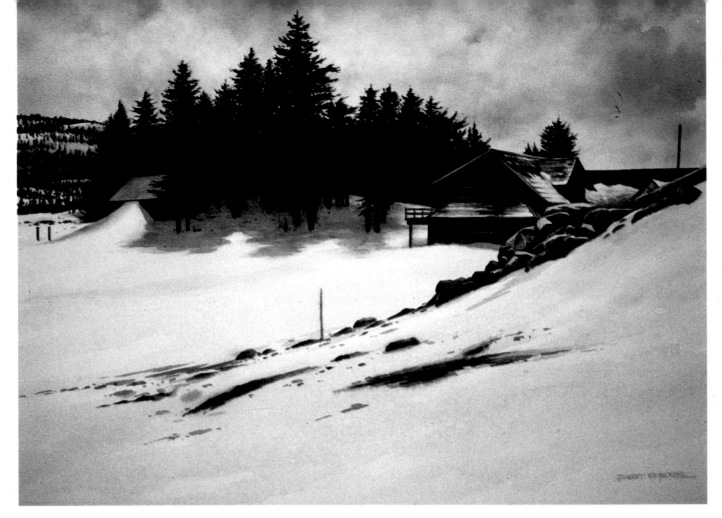

WINTER AT KAY'S, 22″ × 30″, Collection of E. Proctor

DOMINANCE. As with the other principles of design, dominance can be achieved using one or more of the design elements. Allowing one element to have dominance will add contrast and drama to your paintings.

Generally, dominance should create or support the center of interest, not compete with it. For example, the center of interest might be the most intense color in your composition, or the area with the strongest value contrast or both. In either case, the intent is to allow that area of the composition to dominate— i.e., to capture the eye. If you inadvertently create dominance in an area that you intended to be quiet or low-key, that area will conflict with the true center of interest.

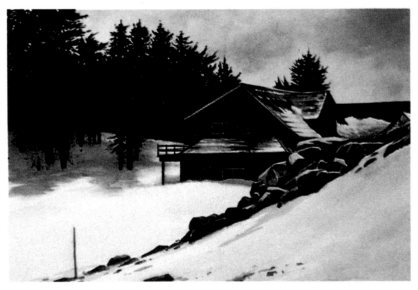

In *Winter at Kay's*, I contrasted dark tree shapes against a winter sky. Together with the diagonal rocks in front of the building, they provide value contrasts and a strong foreground diagonal, which lead the eye to the building that is trapped by the white snow. The strong contrast between the building and the snow provides a dominant value contrast at the center of interest.

I kept the sky a middle value, hoping the interplay of the clouds' subtle darks and lights would provide an interesting contrast of shapes, but not one so strong that it would conflict with my other compositional components. I intentionally made the trees larger than they actually were to create a contrast of scale. This made them more dramatic in relation to the building.

BALANCE. Two identical squares spaced equidistant from the center of a painting are, in theory at least, balanced. Unfortunately, the result is rather static and boring. In paintings, balance should be both interesting and dynamic. In most cases, this can be achieved by applying the principle of variety. In other words, shapes, colors, directions and values can be arranged to create a pleasing, dynamic and visually interesting balance that results from tension between dissimilar elements or from an asymmetrical use of the same element.

GRADATION. Few natural objects in a landscape are uniform in value or color. Differing growth patterns, natural variations in coloration, and exposure to weather all work to produce interesting gradations in color and value. Direct and reflected light also produce gradation, as do the rounded surfaces of objects such as tree trunks or boulders that curve toward or away from the light source.

Gradation creates movement and volume in a painting and adds visual interest while capturing a "truth" in nature. In addition to the examples just mentioned, gradation can be seen in many other ways in nature, which can be expressed (once again!) via the Elements of Design. For example, shapes of equal size, such as trees, gradually appear smaller as they recede into the distance, colors gradually become lighter and less intense along the same progression, textures gradually become less distinct, and so on.

A. A perfect balance, but static and uninteresting.

B. A bit more interesting, but lacking interesting conflicts, and the design doesn't take advantage of the full rectangle.

C. A more pleasing design that utilizes the rectangular space and employs repeated similarities and interesting oppositions.

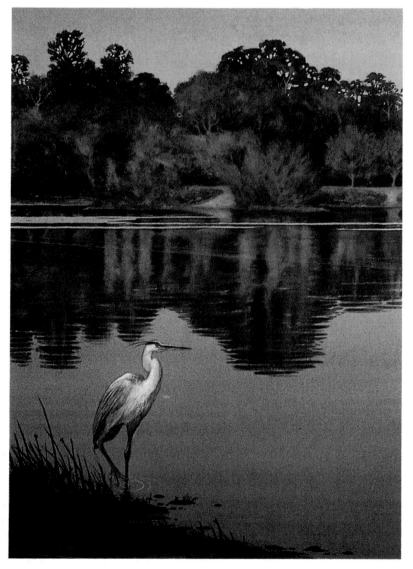

AFTERGLOW, 22" × 15", Private collection

In *Afterglow*, thin, indirect gradations of color, value and color temperature in the sky and water add depth and help convey solitude.

These gradations were created by applying a graded wash of alizarin crimson to the middle of the composition and then diminishing (gradating) its intensity and value above and below the middle. After it had dried, a series of additional gradations (using cerulean, cobalt and Prussian blue) were glazed over it, with each wash allowed to dry before the next was applied.

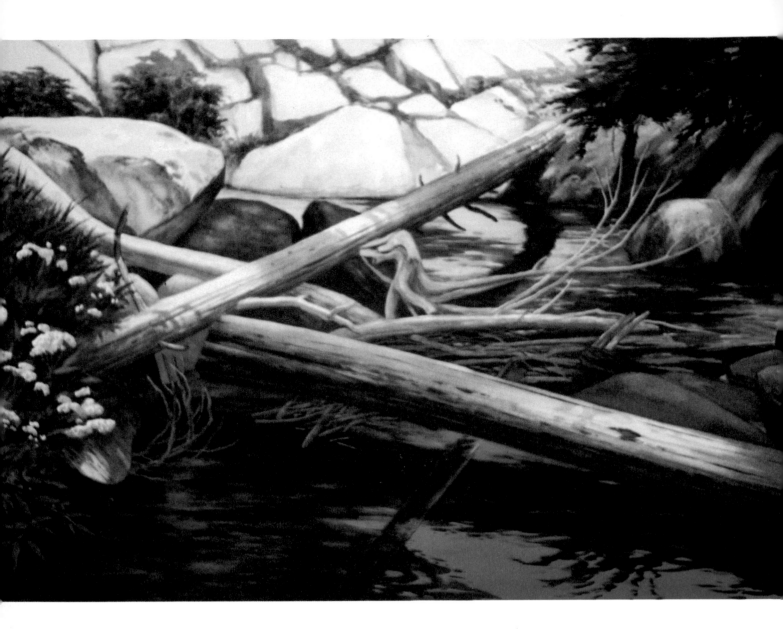

RIVER PATTERNS, 24″×35″ (location study), Collection of Bill Todd

In *River Patterns*, note how tension and conflict are created by the positions and relationships of the logs. To keep the conflict from becoming disturbing, I arranged several of the log forms to repeat the main angles of the composition so that, through repetition, unity was maintained. I also intentionally allowed the log forms to extend off the edges of the image in order to break the composition into a number of interesting shapes in a variety of sizes.

CONFLICT. To highlight important areas of a painting, I create emphasis through contrast and conflict by playing opposites against each other—for instance, a hard edge against a soft edge, a simple shape against a complex shape, a large shape against a smaller one, a lighter value against a darker one, a muted color against a vibrant hue, and so on.

Conflict between opposing design elements not only creates interest but also offers a means of expressing my own emotional reactions to a subject via the use of tranquil, agitated or turbulent contrasts.

SCALE. Viewers naturally and unconsciously apply their own experience of "seeing" in the real, three-dimensional world to the illusions artists create in two-dimensional paintings. Because of that, changes in scale are some of the most effective tools at our disposal for creating the three-dimensional illusion. In paintings, as in the "real" world, viewers use contrasts between familiar objects of known size to infer the third dimension of space.

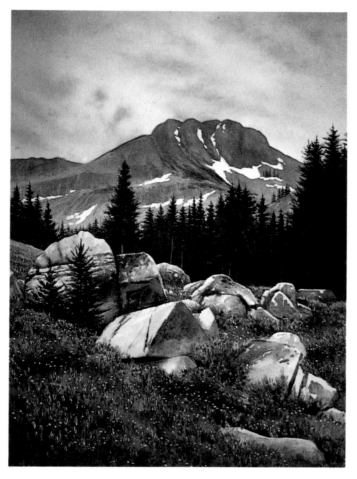

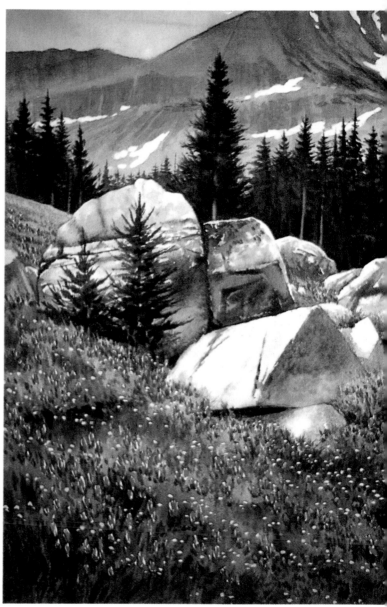

EARLY SUMMER/ROUND TOP, 30″ × 22″, Collection of C. McAdams

Even without really thinking about it, viewers know the approximate size of the red blossoms in the foreground of *Early Summer/Round Top* and from that can infer the size of the boulders. In a similar manner, viewers know the approximate size of the trees in the background and from that can infer that the trees must be farther back in the spatial illusion since they appear small in relation to the rocks and flower blossoms.

Sierra Brook

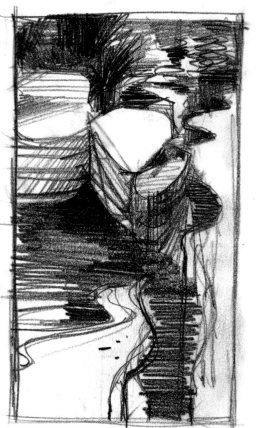

In the outdoor painting workshops I teach, I've noticed that many students have difficulty beginning sketches during their first few times on location. For those who haven't previously sketched directly from nature, it's an intimidating challenge to reduce the visual complexities before them into a pictorial, graphic arrangement.

I understand their reticence because when I first faced the magnificent expanse of Yosemite Valley, I too was overwhelmed. After I realized that I was simply overreacting to the great beauty of Yosemite, rather than approaching it as I would any other subject, I overcame my intimidation and gained the self-confidence to sketch and paint there.

Now when I go outdoors in search of material for future paintings, it's easy to get excited about potential subjects. Of course, being somewhat pragmatic, I usually have several design concepts in mind, but I'm always open to design opportunities beyond those I originally envisioned. The key is to keep an open mind when confronting the many visual images found in nature. Then when a subject strikes your interest, it is simply a matter of applying the Principles of Design.

When the subject is complex, it's best to begin by reducing the forms into rudimentary terms that can be understood by both you and the viewer; the composition can always become more complex later. Another way is to limit the scope of the scene, as I've done in *Sierra Brook*, the subject of this demonstration.

I was familiar with this brook, and so after a rain one evening, I was certain that it would be flowing well. Early the following morning, I walked along its bank and before long, came to a natural dam created by trapped granite rocks. I had no preconceptions as to the best format, but when confronted by the stream and granite rocks, the scene itself immediately suggested the tall, vertical arrangement. Normally, choosing a format isn't so easy.

Planning the Design/Composition

Once I've located a scene that holds promise, my first step is to begin analytically questioning how to translate it into graphic terms. I also determine if my initial viewpoint will work graphically, whether I'll need to find a new viewpoint, or if I should simply back off and look for a different location.

Generally, I make several sketches in which I try various formats and compositions — trying, not to be seduced by the subject, but to consider the scene as related shapes. Most experienced artists can usually arrange their subjects to suit whatever design or format they have in mind. Even so, I always have a nagging thought that, just as Michelangelo believed there was a figure within the stone waiting to be released, so too is there an "ideal" composition within each

I begin with a quick preliminary compositional sketch (above), then I try to relate those natural forms to cube shapes (below) to help me visualize their volumes in the composition.

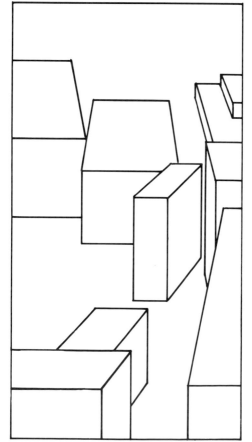

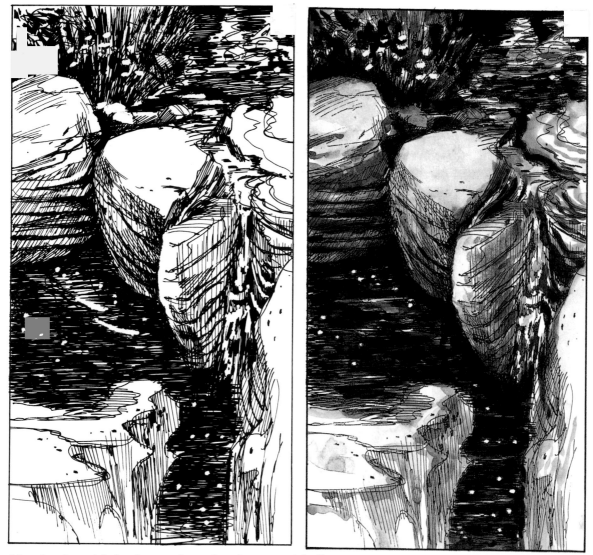

Next, I make an ink sketch to work out the values . . . and finally, a color study for *Sierra Brook*.

subject for me to discover. A romantic notion to be sure, but painting nature's landscapes *is*, after all, a romantic endeavor.

If I decide to carry on, I begin with a composition that is simple in its first structures, perhaps establishing a direction that is unified with repeated, similar angles. I carefully analyze every feature of the subject—its form, lighting and color. At this stage, I'm more interested in whether I understand the composition than whether viewers will; in fact, my first quick sketch is often a form of shorthand that makes sense only to me.

As I progress to a more concrete sketch, I attempt to translate the unfamiliar into more familiar terms. For example, one of the ways I do this is by visualizing natural forms and relating those forms to cubelike structures. In other words, I try to communicate the shapes by creating forms that have sides, tops, bottoms, fronts and backs because I want to visualize how they work as volumes within the com-

position. In *Sierra Brook*, for example, I mentally broke the various volumes into cubes, as shown at left. Naturally, I don't actually make formal diagrams, but these cubes will give you an idea of what I visualize so that I better understand the volumes in a composition.

This may seem like a needless concept, but after many years of teaching drawing, I've concluded that if an artist doesn't understand and have the ability to draw a cube in various positions in space, he or she will almost certainly have difficulty drawing from nature.

Once I've completed my rough compositional sketch and have mentally analyzed the volumes in the scene, I draw a more finished pen-and-ink sketch to finalize the design and work out the arrangement of values. At this time, I often spend another hour or so completing one or more small, loosely rendered color studies to test various color relationships and to determine the best colors to convey the mood I have in mind for each subject.

The Painting Process

When I return to my studio, I lightly draw the scene full-size onto stretched watercolor paper, using a no. 2 graphite pencil. Since too much graphite on the paper might "dirty" the first washes of color, I don't indicate dark values with a lot of graphite. Instead, as I work, I refer to my ink drawing (see previous page), which serves as a value plan and "sets" the course of the design.

I begin with several washes in the background to achieve a sense of depth or dimension at an early stage. Because I'm not trying to convey the illusion of recession into deep space, the colors don't have to be overly cool. I do, however, use various blues such as Prussian blue mixed with burnt sienna for the shadows, and cerulean blue here and there, to keep the area relatively cool. Most of the work in this area is completed with a no. 12 round brush.

Next I apply color to the rock forms and the water area that falls between the rocks. My first concern is to break the rocks into two values so the light and dark will convey the illusion of volume. It's important for me to establish this graphic volume before I begin developing the more subtle qualities, such as the weathered look of the rocks, spattering to suggest texture, and light glazes to suggest the sun's rays.

Having established the basic illusion of volume and depth, I proceed to paint the main body of water below the rocks in a dark blue with warm areas of burnt sienna and cadmium orange, suggesting the rocks below the water's surface. I allow the dark color of various blues, such as French ultramarine or Prussian blue mixed with burnt sienna, to dry, and then use wet facial tissues to lift color out of the water area to suggest light and movement. Over some of these "lifted" areas, I float cerulean blue while they are still damp and continue to use tissues to soften edges.

Later I go back into previously painted areas to add more detail and, in some cases, more color, such as cerulean blue (in the upper area). I use the wet-tissue lift method in a number of areas, especially in the upper grass area when it becomes too dark and uninteresting. I also use some salt to create the texture in the lower foreground rocks.

Compositionally, this painting borders on the abstract. In fact, I took liberties with some of the natural forms to create a better design—the narrow format, for example, creates a potential for conflict that I feel adds to the overall sense of movement. For me, *Sierra Brook* succeeds at two levels: First, it is built on a sound abstract design, and second, it captures "the sense of place" that attracted me to this location in the beginning.

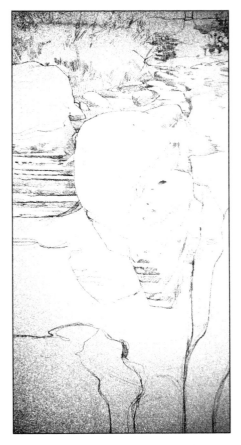

STEP 1. With a graphite pencil, I lightly draw the scene, full-size, onto my watercolor paper.

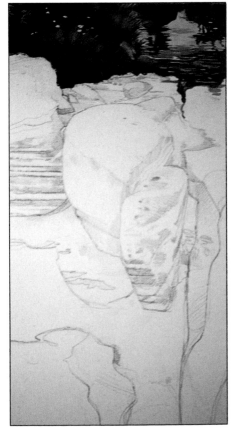

STEP 2. I begin with several background washes of various blues to establish a sense of depth.

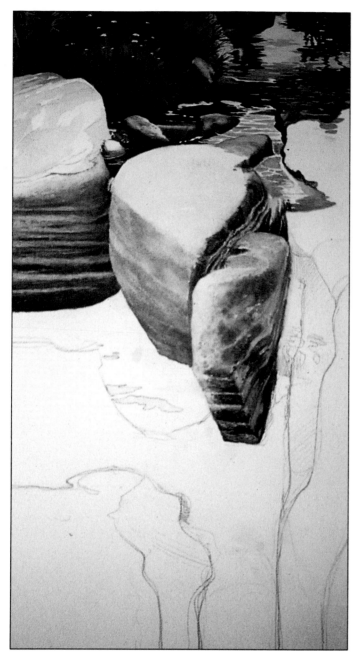
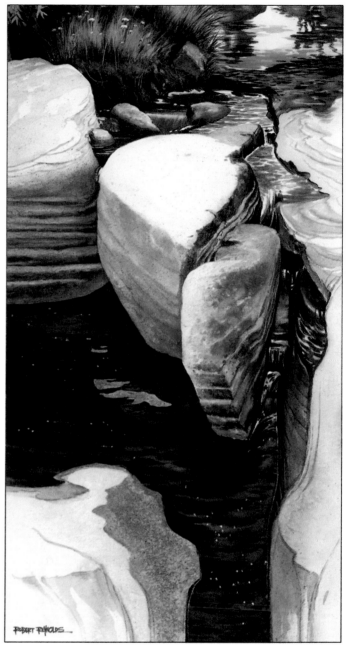

STEP 3. Next I create contrasting values in the rocks to convey the illusion of volume.

Sierra Brook, 38″ × 20″, Collection of the artist

DEMONSTRATION TWO
Summer Wind Patterns

When I came upon this scene at Silver Lake in the High Sierra, I was struck by how beautiful the long, clean, blue lines of the lake looked next to the yellow catamaran. A less narrow composition probably would have worked, but I wanted to exaggerate the long, horizontal pictorial elements in the composition, and the best way to do that was to use a long, narrow format. The boat serves the design well because it provides a counterangle of opposition that complements the horizontal elements behind it.

Planning the Design/Composition

Once I've completed my preliminary compositional sketch in pencil, I proceed directly to my ink sketch. The ink sketch clarifies my thinking and "sets" the image.

Several design principles are used in this composition. For example, the repetition of similar directions and angles throughout the composition aids unity. Opposing angles, such as the boat's mast and the angles of the foreground rocks, provide a counter to the repeated horizontal elements of the composition (and create variety). The sunlight that highlights the horizon of the lake and the edges of the various forms provides emphasis to create interest. Overlapping forms and a warm-to-cool color progression aid the illusion of depth; the detailed foreground contrasts with the distant mountains (which have very little detail) to convey the three-dimensional illusion of distance. A full range of values adds believability; sharp highlights characteristic of the morning sun add "snap" to the image.

A preliminary compositional sketch in pencil helps me plan my values for *Summer Wind Patterns*, and an ink sketch clarifies my thinking and sets the image.

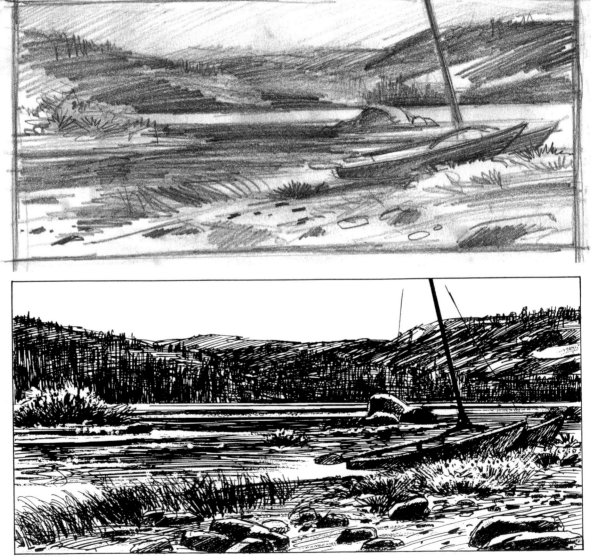

In this quick color rough (which I don't do for every painting), I had the opportunity to see how my color scheme could work without spending hours on the result. My intention was to keep the foreground light and warm, and the middle ground (water and mountains) in a cool, middle to dark value, so I could capitalize on the sharp highlights that sparkled throughout the scene. I kept the sky light to maintain the feeling that it was filled with sunlight, falling from left to right.

The highlights on the lake were created by wind patterns (hence the name of the painting). Basically, the water's surface was being "tipped" by the wind, which shifted the plane of the water's surface so that parts of it reflected the sky, while the areas unmoved by the wind reflected the mountains.

The Painting Process

With my design preliminaries completed, I returned to my studio and transferred the drawing onto a 22" × 39" sheet of watercolor paper. Along the edge of the lake's horizon, I laid down a strip of masking tape to keep the edge of the water next to the background mountains sharp and straight.

As usual, I began with the sky, carefully painting to establish a horizontal gradation—i.e., making the left side warm and gradually shifting to cooler hues on the right, away from the sun. Next I painted the background mountains using a "lost-and-found" method. Then rather than painting forests of individual trees, I blocked in the color as a mass and suggested individual trees along its edge. Other trees were suggested as silhouettes at the tops of the mountains.

I used various blues, such as cobalt and French ultramarine, to paint much of the mountain area, adding alizarin crimson where necessary to give the blues a purple cast. Unwanted edges were softened with the tissue-lift method, and shapes that had become too dark or lacked interest were lightened or modulated using the same technique.

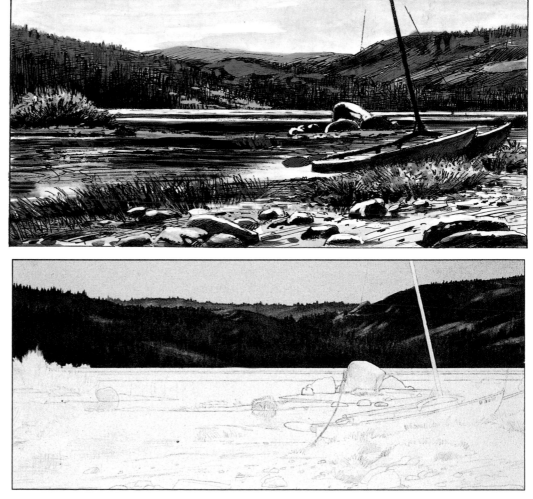

In this color study of *Summer Wind Patterns*, I can see if my color scheme is going to work before I begin my full-size painting.

STEP 1. After transferring the drawing onto my watercolor paper, I begin with the sky, keeping the values light, and then convey the background mountains in contrasting, darker values.

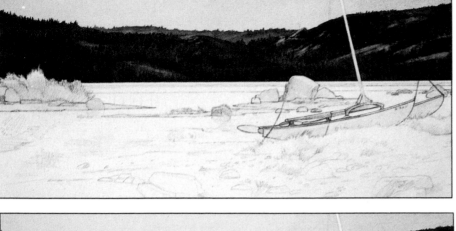

STEP 2. Masking fluid applied to key areas allows me to more easily paint the lake.

STEP 3. The lake colors are made up of Prussian blue and cerulean blue, plus a little cadmium yellow for the blue-green reflections of the trees.

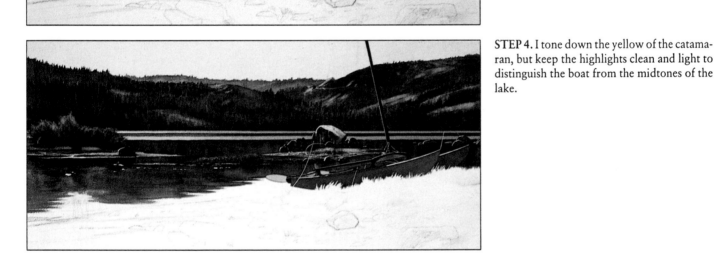

STEP 4. I tone down the yellow of the catamaran, but keep the highlights clean and light to distinguish the boat from the midtones of the lake.

At this stage, I applied liquid masking fluid to key areas so I could paint the lake without being concerned about saving the lights on the objects that fall across it.

I painted the lake using Prussian blue and cerulean blue and, for the darker areas, a bit of burnt sienna. In the reflective areas, I added a little cadmium yellow pale and cadmium yellow to turn the blues to a blue-green to convey the tree colors above the lake. Then I removed the masking from the grassy and rocky areas and carefully painted them in. I used no. 12 and no. 10 round brushes for this area—in fact, most of the painting was executed with these brushes.

Painting the catamaran was tricky. Without the highlights the boat would have been lost in the middle tones of the lake. My intention was to paint it yellow, but I wanted the color to remain rich because most of the boat's shapes were in shadow. So after diminishing the value and intensity of the yellow with its complement (purple), I added cadmium orange to the mixture to achieve the richness that I wanted.

I minimized the lines (ropes) on the boat because they can become utter disasters if painted too consistently dark or if the shapes are unintentionally widened. Keeping highlighted areas clean and light was the secret to painting this boat.

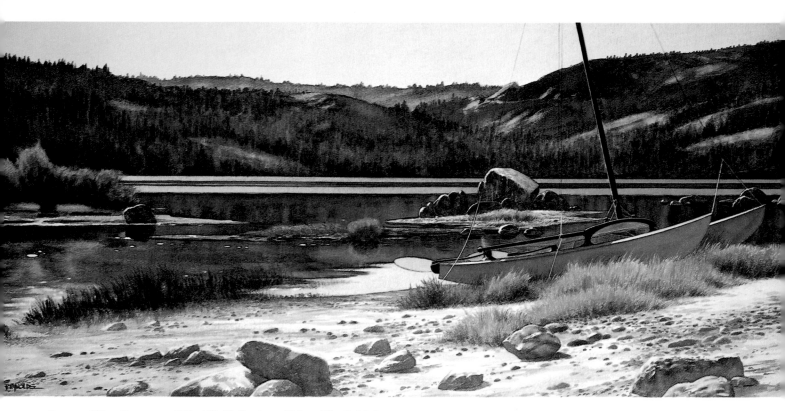

SUMMER WIND PATTERNS, 22″ × 39″, Collection of Mary Alice Baldwin

The foreground had to be light; otherwise, it wouldn't have contrasted with the dark areas in the water. The foreground rocks provided interest and variety, and on closer observation, you'll see that many of them also repeated the angle of the boat, providing a similarity that adds unity. Scale changes in the foreground rocks created variety.

After allowing the painting to sit for a few days, I made several minor changes where I felt that (1) edges were too sharp, (2) an area was too bright or too dull, (3) an area needed accents, and (4) an area was too detailed or not detailed enough. In general, these were minor adjustments; my first and main objective was to make sure the broad shapes and colors were successful.

PART III
MOOD AND SPIRIT OF PLACE

All great art is the work of the whole living creature,
body and soul, and chiefly of the soul.
JOHN RUSKIN

To be truly successful, a painting must succeed at three levels—that is, it must demonstrate (1) solid technical execution, (2) sound design and composition, and (3) a unique and personal artistic vision. This last characteristic, often called the "mood" of a painting, is a somewhat elusive concept. Clearly, "mood" is what makes the *Mona Lisa* different from a thousand other portraits, and it's what makes Monet's *Waterlilies* more than simply another bucolic painting of a country pond.

Obviously, most of us know mood when we see it, but how do we get beyond merely achieving a faithful likeness and begin creating a more personal vision of our subject? Actually, there are many ways.

In Part I, for example, Robert Reynolds described the materials he uses and how he handles them. On the surface, these might appear to be wholly impersonal and purely technical processes—descriptions of tools and materials arranged into logical steps that anyone should be able to repeat to produce similar results. To a degree that's true, but Reynolds also pointed out that many of these techniques have another dimension, one that is immensely more personal. Take sketching a scene, for example. For Reynolds, it serves *two* purposes: First, it allows him to record key details and design relationships; second, it helps him become sensitized to the subject—helps him immerse himself in its essence until he can paint not only its literal reality but also its mood or sense of place. Or to put it another way, Reynolds sketches not simply to see his subject but also to feel it.

In Part II Reynolds described the Elements and Principles of Design and told us how he uses them to analyze a scene to create an orderly design and composition. For those in search of absolutes, these Elements and Principles might seem as definite and conclusive as the Law of Gravity (what goes up must come down), but they too have another, more personal, dimension. For example, do you remember Reynolds's comments about the design elements of line and texture and the principle of unity? "Expressive use of line," he said, "is much more than a way of recording and ordering subject matter; it is also a means of expressing the intangible—a thought, an idea or a mood." Texture, he said, "is often the telltale fingerprint of an artist." Still later in Part II when discussing unity, he concluded, "a painting's success often depends as much on intuition as it does on intellect."

Acknowledging the existence of this "second dimension" in no way diminishes the importance of mastering basic skills and principles, but it does suggest that just as a compass needle is drawn by invisible magnetic forces toward true north, so too must these seemingly impersonal techniques and rules inevitably be affected by each artist's feeling or mood. Alas, there are no rules to tell us how to

make mood. That uncharted land lies waiting for each artist to discover on his or her own. At best, we can only do what Christopher Columbus must have done when he went in search of the New World—study the experiences and observations of our predecessors and contemporaries to make certain that when we set sail, we are at least pointed in the right direction.

With that in mind, in Part III Reynolds charts a brief philosophical "map," identifying key landmarks he uses to guide him through the somewhat inscrutable realm of mood. Thereafter, he describes several techniques (such as using light and exploring variations in similar subject matter) that will help you get in touch with the mood you're trying to express. Finally, in a series of demonstration sequences, he allows us to look over his shoulder and be privy to his thoughts as he brings together his knowledge of materials and techniques and design and composition to capture mood in each of six different subjects.

As you set out on this final leg of our artistic journey together, keep in mind that in art there are few absolutes. Success is relative and highly subjective. The search for mood is, in reality, a search for ourselves—an effort to learn to paint the landscapes we "see" with our hearts with as much certainty as those we see with our eyes.

—Patrick Seslar

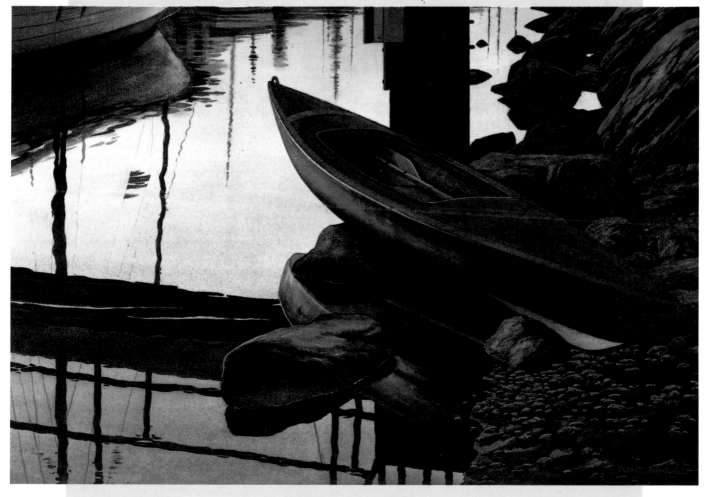

Low Tide at Dusk, 25" × 39"

*Whenever we go in the mountains, or indeed, in any of God's
wild fields, we find more than we seek.*

JOHN MUIR

Though written over one hundred years ago, Muir's observation remains an apt description of the essential relationship between artists and nature. It suggests that although it is the raw beauty of nature that attracts us initially, there is much more to painting than merely producing credible likenesses of surface imagery. Ideally, as representational artists, we should strive to infuse the literal reality of what we see with the far richer reality of what we feel—the mood or spirit of the place. When we succeed at this, the result will always be far stronger and more telling than the most technically perfect, but otherwise impersonal, rendering of the "facts" of the scene.

For me, the quest for mood begins with a personal philosophy that has helped me define and understand my own innate reverence and respect for the natural landscape. To supplement my philosophy, I've also studied the work of successful artists of the past and present to see how they went or go about conveying mood in their paintings. My own painting style—the visual language I use to express mood in my watercolors—is the result of those two influences. Your philosophy will undoubtedly differ in certain key respects from mine, as will your way of expressing mood in your paintings. Nevertheless, here is a brief glimpse into the forces that have shaped my work—perhaps, in some way, they will help you shape yours.

A Personal Philosophy

Nature provides a constant source of creative inspiration, but to capture its spiritual essence, artists must first discover their own emotional connection to it. As we try, through

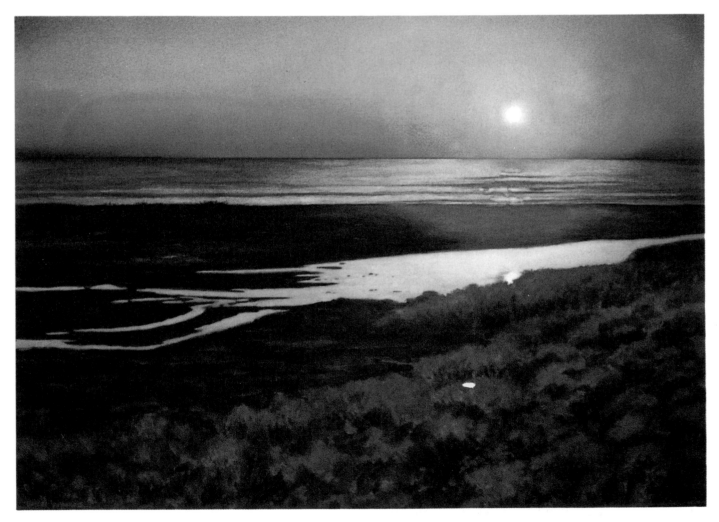

MOONSTONE GOLD, 22" × 30"

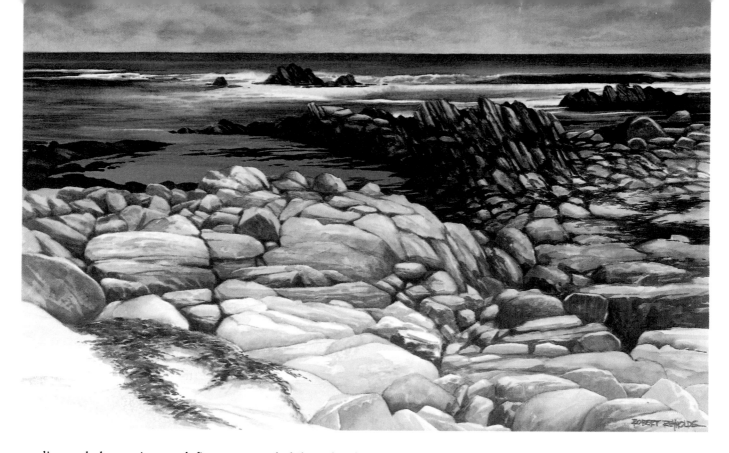

PACIFIC BLUE, 22″ × 30″, Collection of Elizabeth Zeverly

reading and observation, to define a personal philosophical basis for our paintings, it's only natural to look to other artists' work. This is a healthy part of the process of artistic growth, provided we look beyond the obvious and realize that what attracts us to a particular artist's work usually isn't his or her choice of subjects or painting techniques but rather the work's spiritual quality—that special something that grows out of each artist's intimate personal involvement with and sincere feeling for the subject.

Quite frankly, although I spent much of my early career learning to create interesting pictorial arrangements and still consider it an important skill, in the last ten years I've developed a new awareness and attitude toward my art. I've realized that a subject that holds no meaning can all too easily become little more than an exercise in "picture making," something that conveys little feeling or sincerity and certainly shows no commitment. I've also realized that each subject does, indeed, have a life of its own that extends far beyond its physical appearance, that each rock and tree is symbolic of something larger than itself, that each connects to a range of shared human experiences, and that each is host to intimately personal thoughts and associations.

I've learned that by consciously attempting to paint subjects with a definite meaning or relationship to my own life, my art gains a new richness and emotional dimension. I don't mean to suggest that you or I should go about mindlessly copying everything in front of us, but viewed from this perspective, anything or any place *can* be a suitable subject, provided we express our genuine feelings for it through our paintings.

I've painted at many other locations along California's central coast for years, but somehow the color of the water here seems different than elsewhere, and the rock formations seem to have a character uniquely their own. Although I carefully considered the design of this image during the preliminary stages, this painting ultimately became a very personal expression of my mood and feelings about an area near Monterey, California, that's very special to me—a place I go when I need to be refreshed and renewed.

On the day I painted *Pacific Blue*, I was attracted by the way the rocks and seaweed lay exposed by the outgoing tide. Clouds partially blocked the sun, creating interesting and dramatic patches of light on the landscape and water below. The rustlike color of the rocks and seaweed provided a beautiful contrast to the pink and gray of the dry rocks above the tide line.

To capture the lush color of the water, I mixed Prussian blue, cerulean blue and a touch of alizarin crimson, which I countered with burnt sienna to keep the color dark and rich and to provide a strong contrast against the light foreground rocks.

Lessons From the Past

There are probably as many ways to express mood in paintings as there are artists, but one of the best ways to do that is by applying the elements and principles of design described in Part II. As with other intangible phenomena, there are, of course, no hard and fast rules telling how to use the Elements and Principles of Design in a way that automatically and predictably conveys a certain drama. Nevertheless, throughout history successful artists have returned again and again to certain dramatic devices to express the spiritual qualities or moods of their subjects.

The following list is hardly exhaustive, but it should provide you with a quick overview of several useful techniques for expressing mood in your watercolors. In each case, the resulting drama can be subtle or grand, depending on exactly how these dramatic devices are used.

POINT OF VIEW. Where you place the horizon as well as how close to the "action" you make your viewers feel contributes to the drama of the subject and serves as an effective tool

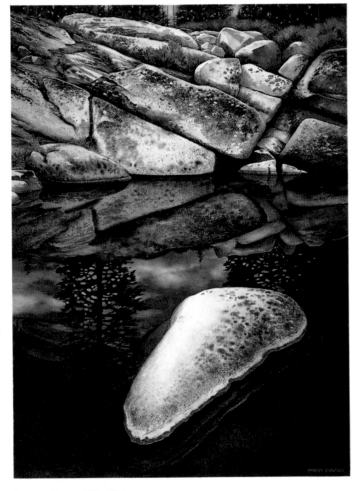

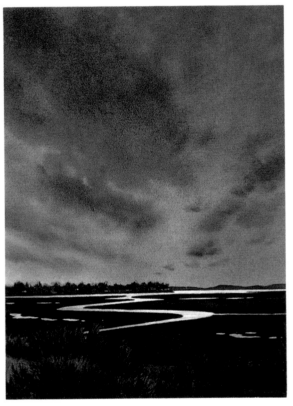

TWILIGHT, 20" × 14"

As evening approaches and meandering courses of water reflect the setting sun, much of the landscape becomes dark. In *Twilight* the low horizon and dramatic expanse of sky and clouds creates an ethereal and rather spiritual mood, seeming to hover ever so lightly above the narrow foundation of the dark landscape below.

INDIAN POOL, 39" × 25"

A close-up point of view can create a mood of intimacy between subject and viewer. In *Indian Pool*, for example, I deliberately planned the composition so the viewer would be in an intimate relationship with the subject, as though with only a little effort the viewer could reach out and touch it. In *Efflorescence*, which appears earlier in the book on page 50, I went a step further: I coupled an extreme close-up view with a large format (37" × 25") in the hope of offering viewers a new perspective on an object so common in the Sierra that it's easily taken for granted—an ordinary pinecone.

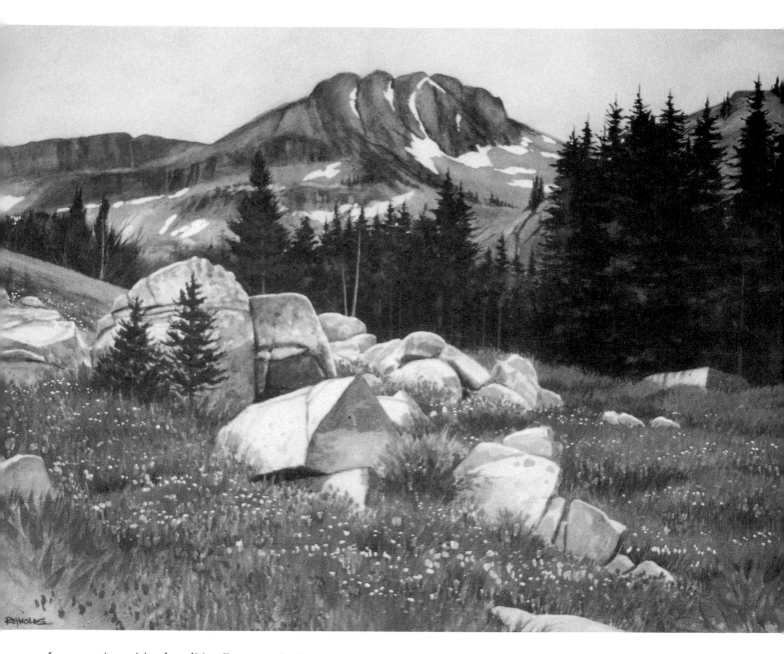

for conveying spiritual qualities. For centuries American artists such as George Inness (1825-1894) and British artists such as John Constable (1776-1837) and J.M.W. Turner (1775-1851) have realized that a low horizon emphasizing a large, dramatic sky could be used to convey a mysterious, spiritual feeling. By contrast, many artists from the Hudson River School, such as Asher Brown Durand and Thomas Cole, chose high points of view overlooking valleys and canyons to achieve similarly dramatic results. By studying the paintings of these artists and others, you'll soon get a feel for the dramatic potential of compositions built around high- or low-horizon points of view; and at the same time, you'll develop an understanding and appreciation for the history of landscape painting.

ROUND TOP, 22″ × 30″, Collection of Mr. and Mrs. Jack Martinelli
I've painted along this trail to "Round Top" many times. A high horizon seemed a natural solution because the trail is climbing at this point, and I wanted to give the viewer the feeling that the mountain is still some distance away. I also wanted to highlight the spring flowers in the foreground and thus needed a generous area to provide for it. You might also want to turn back to page 91 for a look at another treatment of the same subject.

SCALE. A low or high horizon immediately creates a feeling of vastness, suggesting great contrasts in scale, both in the physical size of objects and in the illusion of three-dimensional space. Though their paintings may be overly dramatic by today's standards, it is nevertheless enlightening to study the works of artists like Albert Bierstadt (1830-1902) and Frederick Church (1826-1900). They were masters of this concept and used it in many of their works to create a mood of reverence, fear or mystery through spectacularly dramatic contrasts of scale and luminous "atmosphere." When confronted by one of Bierstadt's or Church's canvases, which are often quite large, viewers can scarcely avoid sensing how small the artist felt in relation to the powerful elements of the great outdoors.

Study how Bierstadt, Church and other artists used contrasts of scale to create mood in their paintings, and you're almost certain to get a few new ideas of how the literal "facts" of a scene can be altered in paintings to show viewers not only what you saw but, more importantly, what you felt.

SKIES. A luminous sky quickly sets the mood for everything else in a painting. J.M.W. Turner, one of the most influential and prolific artists of his time, was well known for the moody and often turbulent skies that appeared in his paintings. As he and many of his British contemporaries obviously knew, when clouds partially block the sun, the resulting scene can be translated into wonderful and mysterious design elements, refracting the sun's rays into beautiful shapes, while casting shadows onto the land below (to create still more interesting shapes, provocative highlights and dramatic value contrasts).

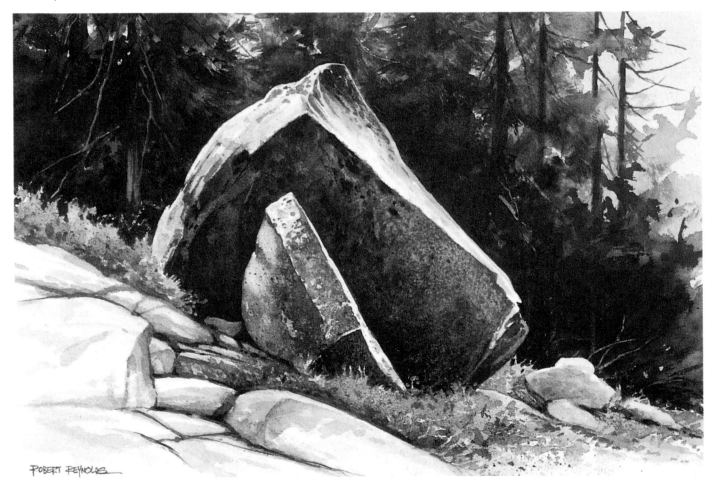

GRANITE SPLENDOR, 22″ × 30″, Private collection

Contrasts in scale are an effective tool for focusing on a dynamic foreground while dramatically separating it from the background. In *Granite Splendor*, for example, I designed the composition to emphasize the physical size and weight of the massive boulders in the foreground by allowing their shapes to literally dwarf the background trees.

If you haven't yet had the pleasure of studying Turner's paintings, I urge you to do so at your earliest opportunity. No doubt, you'll soon discover why so many contemporary artists choose to explore the expressive potential in the colors of morning, as the landscape gradually makes its transition from the cool shadows of darkness to the warmth of day, or in the colors of early evening, as the last rays of warm sunlight give way to the cooler light of approaching night.

In my own paintings, I compose a sky with many clouds by approaching it from a design standpoint—i.e., as one larger shape (the sky) within which a number of smaller shapes (clouds) must work together to function as a complete and unified statement. Naturally, other Elements and Principles of Design, such as color, value and gradation have to be considered as well. Even so, the exact "mix," or balance, between these elements is highly personal and intuitive, and as a result, skies are usually one of the more challenging areas for me. Curiously, my most successful skies appear to be the ones that viewers don't see at first glance because, rather than screaming for attention, they function as background and as an integral part of the total image.

Dramatic skies must be used with discretion to avoid becoming overblown or trite, but they remain one of the most effective tools for creating mood in landscape paintings.

LIGHT AND COLOR. In many ways, light is color and, as such, is a tremendously flexible tool for creating a particular mood or feeling. In fact, light in all its forms (direct, reflected or absent via cast shadows) may be the single most important tool available to artists for imparting mood or a spiritual feeling in paintings. Contrasts between light and shade create dramatic visual effects that heighten suspense, while cast shadows often provide movement and direction.

As Monet's pioneering work illustrates, even when working with the same subject, changes in lighting from hour to hour and, sometimes even from moment to moment, are sufficient to produce a variety of different and intriguing paintings. Monet's *Haystack* series, for example, is ample evidence of just how carefully he observed and recorded the varied effects of light at different times of day and under changing weather conditions. For Monet these first studies of the effects of light proved to be the catalyst that eventually resulted in several exquisite series of paintings with changing light as their theme, such as those of the Rouen Cathedral, the Poplar Trees, and the Japanese Bridge arching so gracefully over Monet's beloved water lily pond.

I give Monet's paintings credit for inspiring me to return to locations where I'd worked previously and allowing me to literally "see them in a different light"—by painting at other

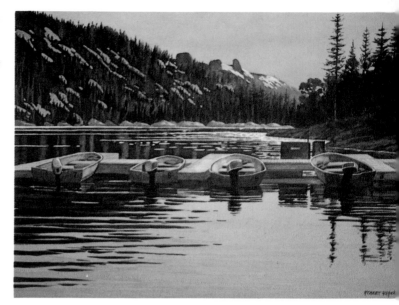

DUSK AT CAPLES, 22″ × 30″,
Collection of Robert and Lynn Schweissinger

Light takes on a spiritual quality when used in a manner that suggests mystery. This is especially true when it is used in uplifting, dramatic arrangements, achieved through careful planning and arranging of values. Obviously, the effect of brilliant light won't be credible unless darker values are placed nearby to surround and direct the source of light. Also, elements that are within the light must reflect its effects, usually through changes in value and color. For example, a general misconception is that elements such as trees or mountains that appear in front of a strong light source (such as a setting or rising sun) will become sharpedged and almost black in value. In reality those shapes usually become lighter in value, and their edges become softer and more colorful.

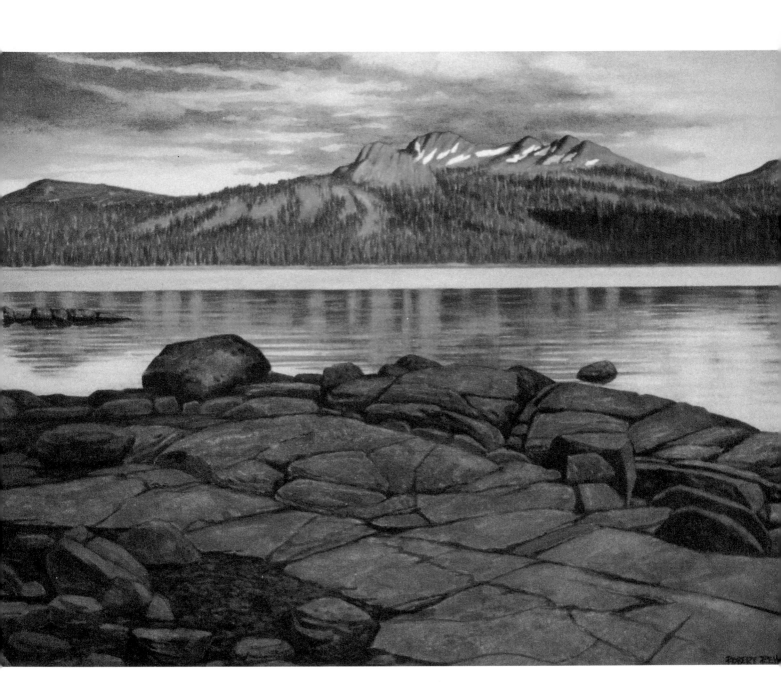

CAPLES LAKE, 22″ × 30, Collection of C. McAdams

times of day or under different lighting conditions. Earlier in my career, I probably wouldn't have found this exercise particularly attractive, but for the past ten years, much of my work has focused on light and its effects on the natural landscape; in many ways, my fascination with light has helped me become more sensitive to and adept at capturing the nuance of mood through subtle variations of light and color.

Light is one of the best visual tools available to artists for graphically expressing an emotion that conveys drama, romance, mystery, and hopefully, spirituality. It can be used as a visual symbol in almost limitless ways; history has shown that experimentation will assuredly produce still more innovative approaches in its use in the future.

I've painted at Caples Lake on numerous occasions and at many different times of day. On this day, I was taken with the contrast between the cool foreground and the warm background, a situation that reversed the normal warm-to-cool convention of color recession—proving once again that there are always exceptions to rules, which is why "rules" should serve only as guidelines. In this version, I placed the viewer in the foreground shadows so that I could focus attention on the sun-warmed mountains across the lake. This, incidentally, is another example of the "alpenglow" described on page 120.

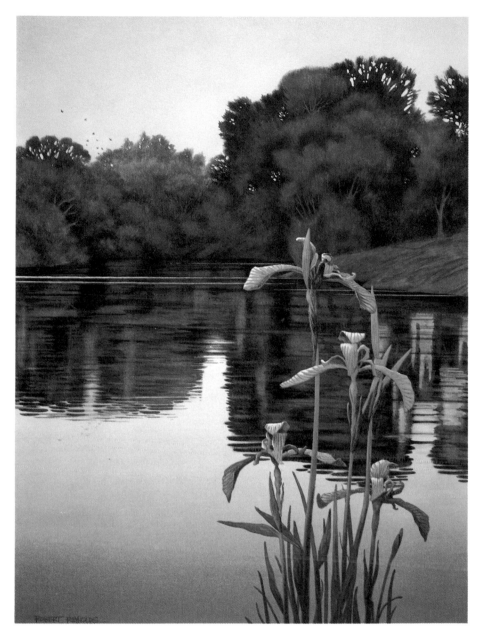

Exploring Variations in Similar Subject Matter

My subjects are usually drawn from the High Sierra or the central coast of California — areas with which I'm intimately familiar and which have a special meaning for me. Like Monet, I've returned again and again to many of the same locations to paint under different weather and lighting conditions and I never worry about repeating subjects because there is always something new to be said about a scene if only you look hard enough.

Exploring variations in similar subject matter is an excellent way to challenge your visual and artistic senses to see and express the mood of a scene more clearly. In my *Symphony Suite* series on the following pages, I've used essentially the same scene and basic composition to explore the effects of variations in light and color as well as smaller design elements (the boat, grasses, egret and so on). Each of the resulting paintings has a subtly different mood. In addition to those versions, *Symphony Suite: Interlude* (pictured here) offers another interpretation. Each of the paintings in this series was done with many overlapping, graduated color washes, which I applied with a wide hake brush.

The next time you paint one of your favorite subjects, why not try creating several different versions that express variations of color and mood? You'll be surprised at what emerges!

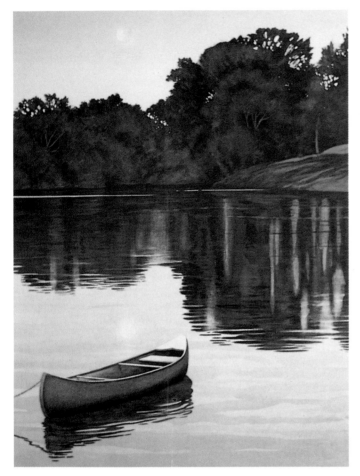

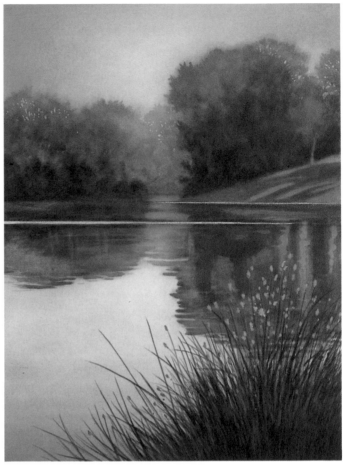

SYMPHONY SUITE: FULL MOON, 35″ × 24″
Collection of Elizabeth Rochefort

Full Moon captures the faint image of the full moon during late day-light hours. In this version, the canoe serves as a gentle reminder that people have been or will be here. I was initially attracted to this scene by the interesting shapes; afterward, I experimented with various color schemes.

SYMPHONY SUITE: GOLDEN LIGHT, 35″ × 24″
Collection of J.M. Biddle

In *Golden Light* the warm colors of early morning result in a completely different color scheme and a very different feeling.

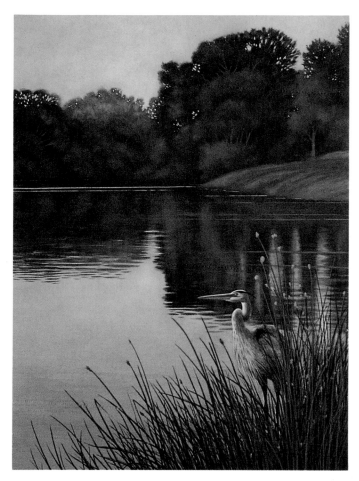

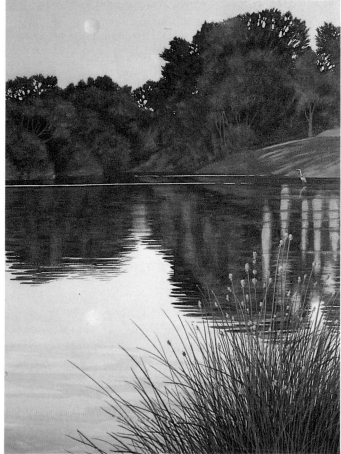

SYMPHONY SUITE: BLUE HERON, 35″ × 24″
Collection of Elizabeth Rochefort

A Great Blue Heron was my frequent companion on this lake, and though he never allowed me to get within a hundred feet of him, he seemed to study me as closely as I studied him. In this version, the lighting and color is again a bit different as the setting sun strikes the treetops.

SYMPHONY SUITE: INDIAN SUMMER, 35″ × 24″
Collection of Mr. and Mrs. Richard Equinoa

In this version, I returned to the theme of the full moon reflecting on the water, but with different elements. Without the foreground canoe, the mood is even more tranquil and the eye is directed by other foreground subjects, such as the vegetation that reaches up into the painting.

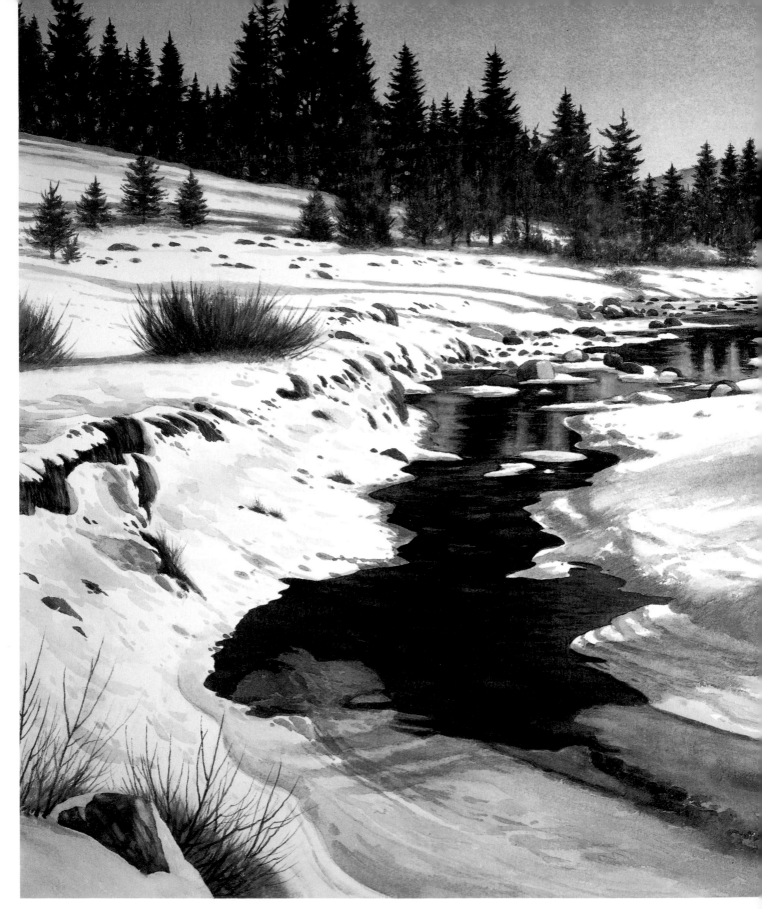

FIRST SNOW/HOPE VALLEY, 25″ × 39″, Collection of Mr. and Mrs.
Ronald T. Morck

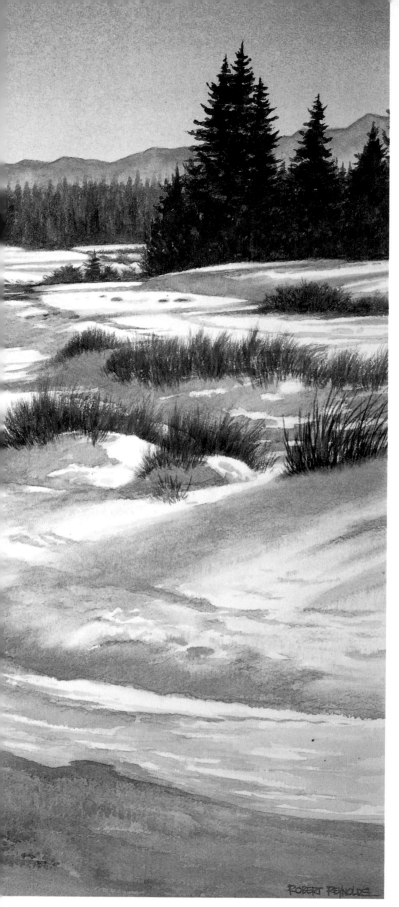

ROBERT REYNOLDS

DEMONSTRATION ONE
First Snow/Hope Valley

MOOD/CONCEPT. I came across this scene only a day after the first snow of the season had fallen. I was immediately struck by the quiet loneliness of the landscape divided by the dark, winding river, which seemed to come from nowhere as it carried away the melting runoff. Except for the sound of moving water, everything was still; no living creature stirred in or near the area. In spite of the cold, the sun warmed the scene and cast long shadows that defined the icy surfaces. Warm vegetation reached above snow covered ground that did not yet seem prepared for the onset of winter. The scene had a dramatic, mystical appearance that left me with a feeling of deep solitude.

The exact feelings that move me to create a particular painting are sometimes difficult to recall and describe—most often, they're the result of an almost intuitive response based on a lifetime of experiences and influences. For example, I've always been intrigued by dark, directional patterns that move across white or light surfaces. In this case, I saw the potential for a painting built around the pattern of interesting shapes and divisions of space created by the river and the surrounding crevices of the landscape, but it was the sheer solitude I felt the instant I came upon it that motivated me to capture this image.

Designing this composition created a problem: The river moved down through the middle of the composition, eventually turning toward the lower right corner of the rectangle. To counter this, I made sure that as the river approached the corner, its values and colors diminished into an icy arrangement of close values. On the lower left side of the composition, I used overlapping forms to create a dimensional change that directed the viewer's eye into the painting; to add to this emphasis, I kept the strongest contrasts in the central area of the painting, away from the lower corners. Finally, by choosing a high horizon, I was able to define a number of cross-contours on the landscape to add interest and help create the illusion of space or distance as the river recedes into the painting.

In keeping with the quiet solitude of the scene, I decided to work with a limited palette. With the exception of the warmer vegetation, which I mixed from burnt sienna and cadmium orange, the main parts of the painting were painted with cool mixtures of cerulean blue, ultramarine blue, cobalt blue, Prussian blue and Payne's gray. The final washes were added using a warm, diluted mixture of cadmium yellow and cadmium orange, which I glazed over the white surfaces to achieve the illusion of sunlight striking the white snow.

STEP 1. As usual I began with the sky, which was painted with a series of graduated washes. To keep the distant horizon somewhat warm, I began with a pale graded wash of alizarin crimson, using a 2-inch hake brush. After it dried, I laid in a second graded wash using cerulean blue. Since the lower two-thirds of the painting would be rather complicated, I kept the sky subtle and unobtrusive.

Next I painted the distant mountains, keeping them high key and cool, using ultramarine blue with a touch of alizarin crimson and cerulean blue. Next I laid in the first of the trees to roughly establish a value range.

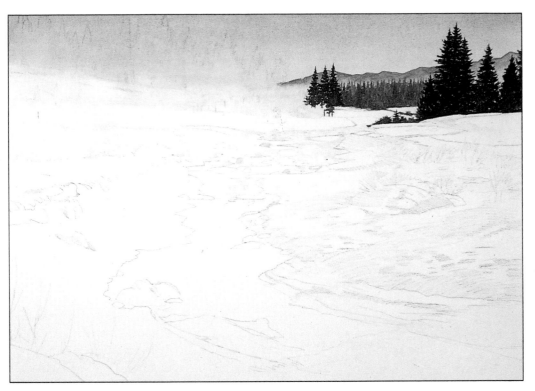

STEP 2. The tree shapes were painted with mixtures of burnt sienna, Prussian blue, ultramarine blue and a touch of cobalt blue. Cool shadows on the snow along the river's banks were painted with mixtures of cerulean blue, ultramarine blue and a slight touch of alizarin crimson. I also added some of the first warm colors of the vegetation, which would later be added to the middle and foreground, using mixtures of burnt sienna and cadmium orange. These initial colors gave me an idea of how the overall color scheme would look.

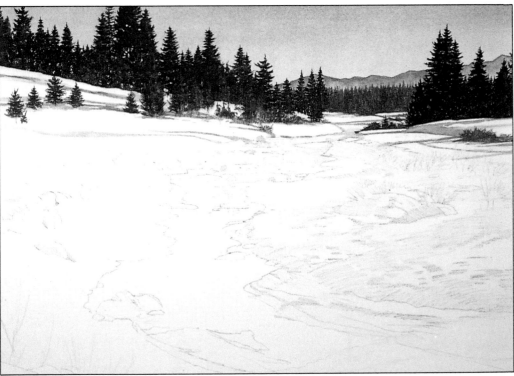

STEP 3. As I painted the icy river cutting through the snow, I tried to create interest and a believable sense of perspective by varying values, edges and shapes along the turning river. In painting the lights and darks in the water, I followed a basic rule concerning reflections—i.e., distant water reflects the low sky, while foreground water reflects the high overhead sky. I painted the dark river mostly with Prussian blue and burnt sienna, using a variety of round brushes along with damp tissues to lift color and model the reflections.

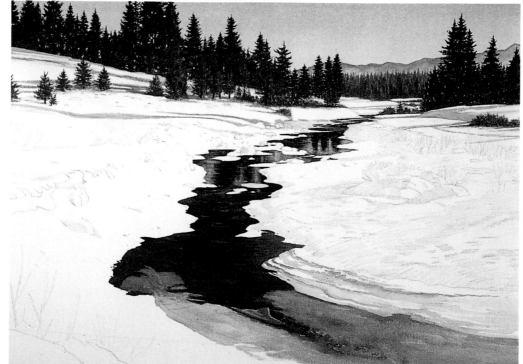

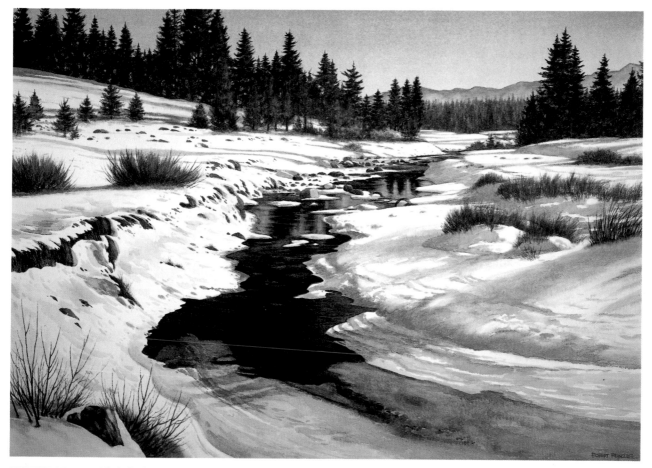

FINISH. Next I added shadows throughout the foreground area, using mixtures of cerulean blue, Payne's gray, ultramarine blue and alizarin crimson, which I once again applied with a no. 10 and no. 12 round brush. To complete the painting, I repeated the warm notes from the background in the exposed areas of stream bank and dried grasses, using burnt sienna and cadmium orange. In addition to keeping the painting from becoming tiresomely monochromatic, these warmer notes also helped assure that the solitary mood of the painting was warm and inviting, rather than cool and isolated.

Rock Pools

MOOD/CONCEPT. When dark shapes, such as trees, are reflected on the water of a stream or lake, portions of the water's bottom are often visible below the surface. In *Rock Pools*, the complicated interplay between the sky, the tree reflections, the water's surface and the riverbed provided a subject that was visually exciting and challenging to execute. At the same time, on another level, these same elements provided the basis for a wonderful abstract pattern and a rather mysterious mood. When considered in this way, *Rock Pools* is a metaphor for the painting process itself, the fact that the images we paint exist at three levels simultaneously: (1) obvious surface imagery and the technical mastery necessary to depict it, (2) design and compositional considerations, and (3) a personal expression of the artist's emotion, spirituality or mood.

Even as I write this, I can hear the soft trickle and gurgle of cool mountain water tracing its sinuous course over these rocks; I can smell the pure High Sierra air and the sweet fragrance of fir spilling from the surrounding trees. The quietness and beauty of this area are, to me, very spiritual, especially when I'm alone there. So despite the fact that the technical aspects of painting this scene are demanding, I try not to forget that it is its spiritual essence I'm trying to capture.

This scene, like the stream that runs through it, has provided me with a constant flow of new ideas and inspiration — perhaps that's why I've returned to it so often. I've painted several versions of it in spring, summer, fall and winter, using a variety of horizontal and vertical formats; each painting seems to elicit a new and different way of expressing not only what I see but also what I feel about the scene.

When I first found this hidden grouping of pools, it seemed to me that the rocks and surrounding area had an "antique" look. The patinas on the rocks, the result of time and constant wetness, formed interesting patterns and textures, which contrasted with the crisp, clean look of the reflection of the sky areas, and I felt it was important to convey that main contrast.

Since the sky won't be seen by the viewer, I usually feel free to redefine or manipulate the various shapes and patterns of the sky reflected in the water. This allows me to create a more effective abstract design and build a more natural movement through my composition. In this instance, I balanced the strong vertical sky reflections against the diagonal movement of the stream as it wended its way right and then left and receded into the spatial illusion.

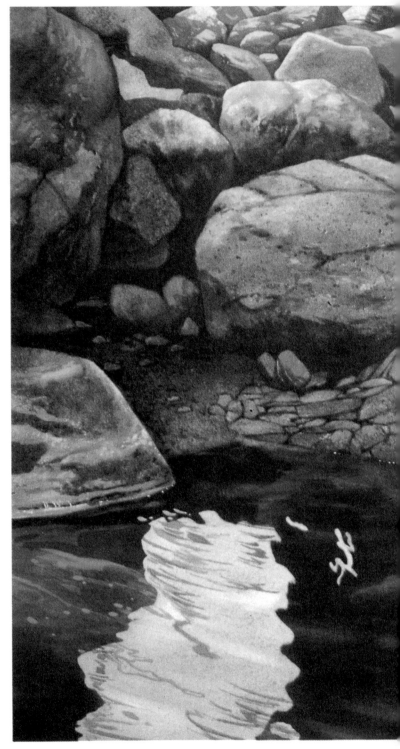

ROCK POOLS, 25" × 39", Collection of Mr. and Mrs. Clayton Neill

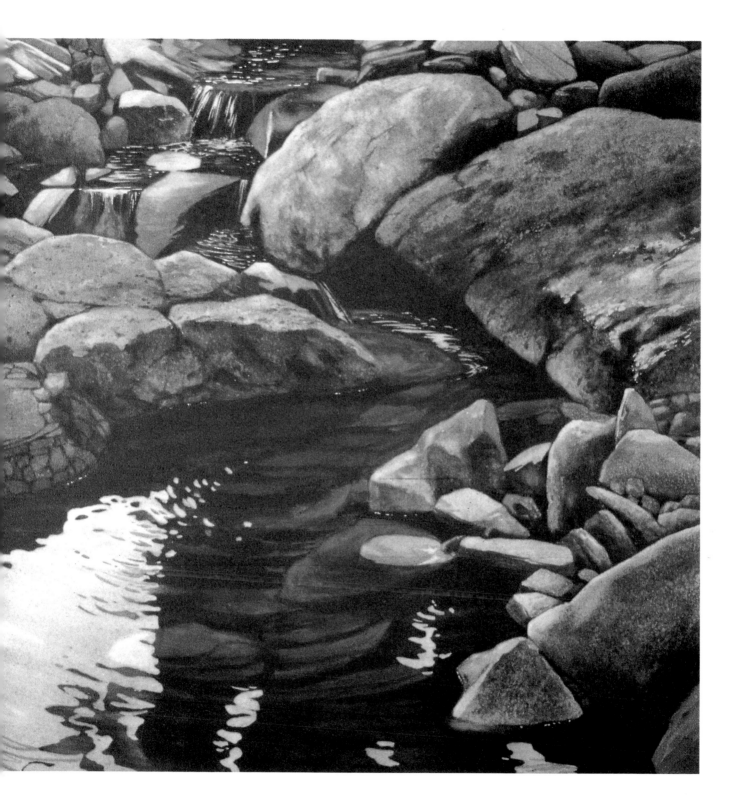

STEP 1. After lightly drawing the composition on a sheet of watercolor paper, I used liquid masking fluid to block out the edges of the rocks where they meet the water, as well as several patches of sky reflections (bottom left quadrant). By masking only those areas of the stream necessary to retain the whites and highlights of the water, I avoided blocking out the entire water shape. This allowed me to concentrate on the water and details without worrying about unintentionally painting over the rock areas or highlights.

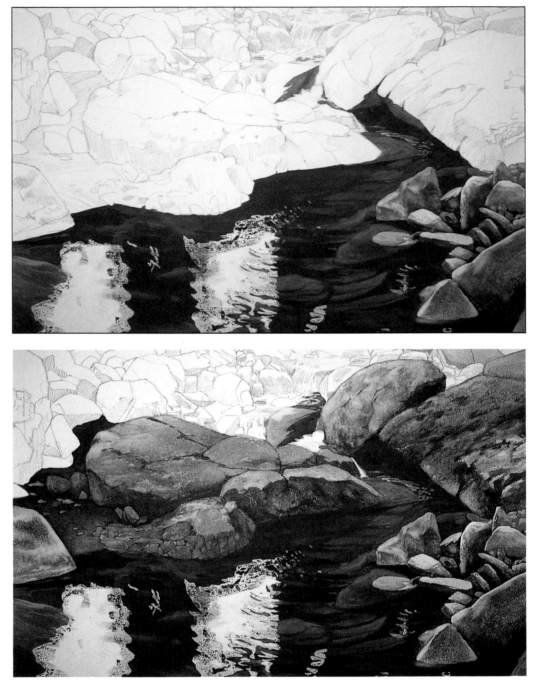

STEP 2. As I painted the rocks lying on the streambed (visible through the dark, reflected areas), I tried to keep their shapes close in value and color. Quite often in passages such as this, I use a dampened facial tissue to "mute" or soften the edges of any rocks or forms that are to appear below the water's surface. By contrast, rock shapes that appear above the water's surface can have more definite edge, value and color contrasts because they aren't blurred or distorted by the depth of the water and, of course, because stronger contrasts at or above the water's surface add "snap" and sparkle to the overall image.

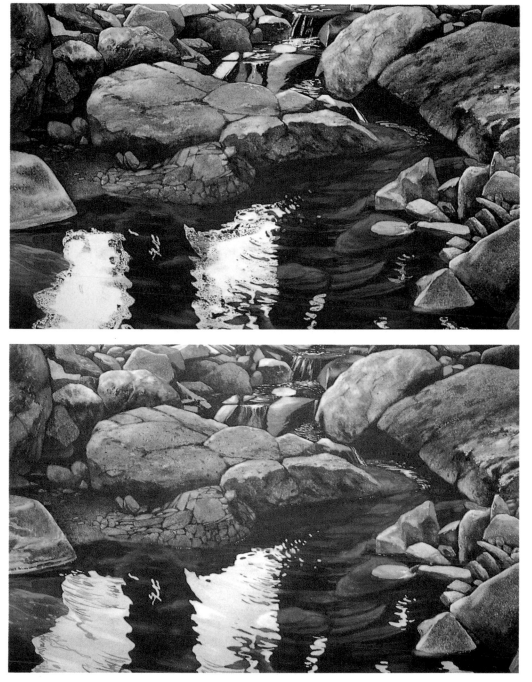

STEP 3. There are many similarities in color among the rocks, but there are also subtle and significant differences in the textures and patterns of the shapes that convey sunlight—if you lose the definition of light, you also lose the form of the object. To highlight these subtle differences between the rocks, I used a number of textural techniques such as salt, spattering with a toothbrush, lifting and glazing, along with thin washes of transparent colors that overlapped already dried colors I'd applied earlier.

Most of the brushwork at this stage and later was completed using my larger round brushes. Quite often I'll begin painting rocks using a warm color and then, as various stages develop, glaze over the warm colors with washes of cooler colors like cerulean blue, Payne's gray or ultramarine blue, all of which are sometimes mixed with alizarin crimson. Because of the intensity of Prussian blue and its tendency to turn green when mixed with burnt sienna, I seldom use it as a glaze over rocks.

FINISH. To complete the painting, I removed the masking from the foreground sky reflections and painted them with pale mixtures of cerulean blue and alizarin crimson. The bright contrasts of light blue enhanced what might otherwise have been a rather dark painting.

Take a moment to look over the rocks below the surface of the water. Although their arrangement might seem quite random and "natural" at first glance, in fact, I carefully designed their arrangement to fall into a circular pattern to help keep the viewer's eye "in" the painting while also supporting the circular pattern/design of the rocks above the water.

DEMONSTRATION THREE
Alpenglow

MOOD/CONCEPT. I'm intimately familiar with this scene, located at the Kit Carson Lodge on the shore of Silver Lake in California's magnificent High Sierra range. The distant peaks are those of Thunder Mountain, so called because quite frequently when storm clouds form, thunder booms and reverberates from the mountain's towering granite walls and buttresses. I've painted the mountain from many vantage points around the lake, and with each change of season, weather or time of day, it presents a new and different appearance. I recall one day several summers ago when following a rain, I was greeted by a double rainbow arching over the mountain—an image I quickly dismissed painting, thinking it would never be believed!

I created *Alpenglow* just before sunset on a day when the sky was clear and the distant faces of Thunder Mountain were warmed by the sun's last rays—a brief lighting effect known as "alpenglow." When the weather is clear, alpenglow is a dramatic, daily occurrence. Its intense and warm colors attract your eye with an almost irresistible force, and in the still of the oncoming evening, the silence is broken only by the sound of birds scurrying to make final preparations before nightfall. This is a magical time of day for me because of the stillness, the beauty, the feeling of oneness with nature, and a slightly sad awareness that the day is coming to an end.

In *Alpenglow* I wanted to create a dramatic contrast between the dark values in the foreground and the lighter values and warmer colors of the distant faces of Thunder Mountain. I considered both horizonal and vertical formats but chose a vertical format so there would be fewer trees or other foreground elements to distract from the dramatic feeling I wanted to convey. I also felt it was important to make sure the foreground trees had at least some soft, warm highlighting so they would be more interesting than simple, dark, flat shapes or silhouettes. Also, although the light on Thunder Mountain doesn't contrast as strongly as the elements in the foreground, the warm color of the distant mountain pulls your eye into the scene and helps establish the three-dimensional illusion.

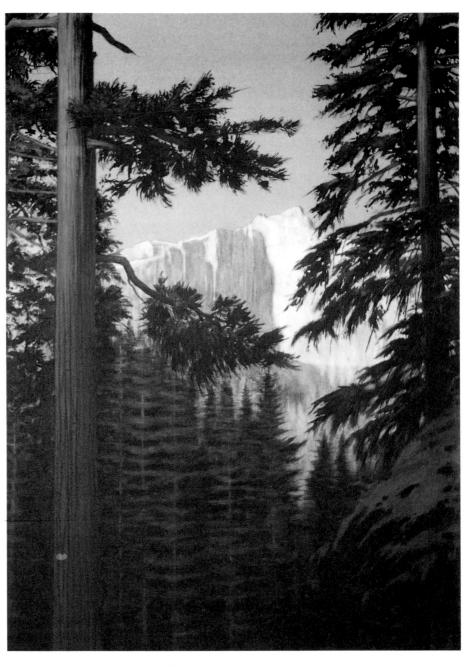

ALPENGLOW, 39″ × 25″, Private collection

Finally, I carefully designed the negative shapes that appear between the foliage (revealing the lighter background sky) to create interesting shapes that visually pull the viewer's eye "through" the trees. All these carefully planned design elements (interesting shapes, color and value contrasts, and so on) combine to support the center of interest—i.e., the light shapes of the distant mountain's face, delineated by the sun's waning rays.

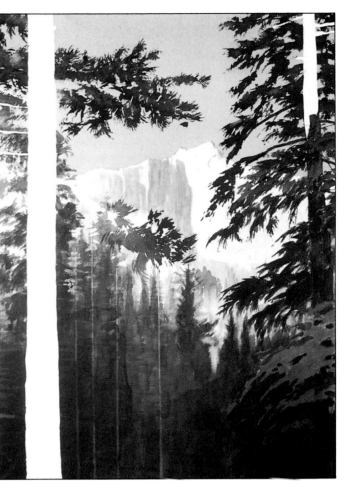

STEP 1. After sketching a few rough ideas to explore various compositional possibilities, I was ready to start the painting. Since this painting depended a great deal on color and since I was quite familiar with the details of the scene, I didn't bother with a preliminary pen-and-ink drawing.

After enlarging my compositional sketch full-size onto a sheet of watercolor paper, I applied liquid masking fluid over the distant mountain and foreground tree trunks and branches, then laid down my first wash of alizarin crimson. After it had dried, I applied a series of graded washes, using mixtures of cobalt blue, cerulean blue, and a touch of diluted Prussian blue, allowing each wash to dry completely before applying the next. I continued to apply additional washes of color (as many as five or six) until I got exactly the blend and density of color I was after, taking care to stop before the passages became too opaque or too dark.

STEP 2. With the masking removed, I used a no. 12 round brush to apply a wash of yellow ochre and alizarin crimson to the mountain to convey the warmth of the sun. After that had dried, I used a no. 8 round brush to paint the distant mountain's atmospheric shadows using a violet color I'd mixed from alizarin crimson, cerulean blue, and a touch of cobalt blue.

Next, I painted the tree shapes and colors with round brushes and various mixtures of Prussian and ultramarine blue mixed with burnt sienna. Then after bringing the tree forms to a near final stage, I removed the last remaining masking from the trunks of the trees.

FINISH. (Shown on facing page) To complete the painting, I added the final details of the tree trunks with a no. 10 round brush and various mixtures of burnt sienna and cadmium orange mixed with ultramarine blue. As I worked, I was careful to create a gradation of light across the width of the tree trunks as well as up and down, leaving the strongest light and color near the top of the tree trunks. This variegation of color and light is not only much more interesting than a simple flat tone, but from a design standpoint, it also helps direct the viewer's eye away from the darker bases of the tree trunks and toward the center of interest—the "alpenglow" on the distant mountain.

DEMONSTRATION FOUR
Early Morning/ Silver Lake

MOOD/CONCEPT. Discovering dramatic cloud arrangements is often a matter of luck—of course, it doesn't hurt to improve your "luck" by listening to the weather report so you can arrange to be at the proper location when effects like this are most likely to occur! For example, during the summer in the High Sierra, thunderstorms seem to occur about every eight to ten days. Sometimes they last for a day, sometimes for five. Either way, you can be fairly certain that afterward you'll find vapor like this rising from the lakes.

At a quick glance, *Early Morning/Silver Lake* might appear to be a winter scene, but it was actually painted on a cool July morning. I completed the on-location work around 6:30 A.M., just as the first tentative glow from the morning sun began to strike the mountains and water; here and there clouds blocked its passage, providing lighting that was quite dramatic. Even so, the colors were muted due to the time of day and the filtering effect of the clouds. Surprisingly, quite a few whites were left in this painting, representing holes and crevices in rocks that were filled with rainwater and rocks that were still slick with moisture from the morning dampness.

My primary concern in this painting was to capture the dramatic light that struck the water near the lake's horizon. After that I designed the vertical reflections on the water's surface to create an interesting pattern. The pattern of foreground rocks also intrigued me, and I felt their long lines added to the tranquil, early morning mood of the scene.

From a design standpoint, this composition is based on a number of directional movements that are designed to direct the viewer's eye from form to form so that it finally rests on the dramatic light striking the water's horizon. For example, the viewer's eye follows the right-to-left diagonal movements of the foreground rock slabs "into" the spatial illusion, then turns and goes still more deeply "into" the distance via the left-to-right diagonal formed by the shoreline below the trees. This last diagonal, along with the right-to-left pattern of smaller rocks on the right, "points" to the dramatic light on the water at the lake's horizon.

Try blocking out the bottom third of the painting with your hand—you'll see that what remains still provides a dramatic arrangement of light and atmosphere. Now remove your hand and notice how the foreground rocks provide sweeping diagonals that add interest and complexity to an otherwise simple horizontal design. The vertical reflections on the water also add interest within the larger shape of the lake and create unity between the upper and lower parts of the painting. Compositionally, the strong diagonal movements are balanced and stabilized by the pattern of verticals from the trees and darker reflections on the water.

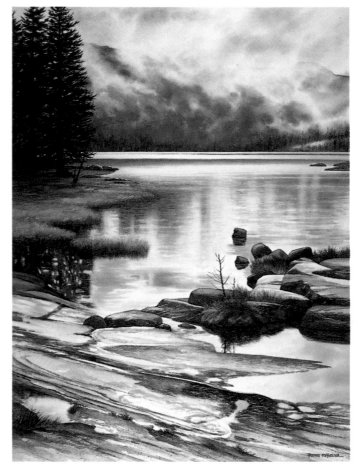

EARLY MORNING/SILVER LAKE, 38" × 28"

STEP 1. Using a wet-into-wet approach, I began with the sky area, keeping it wet most of the time as I established the pattern of clouds using 1½-, 2- and 2½-inch hake brushes. (In later stages, I used a variety of round brushes, but mostly a no. 12.)

Although the clouds look natural or almost accidental, they were actually "designed" fairly consciously based on a careful consideration of their shapes, directions, values and colors. Throughout the sky, I took care to make the most of "lost and found" edges, using a damp facial tissue for lift methods where appropriate. In this way, some portions of the cloud forms have definite edges, while other parts of the same cloud are often diminished and "lost." In other areas, the clouds part to expose the mountain in the background.

Where the mountain is visible, I kept its color cool using mixtures of ultramarine blue and cobalt blue, which I "charged" here and there with cerulean blue using a no. 12 round brush to add color at the last moment while the mountains were still wet. I used cerulean blue for two reasons: First, because cerulean blue is somewhat opaque and when used to "charge" ultramarine blue and cobalt blue, its opaqueness helps keep the mixture dense and with body; second, when it dries, cerulean blue glows and lends a "snap" of color that I feel adds to the painting.

STEP 2. At this stage, I quickly rewet the whole top of the painting with clean water, using a wide hake brush, making certain I moved quickly to avoid picking up dried color from Step 1. Then, with a 2-inch hake brush, I carefully added alizarin crimson and a dilute mixture of cerulean blue and Payne's gray to various parts of the whites of the clouds to make them more interesting and to convey the soft violet hue of early morning light. It is this light that would eventually influence everything in the painting.

Since the sky sets the stage for the colors of the landscape and water below, I used a no. 12 round brush and various mixtures of cerulean blue and ultramarine blue to paint the water shapes; I used a damp tissue to retain the soft edges of the reflections. When those colors were thoroughly dry, I applied pale glazes of alizarin crimson over them to further key them to color of the sky.

STEP 3. Next using several sizes of round brushes (mainly no. 10 and no. 12), I painted the dark tree forms and the green ground covering at their base using various mixtures of Prussian and ultramarine blue mixed with burnt sienna. Afterward, I returned with a more opaque mixture of cadmium yellow light and Prussian blue to highlight some of the foliage so it would be more interesting than a simple, flat shape. The dark values of the trees provided a nice contrast to the light sky and enhanced the overall drama of the composition. Below them I painted their reflections in a more abstract pattern, using the same colors I'd used for the foliage but emphasizing the blue side of the mixture to show that the reflections were influenced by the blue of the water.

FINISH. To complete *Early Morning/Silver Lake,* I painted the remaining details of the foreground rocks and shoreline, using round brushes and a flat hake brush and various mixtures of Payne's gray, cerulean blue and alizarin crimson. I also added accents of burnt sienna. Salt and spattering were also used to create textures on the rocks, although only a slight trace of the salt texture remains visible.

To help bring this area forward visually, I warmed the generally cool granite rock colors by adding a touch of alizarin crimson and a pale wash of cadmium orange as overglazes while keeping my tissues close at hand to lift or diminish the color if it appeared too strong.

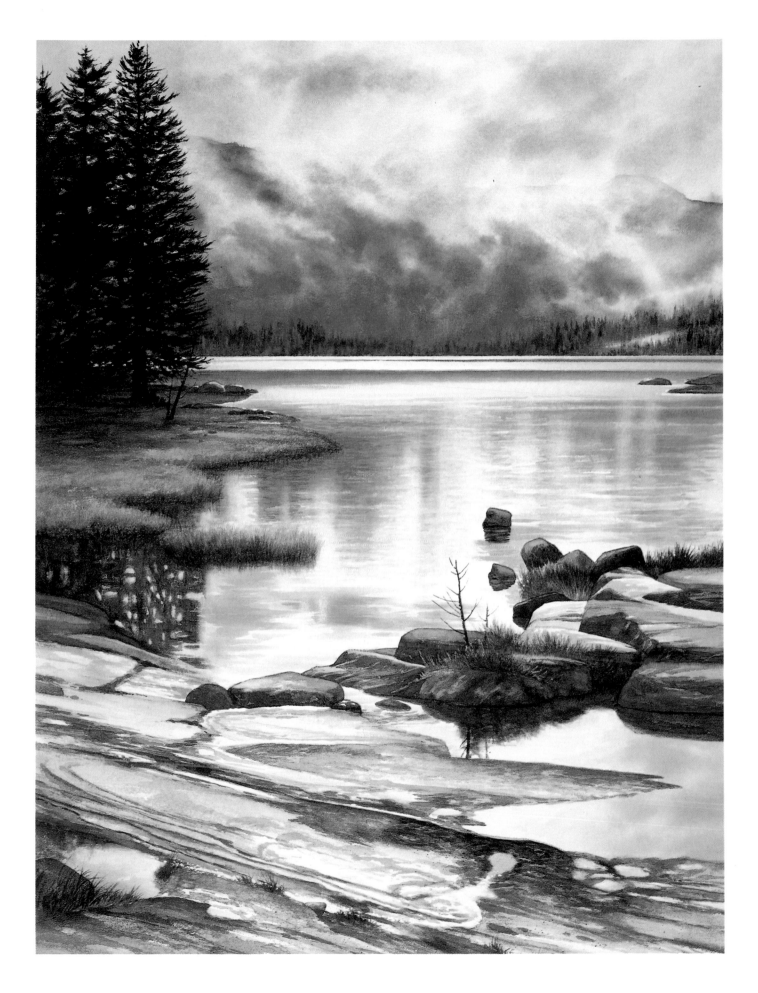

DEMONSTRATION FIVE
Quiet Journey

MOOD/CONCEPT. I recall being over my knees in snow when looking for this stream. I knew it was there because I could hear the water quietly moving over the rocks somewhere beneath the deep snow. I found it by nearly falling into it because the cover of recently fallen snow concealed dangerous rocks and holes around the stream's bank. When I finally got back in my studio—safe, sound and dry—I retrieved the reference photos I'd taken on location and created the composition for this painting.

In *Quiet Journey* I wanted to convey the mood of the remoteness of an area where only snow rabbits and foolish artists in search of unusual subject matter dare run across the precarious snow. I was deeply moved by the stillness of the scene, the pleasant sounds of water running over the rocks, and the sun striking the quiet turns of the stream. This may sound like a small thing, but in many cases, it is the small experiences in nature that are most moving.

The feeling of remoteness also contains a certain element of genuine concern, such as when I nearly fell or when I discovered a large footprint in the snow that may have been the recent track of a mountain lion. When I made that discovery, I can promise you I felt quite alone with nature, but at least it kept me alert as I continued my search for subject matter.

This subject lent itself to a vertical format as you can see, but later I painted a smaller version using a horizontal composition that focused more tightly around the stream. Both formats offered their own rewards. The vertical format created a less comfortable setting that seemed to add to the sense of movement in the stream, while the horizontal format added a "comfort zone" of repeated horizontal components.

In this composition, the strong diagonal movement of the stream is countered by opposing diagonal movements in the snowbank, which moves toward the stream. Also, the rocks within the stream add opposing directions, as do the rays of sun striking the water. These various opposing elements slow the diagonal movement and also complement the shapes with added variety.

The value distribution is based on a pattern of dark against light and light against dark: The foreground shadows provide a contrast to the lights in the lower parts of the stream, while the upper darks in the stream play off of the lights striking the snow on the other side of the stream. The upper part of the composition uses shadows to keep the viewer's eye from leaving the top of the painting. The trees add variety and contrast.

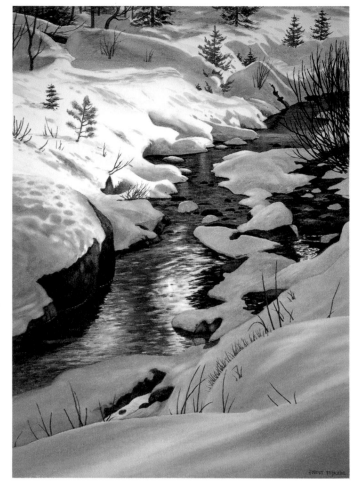

QUIET JOURNEY, 39″ × 25″, Collection of Dr. Donald Rink

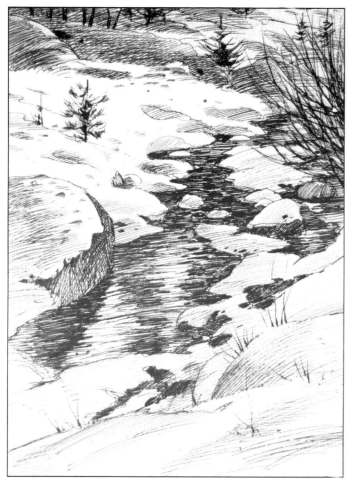

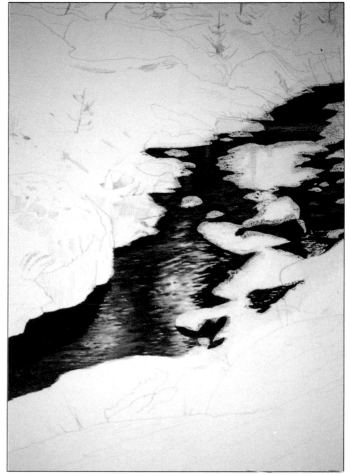

STEP 1. This ink sketch is one of several I completed in the course of determining the best viewpoint and the most effective distribution of values throughout the image.

STEP 2. After drawing the composition full-size onto a sheet of water-color paper, I masked out the rock shapes within the stream and along its edges before painting the lower stream area, using various mixtures of Prussian blue, burnt sienna and yellow ochre.

For the upper part of the stream, I used a combination of burnt sienna and cadmium orange mixed with Payne's gray and touches of ultramarine blue. To add interest and variety, I either painted around or "lifted" the light reflections in the foreground water to describe the surface of the water and suggest its movement.

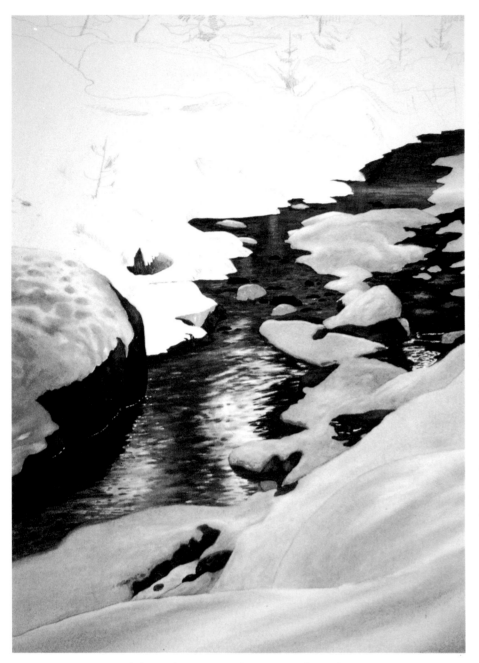

FINISH. To complete *Quiet Journey*, I painted the small trees using no. 8 and no. 10 round brushes and various mixtures of cadmium yellow pale, Prussian blue and ultramarine blue. Then, with mixtures of burnt sienna and ultramarine blue, and smaller round brushes, I indicated the bare branches of the bush in the upper right and the dried grasses throughout the image. Next I returned with several mixtures of cerulean blue, ultramarine blue and alizarin crimson to deepen and form the undulations and shadow patterns in the snow, carefully maintaining a constant source of sunlight to further define their shapes. Finally I softened some of the snow shapes with damp tissues and strengthened others to create sharper contrasts.

This last stage of development was important not only because it completed the image but also because it defined directional patterns, which opposed and complemented the diagonal movement of the stream. As I paint, I'm constantly thinking in terms of design relationships—that is, how all of the areas within the composition interact with each other. Every part of a painting should have variety and sound design, and the relationships between values, colors, shapes, lines and space should be visually interesting. One way to get a better feel for what I mean is to pick one of your paintings and isolate a 4-inch square within the image at random, and examine it closely; even though it is small and randomly selected, it should be interesting and well designed.

STEP 3. Next I removed the masking agent. After painting the rocks with no. 8 and no. 10 round brushes, I took a no. 12 round brush and with mixtures of cerulean blue, ultramarine blue, Payne's gray and alizarin crimson, I painted the shadows on the foreground snow to give form and direction to the composition. This was done in a series of steps, layering new color over dried color. The overlapping foreground snow shapes also add dimension to the composition and help viewers establish that the point of view is looking down on the stream.

Note how the sunlight strikes the other side of the stream. So as not to split the composition diagonally with this separation of light, I've used the water highlights to counter this potential by adding light in another area. Also the reflected lights in the foreground snow help spread lights throughout the composition, even though they're rather subtle.

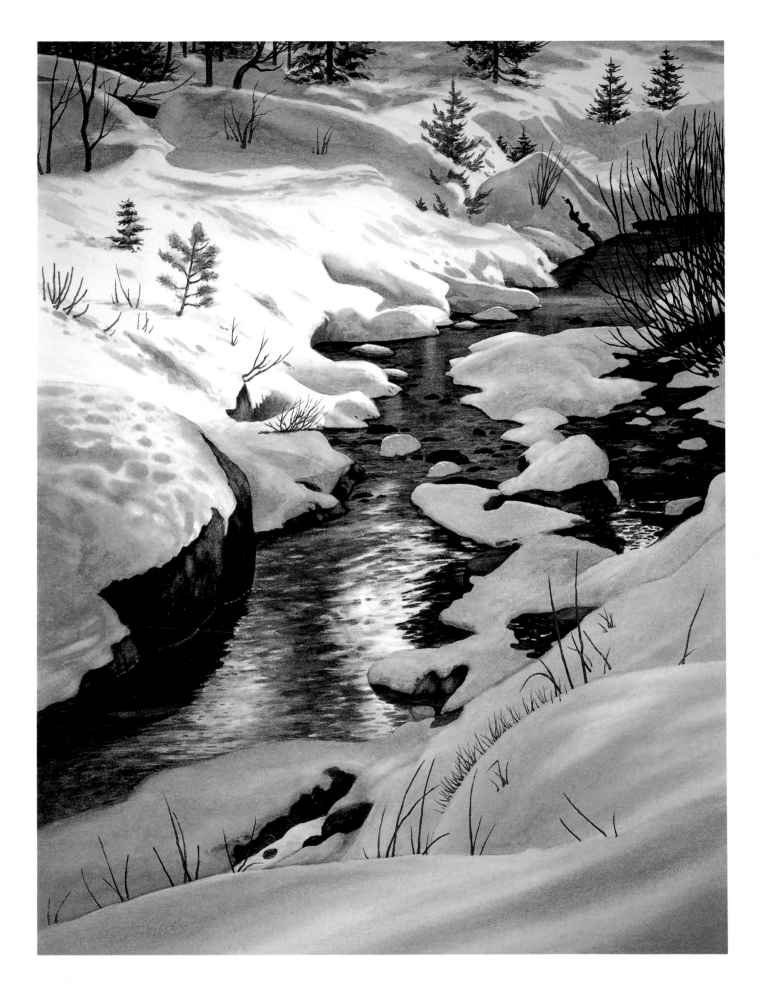

DEMONSTRATION SIX
Back Bay Light

MOOD/CONCEPT. I've painted here on many occasions. It's an area not far from my home, and I'm intimately familiar with the landscape and with the ever-changing light that occurs here.

The concept for this painting was to use a fairly simple and straightforward landscape arrangement to produce dramatic results. So by setting the painting late in the day, just as the sun neared the horizon, I gave myself the maximum opportunity for dramatic contrasts and freedom in my choice of colors. Paintings like *Back Bay Light* require some foresight, however, because being built around limited areas of controlled, strong light, they don't reach their full dramatic potential until the final stages, when the dark, foreground components are in place. Here, for example, the wet sand and darker marshy foreground provided an effective foil of dark values, which I was able to play against the light sky to provide the dramatic and powerful contrasts I was after.

Like many of my paintings, *Back Bay Light* functions at several levels. On the surface, it depicts a mood of solitude and quiet contemplation of the majesty and beauty of the natural landscape; at another level, it shows my intention to create an effective and pleasing abstract design of shapes, colors and values without regard to the actual subject matter. Even so, the mood of the painting is reinforced by its design. Note, for example, the subtle right-to-left diagonals of exposed sand in the lower right corner that gently lead the eye toward the bright left-to-right diagonals formed by the reflective water just above. These diagonals are, in turn, gently reversed once again where the dark marsh meets the lighter wet sand just below the horizon. Finally, except in the center of interest, I intentionally kept transitions of color and value throughout the image gradual to support the overall mood.

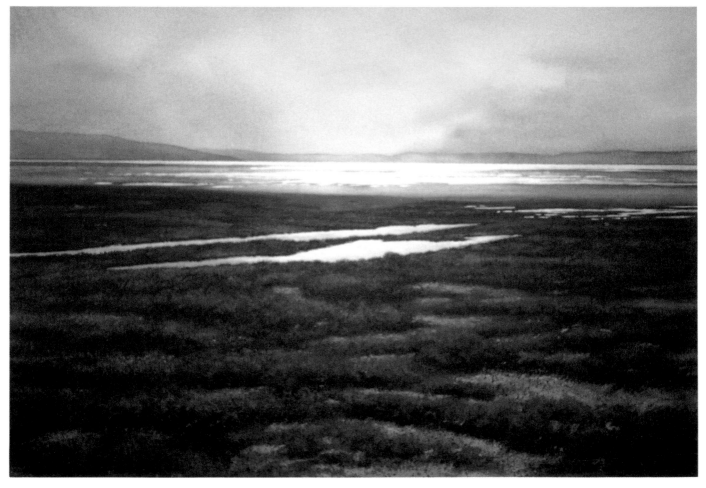

BACK BAY LIGHT, 25" × 39", Collection of Arthur J. Silverstein, M.D.

STEP 1. This painting needed very little preliminary drawing, so I decided to paint it using a wet-into-wet technique. I also decided to base the colors of the sky on a complementary color scheme of yellows and purple.

After I'd determined the large shapes (the sky and beach), I used masking tape to define and save the horizon line before beginning to paint the sky. Then using a 3-inch hake brush, I applied warm, yellow tones mixed from cadmium yellow pale, cadmium orange and a touch of alizarin crimson to the sky area. While those washes were still damp, I indicated the coastal mist and clouds, using a smaller hake brush and several cooler purple and blue tones mixed from mineral violet, cerulean blue and cobalt blue.

STEP 2. When I finished the sky and was satisfied with the result, I allowed it to dry before indicating the distant sand dunes (on the horizon) as a simple silhouette, using a no. 10 round brush. I deliberately indicated the dunes as simple middle-value forms because their primary purpose was to provide interesting shapes and a darker edge—to contrast against the brilliant light that strikes the water just below the horizon line. To paint the dunes, I used a mixture of mineral violet and a touch of cadmium orange. However, at the point where the light from the sky is strongest, I kept the dunes lighter and warmer in color.

Once the dunes had dried, I removed the masking tape and drew the landscape below the horizon in greater detail; I hadn't wanted to invest additional time and effort until I was certain the somewhat risky wet-into-wet technique I'd used for the sky had been successful. Moral: Time is expensive, paper is inexpensive! (Relatively speaking, that is.)

Next I applied liquid masking to block out the areas just below the horizon line and the two diagonal shapes near the center of the painting, which I wanted to reserve for strong, dramatic lights later on. Compositionally, my intention at this stage was to make the water trapped on the beach the strongest element, with the foreground grasses and wetlands providing subordinate directional patterns of darks, halftones and negative areas.

STEP 3. Before applying the dark colors of the marshy wetland areas, I laid in a wash of alizarin crimson to tone the white paper. The overall alizarin tone makes it easier to make accurate value judgments later, when I begin to develop the darker passages. In the same vein, the alizarin tone helps unify the colors and wherever it remains exposed as the painting progresses, it "reads" as a subtle reflection of the sky colors.

After applying the alizarin, I used various mixtures of burnt sienna and ultramarine blue to indicate areas of darker water just below the bright sunstruck water at the horizon. In the central area of this water, I lightened the values and added cadmium orange to convey the effects of the strong, warm light. In the same vicinity, I also added a subtle green mixed from cadmium yellow pale, ultramarine blue and cobalt blue to suggest the presence of seaweed marooned on the beach at low tide.

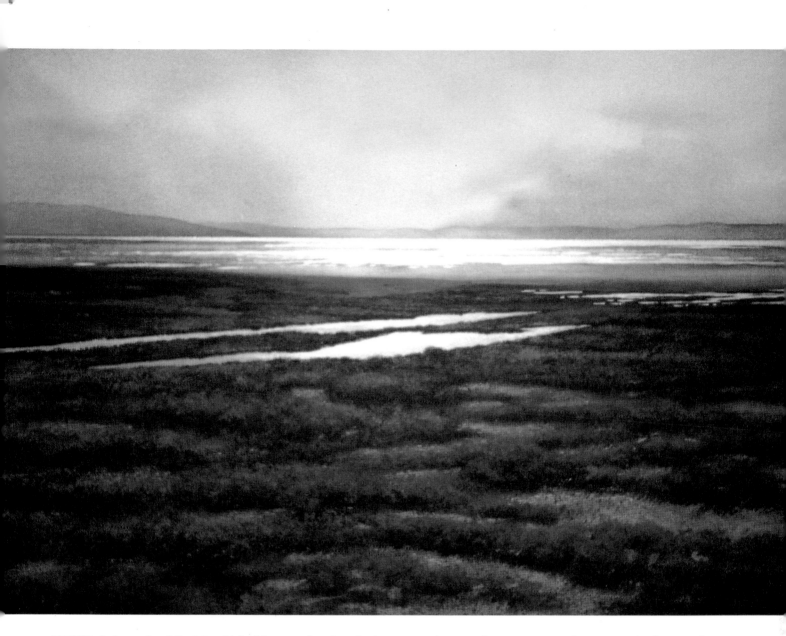

FINISH. As I completed *Back Bay Light*, I kept two key thoughts in mind: (1) to create the illusion of brilliant, glowing light in a painting such as this, I needed to pay careful attention to the darks and middle tones because they are the ingredients that make the lights credible, and (2) although this painting appears deceptively simple, its success, or lack thereof, depends on the inherent strength of a design based on subtle interactions between values, colors and directional thrusts.

With those thoughts in mind, I painted the foreground marsh grasses with various mixtures of Hooker's green, alizarin crimson and vermilion, which I applied initially with an oriental round hog's-hair brush and then refined with a series of round brushes. I used vermilion—the warmer of the two reds—in the central area where the light is strongest to create the illusion of the sun's glow. As the grasses moved away from the direct light, I used less red and made the values progressively darker. At the same time, I "designed" the negative spaces between the grasses to contribute interesting shapes to the over-all composition. Note that, as mentioned in the previous step, the toning wash of alizarin crimson "peeks" through the grasses and wet-lands, suggesting the reflected light of the sky. In some areas, I strengthened this effect still further by applying additional washes of alizarin crimson.

Finally, I took special care as I painted the shapes of the dark grass surrounding the light-valued water: To convey depth in the streams of trapped water, I placed subtle shadows along the upper edges of the water shapes, while along the lower edges, I staggered the shapes of the blades of grass that rise in front of the water to create additional variety. Throughout the foreground, the grass patterns are anything but random—in fact, they are carefully arranged to serve as opposing directional forces to counter the strong diagonals of the water shapes and strengthen the total design pattern of the composition.

INDEX